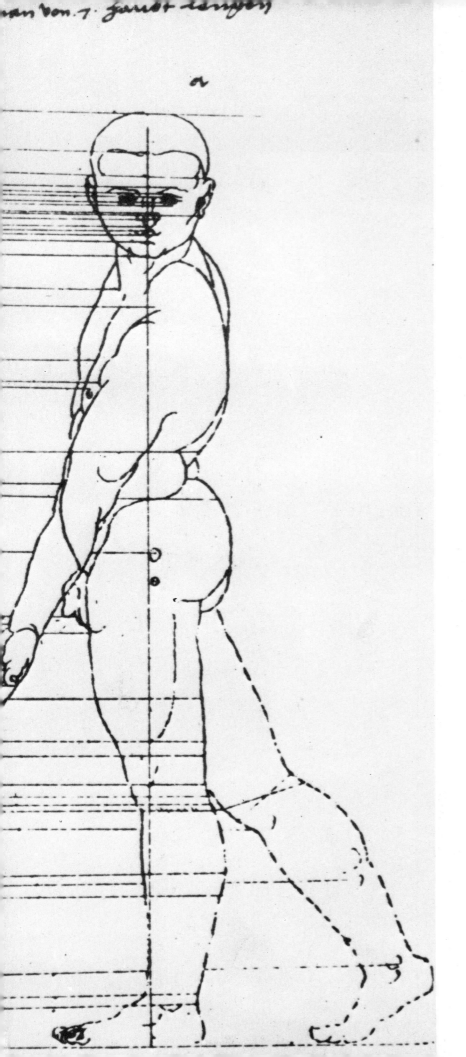

Drawing
Techniques

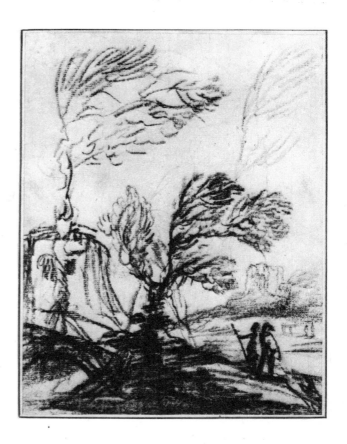

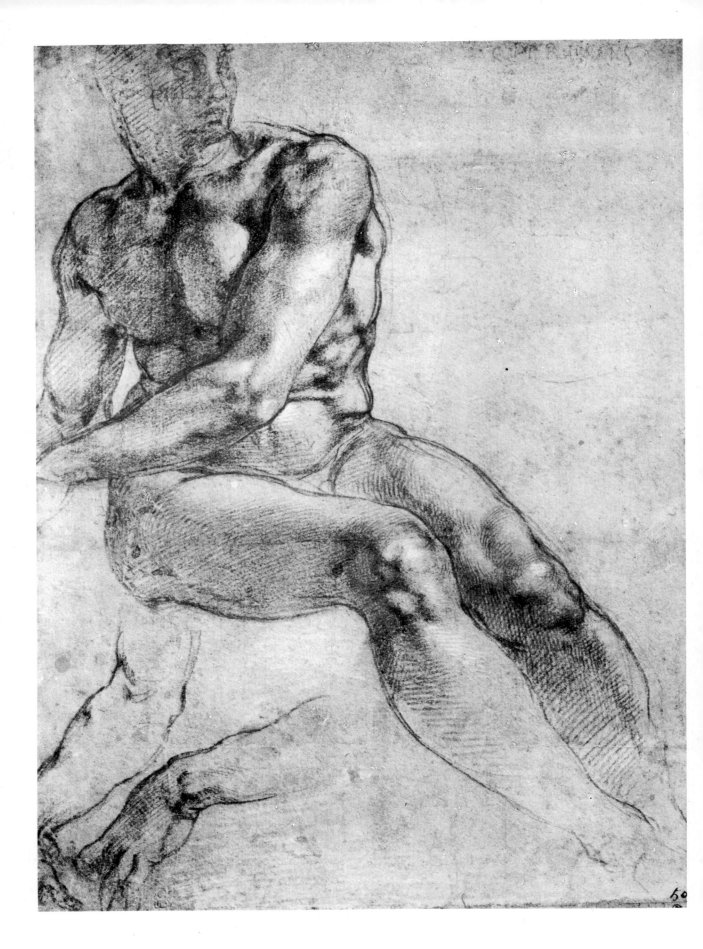

DRAWING TECHNIQUES

Text by Karel Teissig

Selection of pictorial
material by Jana Brabcová

OCTOPUS

1 *(end-papers)*
Albrecht Dürer (1471—1528)
Proportional figure, from the Dresden Sketchbook,
fol. 119 v.
Pen and bistre, 294 × 210 mm
Staatliche Kunstsammlungen Albertinum
Sächsische Landesbibliothek, Dresden

2 *(title page)*
Guercino (Giovanni Francesco Barbieri; 1591—1666)
Landscape
Black chalk, 309 × 246 mm
Moravian Gallery, Brno

3 *(frontispiece)*
An unknown pupil of Michelangelo
Sitting Male Nude and Studies of Arms
Sanguine and white paint, 268 × 188 mm
Graphische Sammlung Albertina, Vienna

4
An artist from the circle of Francesco Salviati
(1510—1563)
Head of a Woman
Pencil, 166 × 141 mm
Graphic Art Collection, National Gallery, Prague

Designed and produced by Artia
First published 1982 by
Octopus Books Limited
59 Grosvenor Street, London W 1
© Copyright Artia, Prague 1983
Text by Karel Teissig
Selection of pictorial material
by Jana Brabcová
Translated by Šimon Pellar
Edited by Susanne Haines
Graphic design by Aleš Krejča
ISBN 0 7064 1739 9
Printed in Czechoslovakia by Svoboda
2/12/02/51-01

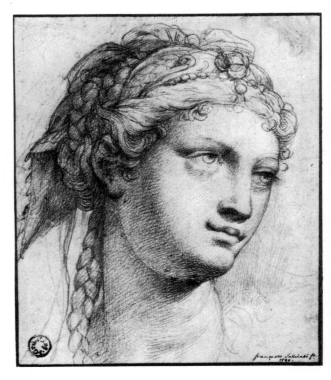

CONTENTS

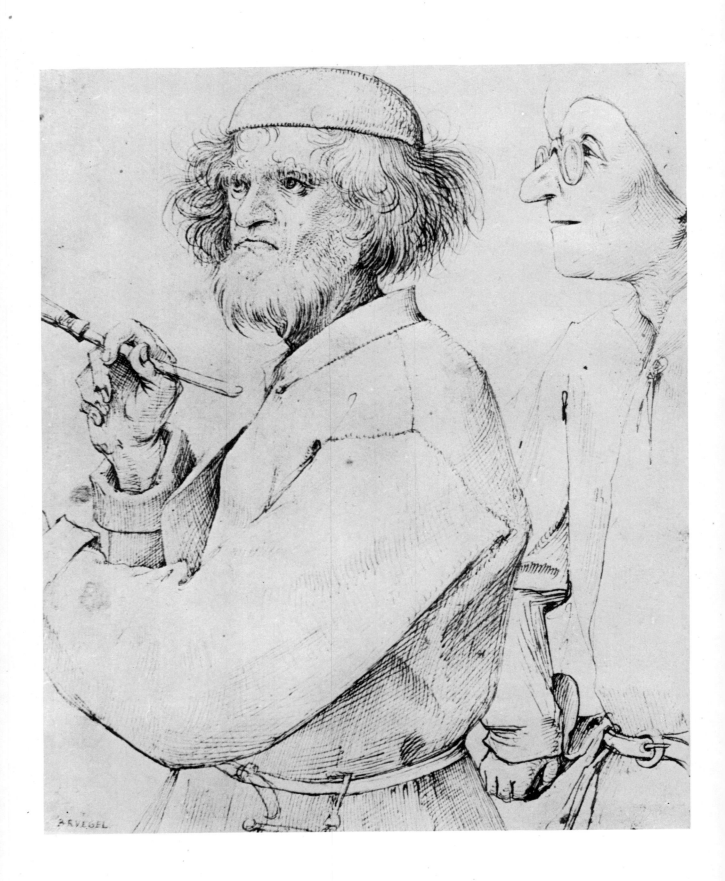

A DRAUGHTSMAN'S CREED

If you ask what drawing is, the answer will be that drawing is a means of artistic expression captured on a surface with lines, dots and hatchings of varying density. It is more pertinent, however, to question the raison d'être *of drawing.*

Undoubtedly it lies in the representation of objects, landscapes, animals, people, feelings, moods, images, thoughts and ideas. Drawing is a means of interpreting reality, it is a communicative language capable of conveying a message.

The most difficult and, at the same time, the most important aspect of drawing (or to be more precise, drawing as an artistic expression) is the ability to bridge the gap between an idea and the realization of that idea. It is not easy to transfer adequately on to paper a magnificent mental image that one can see or feel. It is made difficult by inexperience as well as by a lack of trust in the creative process, by a lack of confidence in what transcends the realization and in the spontaneous grasp of the specific character of a technique or medium and also perhaps in what turns inspiration into a creative act. Drawing is not merely a message, but also a decision; to a certain extent it is even an open manifestation of a philosophy. Yet it remains a phenomenon full of internal contradictions, something which lies halfway between an idea and the actual result. No one is more aware of this conflict than the artist himself; he must either accept the result when he thinks it represents a successful culmination of the creative process, or he will suffer, anguished by the awareness of the imperfections of his work.

Your head may be full of ideas and vivid images, yet until you actually start working all this will not mean much as far as graphic expression is concerned. It is only when you start drawing, when your hand starts learning to obey the impulses of your visual and intellectual perception, that you will understand what it feels like to cope with all the difficulties and obstacles on the path leading to a successful artistic realization of an idea — the anguish inherent in any creative process.

Then once you have spent some time learning to draw, your thinking, your seeing and your hand will become better attuned to the same wavelength and your responses will be more automatic and precise. A patient training is required before you can expect genuine results but the creative joy will be felt at an early stage when you begin to feel how meaningful drawing can be.

Line is considered as the basic structural element of drawing. However, lines as such do not exist in nature. If we disregard the material significance of visual phenomena, everything around us can be seen as systems or sets of surfaces and forms of various colours and different degrees of shading. Only the sharp boundaries and edges of objects seem to constitute a kind of line which, in fact, does not exist either but which one just imagines to be there. The process by which our mind demarcates linear boundaries of an object (of a silhouette of a flower or a profile of a human face, for instance) and translates them into a system of lines requires an ability to make certain visual abstractions. It is this ability that permits us to transfer to the surface of the paper the spatial character of objects by means of lines. This means that one does not actually 'transcribe' the infinite variety of shape and colour of an object, a figure or a landscape but rather tries to simplify it, attempting to grasp the intrinsic character, whether static or in motion, through lines on a two-dimensional surface. As you will discover, it is even possible to use a monochrome drawing to convey something of the colour of an object.

Apart from lineation, drawing has at its disposal a number of other means and their various combinations. However, a line, be it

5
Pieter Bruegel the Elder (*circa* 1525—1569)
Painter and a Patron of Art
Pen and bistre, 250 × 216 mm
Graphische Sammlung Albertina, Vienna

flowing or halting, combined with hatching and stippling, or any other rhythmic marks, still remains the chief means of expression in drawing.

In painting, it is generally the artist's aim to present a complete image; drawing is of a more subtle, more delicate character, it hints at things, it sketches and outlines to suggest an image yet to be executed but already understood. But it can also be a vehicle for more detailed and graphic representation.

A tentative draft, or sketch, captures the emerging image, it is a manifestation of a creative search. This is the reason why sketches are impulsive in character, why they are attractive records of an intimate, spontaneous expression seemingly quite oblivious of compositional or stylistic considerations. This is what makes drawings so irresistibly attractive and it is why they reveal so much about the draughtman's personality.

The immediacy of a drawing reflects a certain intellectual process. The viewer can participate in the process more easily than viewers of other arts where the technical process tends to alienate the artist from the audience. In this lies the instant charm of drawing — a direct art which refines the imagination, sharpens sensibilities and thus opens the gates leading into the realm of the visual arts and graphic expression.

Before the Renaissance, drawing was an auxilliary discipline, rarely regarded as a work worthy of artistic merit in its own right. Drawing served as an initial recording of solutions to technical problems, inventions and tool design. It was also used to make preliminary sketches for paintings, sculpture, architecture or the applied arts, and also to provide the artist with a way of exploring the individual parts of his composition in detailed studies. A cartoon is a full-sized pattern for the composition of the picture. In fact, drawing is inseparable from painting because it is often the starting point of the painter's realization of his idea, a fact well documented by unfinished paintings. Underdrawings have been found to possess a powerful and independent existence. Drawing gradually developed into a recognized discipline and later became regarded as a genuine art form that was shaped by a search for a unique expression and, to some extent, by the style of the period.

There can be no doubt that drawing has proved its right for an independent existence. Today it is the primary force in related fields of art like book and magazine illustration, caricature, animated cartoons, posters and advertising graphics, which all demand a high degree of skill.

Drawing, which once remained virtually unseen beneath the surface of a painting emerges in some painters' works above the artist's personal style as well as in the handling of the brush work. Such a means of expression is said to be of a dominantly 'graphic' character. One only has to look at the work of great artists such as Velázquez, Goya, Daumier, van Gogh or Picasso to observe this approach.

Although the visual appearance of reality has remained the same, its interpretations through drawing bear easily identifiable signs of the style and attitude of the period. A drawing is thus not only a sum of visual perception, but it also constitutes a document. It is exciting to trace how artists of various periods coped with this task of drawing — from the cult images of cave paintings and engravings with animal bones, to the formalized drawings of the Gothic and ultimately to the sophisticated products of the artist's imagination conceived as independent works of art. Such a survey is beyond the scope of this book whose chief purpose is to deal with the methods and materials used by the artist and to suggest certain techniques that will lead to the development of a certain skill in drawing.

Leonardo da Vinci (1452—1519)
St Peter
Pencil, pen and bistre on blue paper, 146 × 113 mm
Graphische Sammlung Albertina, Vienna

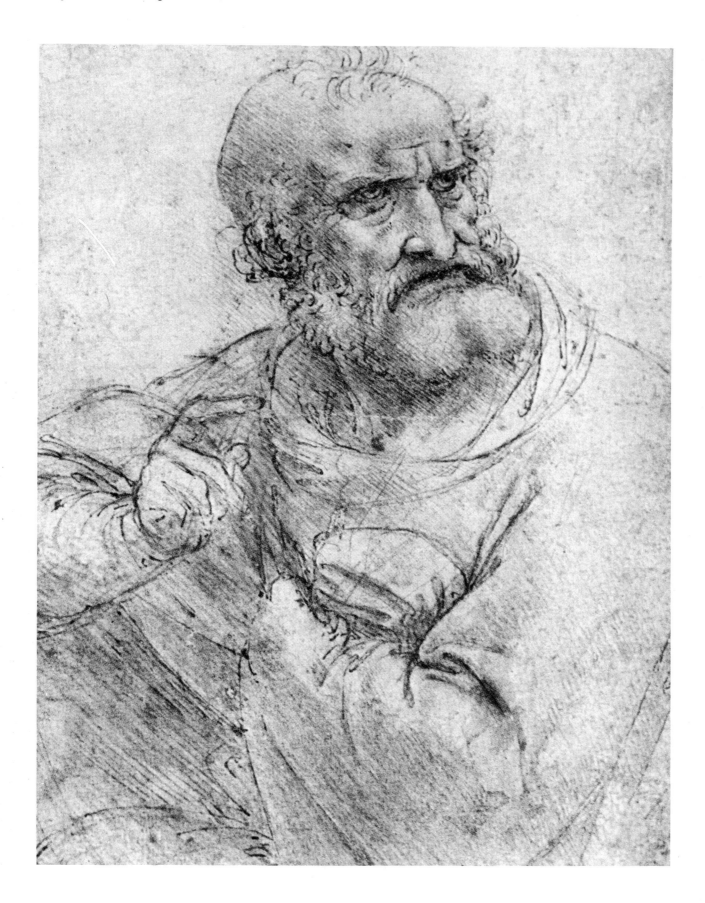

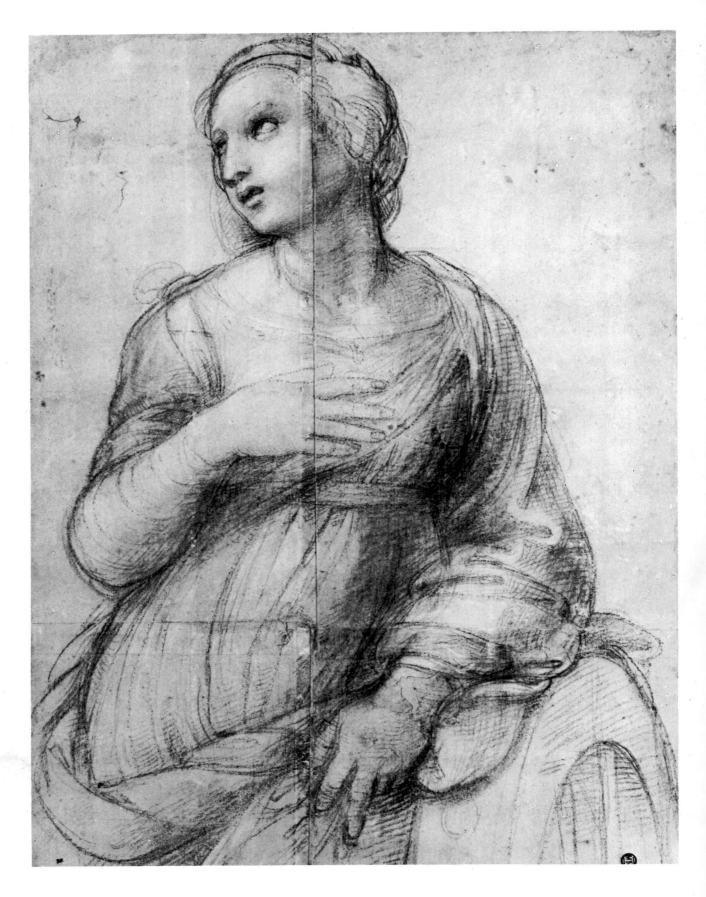

7
Raphael (Raffaello Sanzio; 1483—1520)
St Catherine of Alexandria
Black chalk and white paint, 587 × 436 mm
Cabinet des Dessins, Louvre, Paris

METHODS
OF DRAWING
INSTRUCTION

There are naturally several approaches to the problem of instructing drawing, or rather of imparting a method of learning how to gain a certain capacity for expression through drawing. From the start the future draughtsman must become thoroughly acquainted with reality — the visible world. This basic approach is as valid today as it was in the past although changes in style and in intellectual and aesthetic ideals have determined changes in concepts.

The medieval novice, apprenticed to his master for anything up to seven years, was required to do all the chores in the workshop. However, all his spare time would be spent drawing and copying under guidance, and it was up to his talent and respect for the authority of the artist to determine how deeply the apprentice mastered the basic skills of the trade. This system offered a unique opportunity which raised a mere craft to the level of genuine art.

During the Renaissance the first attempts were made to put instruction on a firmer footing and to set out clearly the objectives. The first Academies — as art schools for student painters and sculptors were called — were founded around 1490 by Lorenzo il Magnifico in Florence and by Leonardo da Vinci in Milan. In both the Medici Academy and Leonardo's *Accademia Vinciana* learned disputations on art were held, with the emphasis on the study of classical art. It was actually in Florence where the Medici amassed a collection of classical examples that the academic tradition of copying from classical sculpture started. Members of Lorenzo's Academy, whose numbers included the young Michelangelo, called themselves *accademici del disegno,* academicians of drawing, and followed a system of education based on principles originally formulated by Leonardo.

Another society of artists was founded more than a century later in 1563 by Giorgio Vasari in Florence. His *Accademia del Disegno* was not only educational, but also had a corporative function, since it offered its members a status independent of the guilds. Soon after the establishment of Vasari's school the *Accademia di San Luca* was founded in Rome in 1593 and its teaching programme remained the backbone of art instruction in academies until the 19th century.

The first stage of this educational process was devoted to the study of perspective, the second consisted of drawing from renowned masters. In this way the student learned about proportion and to train his eye on quality models and patterns. The last and highest level of study involved drawing from nature which permitted the young draughtsman to try out what he had learned.

All over Europe academies sprang rapidly into existence. In the 18th century in France alone there were, apart from the Paris Academy, 36 institutions of this kind. Among the most important European academies at least the following deserve to be mentioned: the *Académie Royale de Peinture et de Sculpture,* established in Paris in 1648 and renamed *Academie des Beaux-Arts* in 1816, the *Sandrat* Academy in Nuremberg (1674) and academies in Vienna (1692), Berlin (1696), St Petersburg (1764) and London (1768).

One of the most renowned European academies was established in Bologna in 1582 by Annibale and Ludovico Carracci. The Carraccis devised a soundly structured educational system, splitting some disciplines into several more detailed subjects; they provided live models and high quality casts and took students to dissections to study anatomy. They were aware, too, that sound instruction must also be based on theoretical studies. Later academies adopted this attitude and extended it considerably to include geometry, perspective and architecture; still later to encompass history, mythology, poetry, iconology as well as study of light and colour.

This more fully developed, rather scientific education helped art to break from the restrictive bonds of the ancient guild system. On the other hand, the separation of the individual disciplines inevitably led to collective teaching, and at the very moment when the academies finally became formally structured, organized schools, the system of collective teaching showed its weaknesses. Students were influenced by the diverse theories and personalities of their teachers who natu-

rally had different requirements and demands, so some kind of objective criteria had to be established for the evaluation of their achievements. Nothing, however, is more alien to an evaluation of a work of art than objectivity. It can also lead to a negation or at least suppression of the personal responsibility of the teacher and the results produced by the student.

It would seem that an evaluation of drawings based on well defined objects are easiest to judge in this way. And thus, the 19th century saw a depersonalization of the art, in the perfectionist drawings which were appreciated as the ultimate result of art instruction. Forms had to be viewed with impartiality; even the figure had to be portrayed as objectively as possible. So, paradoxically, it was then the inanimate model that was judged to be ideal for drawing the human form. The 19th-century academies, which swore by the classics and still honoured Leonardo's views, were characterized by teaching the students to draw from endless series of classical casts.

Undoubtedly the 19th-century painters also knew how to draw, thanks to the rigid drill to which they were subjected at the academies. Yet there can also be no doubt that drawings by the good (though naturally not the outstanding) artists of the period somehow lack the exciting, intimately personal note that is, in fact, one of most valuable features of drawing as an art. It is therefore only logical that the revolt which came later and was directed against the desensitizing, deadening academic objectivism rocked the ossified traditions of the century and put the emphasis on the personal role of the teacher and on the individual disposition of the students within the framework of the required standard. Nevertheless, drawing, either of live models or arranged objects, has remained the backbone of the initial years of art studies even today and is still rightly considered the primary and essential stage in the student's rendering of reality. In spite of all the innovations, methods of instruction continue to be based on the principles established in the first medieval academies: technique, perspective, proportion, and composition are still the time-

honoured essentials. And learning to draw well, essential to the mastery of all means of graphic communication, is as difficult today as it was four centuries ago for artists at the beginning of their training.

Naturally, this introduction is not meant to discourage you. Everybody must make a start somewhere. And everyone must have felt at least once that irresistible urge to draw. That is the moment when an amateur might be naively deluded into thinking that written words on the subject are unimportant. A basic instinct takes possesion — to grab a pencil and to trace a meaningful line on a piece of paper, which develops into an image that becomes, in a sense, an extension of a feeling, a thought or a vision. Yet at the same time problems emerge that stem from disappointed ambitions. Disillusionment may set in at the sight of the unsophisticated image and the reaction is a desire to be able to draw differently (with more skill). In other words, the drawing is the antithesis of what one knows and expects from art; the conflict is one that concerns quality. It is then that one might begin to suspect that much is hidden in the craft or technique itself, that there must be some rules to the 'game' which would be good to learn.

If you are familiar with drawings by various masters, be it Rembrandt, Leonardo, Ingres, van Gogh, Matisse or Picasso, you may relate quite intimately to some, others may seem more remote or even incomprehensible. These drawings reveal different, often conflicting manners of expression and prompt an inquiry into how it is possible that different artists can produce works that vary so much in style. These artists of outstanding creative personality naturally must all have mastered the basic drawing skills and techniques, the 'ABCs' of drawing. Their work transcends this, it is an expression that represents a mature reflection of the inner disposition of the artist, his temperament, education, his immediate mood as well as the aim of his work. But somewhere at the bottom of each of these masterful expressions, behind the façade of superiority, sophistication and ease of expression is the facility to have a firm grasp

8
Annibale Carracci (1560 — 1609)
Portrait of a Lutist
Sanguine and white paint, 407 × 281 mm
Graphische Sammlung Albertina, Vienna

Basic
Equipment

of the main problem — to transcribe careful-ly an object or animate form.

The drawing endeavours of an individual can be compared to the development of the art of drawing from the academic mannerism of the 19th century to the freer approach of the present day. A beginner will be enchanted by a virtuoso representation; the more unat-tainable it appears the more he will strive to translate truthfully an idea or an object. But when a certain level of virtuosity is ultimately reached, he is still not satisfied. The problem is that new, untrodden paths are opened up. The draughtsman has the opportunity to travel through a well-mapped country and to check his bearings by comparison with the example of others. Such a journey has its ad-ventures; it will guide the beginner to a better understanding of his own approach to draw-ing. Never pass a chance to improve your ef-forts even if you regard drawing as a mere hobby. And if by the end of this exploration into a practical training you have mastered at least some means that will allow you to ex-press your feelings, your emotional and intel-lectual relation to what you see around you, then none of our joint efforts shall have been in vain.

Your very first attempts should be made on a cheap paper, such as newsprint (a flimsy, absorbent, white paper on which newspapers are printed), decorator's lining paper, or soft, tinted sugar paper. The rougher side of brown wrapping paper is good for charcoal drawing. These papers are sold either in sheets, or in wide rolls, which allows you to vary the format of the drawing. However, these papers are not stable or lightproof, so reserve them for studies or for practice. Car-tridge is a useful paper which is available in several weights.

Ingres paper is very good for charcoal studies of heads or nudes. It comes in a wide range of colours including a subtle range of yellows, greens, greys, fawn, beige, pink, blue and also white. A charcoal drawing on a pale or dark pink Ingres paper can look very ef-fective. The darker colours, such as blue, are not as suitable for this medium. When held up to the light the ribbed, transparent lines that are produced during manufacture are more pronounced. They can be used to enhance the drawing. The surface can have a slightly fuz-zy feel to it, and some brands have a pro-nounced fleck of a darker colour, which adds to the texture. It will stand up to corrections well; a plastic or kneaded putty rubber will not damage the surface if used carefully, but it is often enough just to blow off the wrong line or to wipe it off with a piece of cloth before continuing with the drawing.

The paper can be pinned, clipped or stretched on to a drawing board or a drawing frame. The paper does not have to be stretched (which is unnecessary for quick sketches) but this will give a firm surface that is advisable for a drawing that is going to be kept and possibly framed in the future. It is essential to stretch paper that is going to be used with wash.

The best method is to soak the paper by immersing it in a basin of clean, cold water, or by wetting it on both sides with a sponge, and then lay it on the drawing board. Smooth out any air bubbles with a sponge and then glue down the edges with gum strip (an adhe-sive-backed brown paper tape).

Stretching a sheet of paper over a drawing

9
Jean Delaune (Delaulne; active circa 1580)
Model of a Mirror
Pen and bistre, with bistre and watercolour wash,
280 × 180 mm
Musée Condé, Chantilly

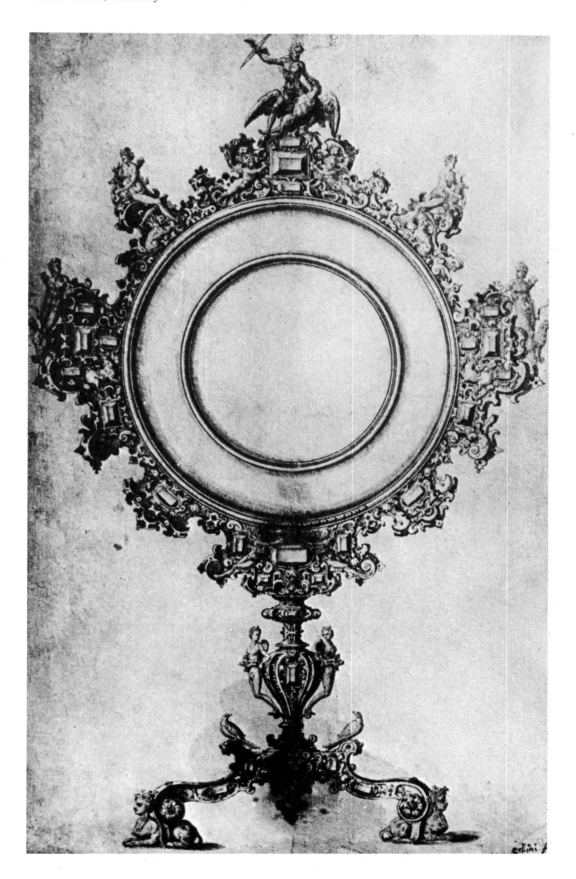

frame requires greater skill and experience. The size of the paper should correspond to the outer dimensions of the frame and the adhesive tape should be folded in half lengthwise so that it will stick to the frame from the sides. The frame should be of a rigid, sturdy construction, a true rectangle, preferably without any pins or nails. It must not get out of shape when it dries. The wet paper should be laid loosely on the frame and taped down. Allow it to dry slowly at room temperature. Rapid drying would result in excessive shrinkage and the adhesive tape could split or the paper could warp. Drawing papers may also be stretched over a thick sheet of glass but this gives a very hard surface.

It is best to prepare your paper well in ad-vance — a perfectly stretched paper is an invitation to start drawing.

Starting to draw

The drawing board and paper can be clipped to an easel or rested against the back of a chair. It is also possible to draw with the base of the board resting on your lap, holding the top edge of the board with the hand that is left free. However, this method has some disadvantages because you will not be free to step back to review your work.

A fully adjustable easel is best. It is recommended to have the top edge of the drawing board tilting slightly away from you at an angle of about 85 degrees. When drawing

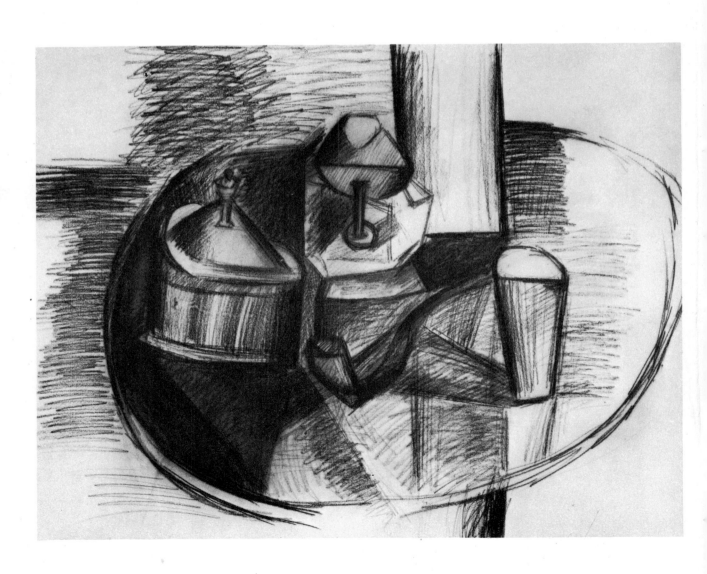

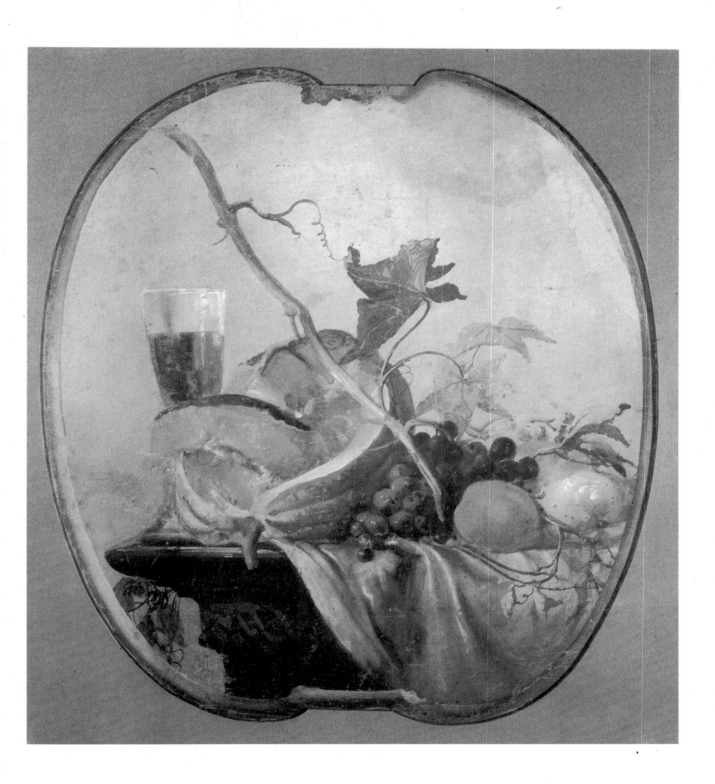

10 *(opposite)*
Pablo Picasso (1881—1973)
Still-life with a Pipe
Charcoal, 486 × 635 mm
Graphic Art Collection, National Gallery, Prague

11
Josef Navrátil (1798—1865)
Still-life with Grape Vine
Gouache, 710 × 645 mm
Graphic Art Collection, National Gallery, Prague

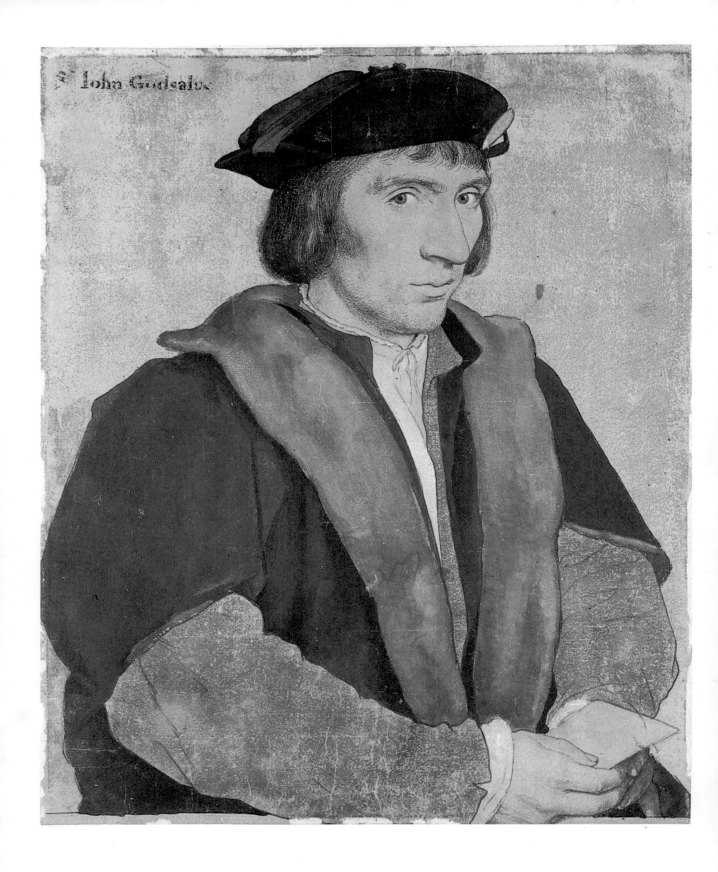

Sͬ Iohn Godsalue

12
Hans Holbein (1497 — 1543)
Portrait of J. Godsalve
Watercolour, 367 × 296 mm
The Royal Library, Windsor Castle
(copyright reserved)

13 *(opposite)*
František Tichý (1896 — 1965)
Still-life with a Skull
Charcoal and sanguine, with watercolour wash,
380 × 502 mm
Graphic Art Collection, National Gallery, Prague

a portrait the height of the board should be adjusted in such a way that the relative height of the model, the paper and the draughtsman's eyes are approximately level. As the work proceeds adjust the board to a more comfortable height.

Start off by making a drawing of a simple still-life composed of various geometrical objects. Later, once you have mastered the basic techniques of drawing, you will use a live model. Stand in front of your easel and relax. If you are drawing a portrait ask the model to sit on a chair raised up on a shallow platform. The model's head should be at about the same height as your eyes and the centre of the paper. You should not be too far away — the best distance is about two or three metres (six or eight feet). The rule is that one

must always have a good view of both the model and the drawing although in a large class some people will naturally have to make do with a less advantageous and more distant position.

Stand in front of the drawing board at the distance of your freely extended arm. You should have ample room behind to be able to step back and review your work. The fear that you will bang into something when stepping back will only make you nervous. So, too, will any trouble you have with your materials. One should therefore make sure to have the best possible conditions for work to be able to concentrate solely on the drawing. Remember that the quality of your work will be directly proportional to your ability to concentrate.

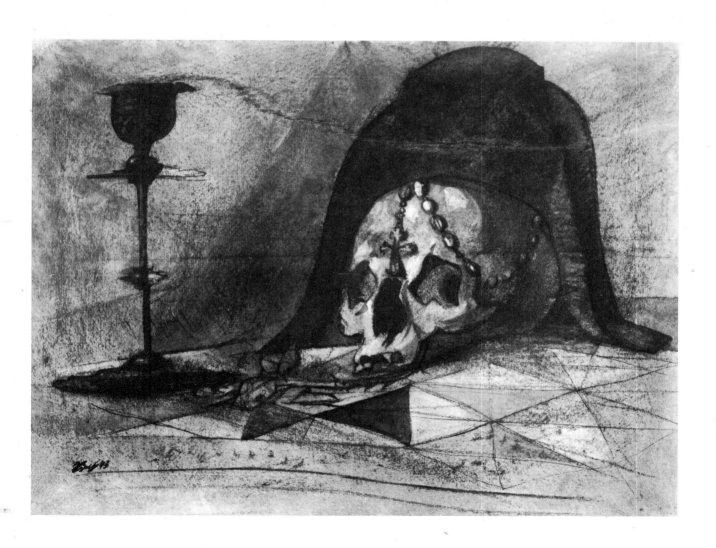

Drawing
Simple Forms:
Still-life

When a child first enters school, it begins to learn the individual letters of the alphabet through pictures; later it starts grouping letters into words and words into sentences. Any total beginner who wishes to penetrate and master the mysteries of the art of drawing is well advised to start in a similar way by first copying the elementary forms and shapes of simple geometrical objects.

Should the beginner attempt to study the 'ABCs' of drawing from a live model, he will soon realize that a kind of tension exists between the live model and the draughtsman which can make it difficult to concentrate. It does not matter whether the tension stems from the physical instability of the model in a difficult pose, or from your feeling that your inadequate skills will not meet the expectations of the model, or simply that you do not get on with each other.

Drawing of live subjects and landscapes may be more enjoyable, but drawing of simple geometrical shapes is a must. If you are a total beginner your first subject should be a very simple still-life, ideally one that is composed of the basic geometrical shapes, such as cubes, pyramids, cylinders and cones, possibly also spheres. Construct them from cardboard or paint ready-made objects a uniform colour. The still-life should be illuminated from one side by daylight or artificial light to enhance the composition in terms of lights and darks and cast shadows.

A good medium to use for these 'elementary' still-lifes is charcoal in combination with some tinted paper, such as Ingres or sugar paper. Later you may want to try this type of still-life in pencil and in pen, reed or brush. Watercolour washes, gouache paint and pastels can be used for colour, but these are discussed later.

Draw the shapes at their actual size, or larger than life, using charcoal; attempt to capture their relative masses. At the same time you may try to render the lights and shadows and the different qualities of the natural and cast shadows that may partially overlap or hide adjacent objects.

Once you have successfully coped with this task, draw a still-life composed of a bottle, a matchbox and a paper bag or cloth. This will be obviously somewhat more difficult to draw as you must try to render different materials (glass, paper, cloth, cardboard) as well as differences in shape, such as a simple spherical or angular object compared with one of a more complex form.

Set up increasingly difficult compositions. A still-life with a top hat and an opened umbrella presents new challenges. But by coping with this sort of problem you will be better prepared to tackle the most challenging of subjects, the ever-changing human face.

Lighting is of prime importance in a still-life; it helps to distinguish the individual planes and spaces to organize the surface. It is the shadow that permits you to define the spatial organization of objects on the two-dimensional drawing plane by imposing a certain degree of stylization and order on it.

Arrange other still-lifes, say one composed of a kerosene lamp, playing cards (which will enhance the decorative character of the drawing) and a length of material. Draw a skull — animal or human — it will prepare you for a better understanding of the skeleton of the head. Compose a still-life to reflect your own expressive drive. The drawing will reveal as much about the artist as it does about the objects themselves. The Italian term *natura morta* is quite adequate but the German *Stilleben* or English *still-life* are much more apt: they imply that one is surrounded with the quiet, still life of inanimate objects.

Pictorial representations of inanimate objects (or still-lifes) appear on classical murals and mosaics; written records tell of numerous still-life motifs for paintings which unfortunately have not survived. The motifs of classical art, such as flowers, fruits, vessels, birds and fish, were later used in early Christian art, again namely in murals and mosaics but also in book illumination and paintings and even in the decorative borders of illuminated Gothic manuscripts. Still-life first emerged as an independent genre in the early 16th century; at this time Dürer made his studies of flowers and grasses. A more realistic still-life was stimulated by the general interest in na-

ture and natural sciences. The Mannerist 16th century gradually established still-life as an independent genre and the Baroque period of the following century differentiated it further into separate subjects, such as kitchen utensils, hunting accessories, musical instruments, books and marine life. The accepted masters of the genre were the 17th-century Dutch artists. In the 18th century still-life was predominantly used for decoration, but the 19th century popularized it greatly as a subject for a canvas or panel picture. In modern art, still-life has become a touchstone of new trends. The Impressionists used it to experiment with the play of light on the surface of objects while the Symbolists employed it to deter-

mine the effect of the surface. The Cubists turned it into an analysis of form and a simultaneous rendition of objects viewed from different angles.

In the past the first few terms in art schools used to be devoted to drawing from plaster casts, mostly of classical sculpture. This was a boring approach and also presented difficulties because casts usually lack sufficient precision.

At first sight it might seem that a still-life composed of wax fruit (which will not spoil and can be left in the same arrangement for days on end) would lack the attractiveness and sensual stimulation of genuine fruit and would therefore make a poor model. How-

14
Honoré Daumier (1808—1879)
Study of Two Heads
Pen and bistre, 158 × 182 mm
Szépmüvészeti Museum, Budapest

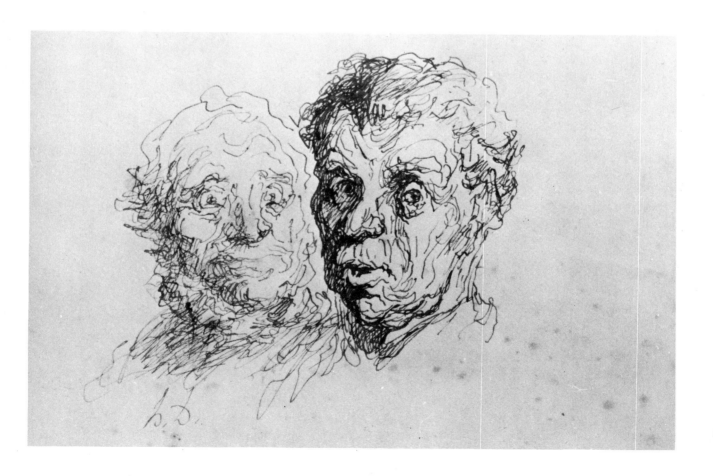

ever, the process of pictorial representation is more complex than that; it is also rather ambiguous — among other things it is also based on sensual experiences and memories. Cézanne did a number of his magnificent still-lifes from wax fruit. What interested him was the formal and chromatic organization of objects. He was guided by his own creative aims and intrigued by theory rather than the inherent character of the natural object that confronted him.

Regardless of the attitude or the temperament of the draughtsman, a still-life requires maximum precision and care. Be as exact as possible and respect the subject; the rendered objects must be recognizable because a still-life is material in character. Work with humility and with patience; these two qualities are probably the best guarantees of your success.

The first portraits were drawn in profile. They appeared in the early Renaissance period to take up the tradition of the profile portraits on classical coins. Artists soon realized the impersonal character of such portraits, but equally the frontal view did not suit fully their endeavours to capture the external as well as internal character of the sitter. In time the three-quarter profile became established as the truest and most popular angle.

A three-quarter profile or front-on view can be started by delineating one eye, then the nose and the other eye, accumulating each detail one by one. It used to be considered proof of virtuosity if the draughtsman could draw a realistic nude by starting with the heel of the left foot and progressing upwards, relying entirely on judging proportions accurately. This method is based on a progression from the detail to the whole and it takes considerable experience to master.

You should work the other way round. Before you start drawing look closely at the model and have a clear concept of what you want to portray. Project the image of the model on to the paper in your imagination. This will reveal to you whether the portrait will fit the format of the paper. Then take a soft, thick piece of willow charcoal. Sharpen the charcoal by rubbing the tip on a piece of emery paper, holding the stick at an acute angle. This will yield a long, slanting facet, about 5 cm (2 in) long, with a sharp, rounded top edge. Whenever the top becomes slightly blunt it should be resharpened immediately.

Now look at the model's head again and concentrate on the outline and the way it is positioned in relation to the torso. Store the image in your visual memory. Relax and draw an accurate, light and simplified outline of the

15
Sir Peter Paul Rubens (1577—1640)
Portrait of Susanne Fournement, the Artist's Sister-in-law
Black and white chalk and sanguine; the eyes, eyelashes and brows in brush and blackish-brown bistre,
344 × 260 mm
Graphische Sammlung Albertina, Vienna

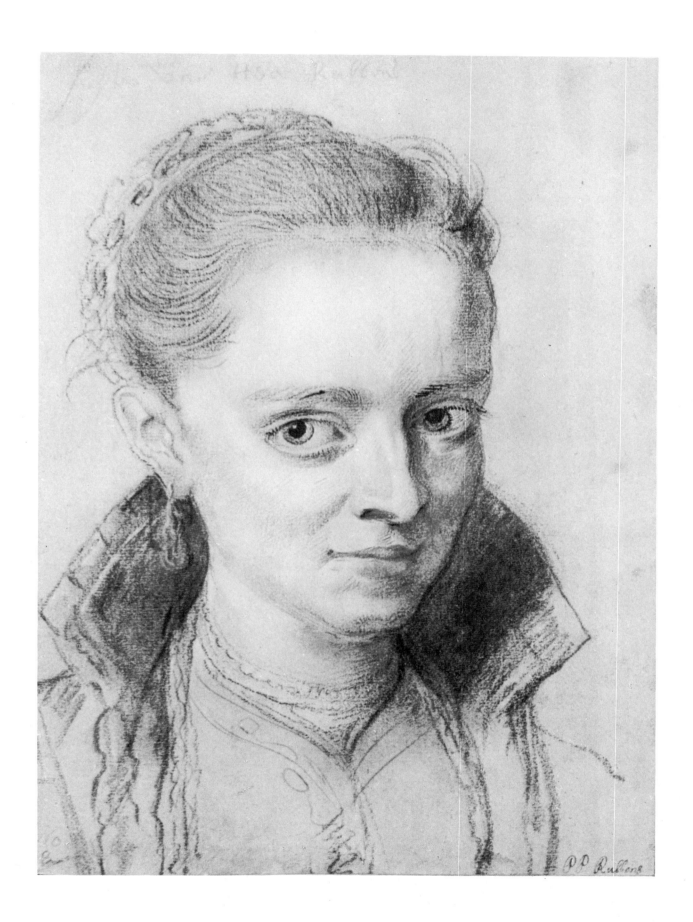

Jan van Eyck (circa 1390—1441)
Portrait of Cardinal Niccolò Albergati, 1431
Silver point, 205 × 173 mm
Staatliche Kunstsammlungen Albertinum,
Kupferstichkabinett, Dresden

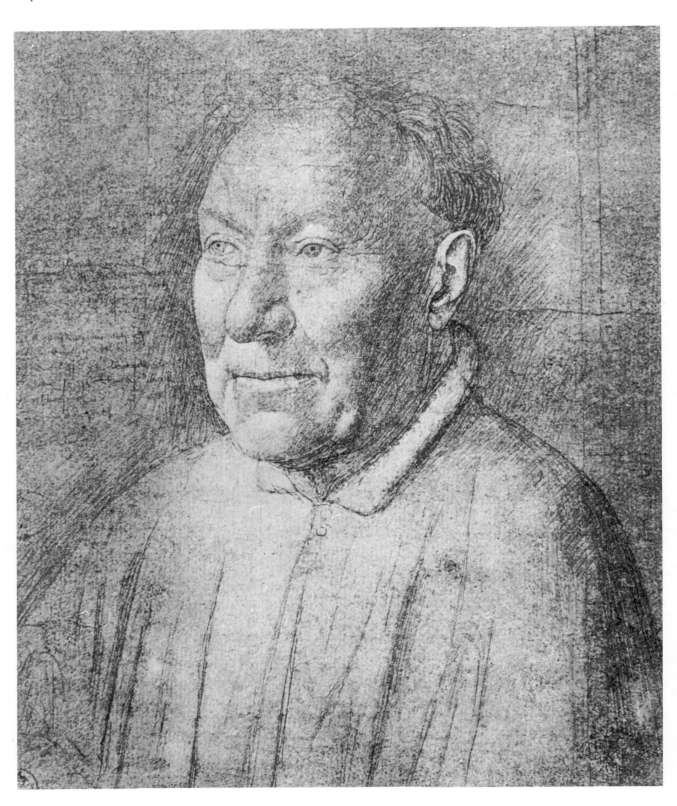

head as an egg, then sketch the neck and the shoulders. From the start try to capture the correct inclination and position of the head and its relation to the neck and shoulders. The tilt of the head is one of the most important features of the entire expression. Bear in mind that a child always holds its head differently from a young woman or an old man. Draw the basic egg-shaped head at life size or a little larger.

Establishing accurate proportions

Use a long, thin stick or brush, or a ruler as a measuring stick. The height of the head should be taken from the actual size: walk over to the model and take the measurements from the profile. Use your finger to mark on the stick the distance between the point of the chin and the hairline. Transfer this length to the paper to determine the size of the outline of the drawing.

The stick can be used for 'scaling', to determine the correct proportions of the face and the body. Scaling is done from the drawing position with the arm outstretched, and one eye shut. The dimensions of the model's face can be established by, for instance, measuring the length of the nose from the tip to the base and then finding out how many times this distance can be measured against the height of the face from the point of the chin to the hairline. A similar check can be done with the proportions of the mouth, the eye sockets, or the forehead. For instance, establish how many times the width of the eye from the tear sac to the outer corner can be put into the height of the nose, or what part of this distance equals the size of the bridge of the nose.

Carefully draw the features into the egg outline of the head. Simplify, and draw lightly, leaving enough space and light for the future detail.

Keep the drawing free and open and do not congest it. Let areas of paper invite you to continue working. At the same time preserve areas that you are satisfied with and do not return them unnecessarily. The drawing should retain such a character that would

permit you to stop working at any time and keep it as an unfinished study. Such a drawing will show definite qualities at all stages of its progress.

Special care must be paid to the anatomy of the head and the torso. The shape of the human head is determined by the general shape of the skull. It is therefore advisable to learn something about the skull and the human skeleton in general. This knowledge will familiarize you with the external structure. You will find that a visit to a museum to draw a skeleton is not a waste of time because you will refresh your knowledge and realize its relevance to drawing the figure.

The facial part of the skull is covered with muscle tissue that gives expression to the face. The quality of the skin is an important characteristic for the face. Decisive for a true pictorial representation of the head is the curvature of the crown of the head (parietal bones), the forehead with two small prominences (the frontal bones) and the eye sockets (orbits). Characteristic also are the arched cheek bones, which are connected to the temporal bones (on the side of the forehead) by a protruding bridge of bone (the zygomatic arch). The nose is formed by the short nasal bone and by cartilages and soft tissue. The upper and lower jaw (the maxilla and the mandible), together with the zygomatic arches and the shape of the chin, the inclination and the height of the frontal bone, the depth of the orbit and the shape of the nose are the most decisive factors of the physiognomy of the human head.

Any tension or distortion of the muscles of the face determines the individual characteristic grimace while their neutral, unflexed position gives the face its general expression. To capture the expression and character of the face is the ultimate aim of the draughtsman's endeavours. To do this the psychophysical appearance of the sitter must be fused with the artist's response to the face. You must interpret the objective likeness of the model in your own way, with a certain emotional charge, be it attraction, compassion or condemnation.

However, let us return to the study you

have just started. A thorough knowledge of anatomy (studied as a mere auxilliary discipline for the artist) is not enough unless it is combined with a mastering of the drawing skills and with a well-trained eye. The study that you have just started drawing will be necessarily objective and realistic in character and perhaps even conservative. Nevertheless, art students all over the world must always start with this kind of study, since only in this way can they discover their ability, drive and talent.

The general shape of the head and the facial features are now lightly sketched in. Remember to save the darker tones for later. Do not attempt to capture yet the gradation of colour values that you should be seeing on your model in terms of a range of greys and blacks. (What is meant by gradation of colour values is the shade scale, or the different degrees of light falling on the local colour of the form.) The colour range should be restricted to monochrome, or different hues of a single colour; drawing is essentially an abstraction. However, when drawing a black-haired model you will naturally increase the intensity of the hair colour, and the hair of blond people will have a lower colour intensity (and, incidentally, it is often paler than the face).

Your drawing should be compact. Rather than copying faithfully every feature of the model's face, be selective and draw the most important aspects. This does not mean that you should not be exact and sensitive. Everything that you draw should be done with empathy; try to understand the physical aspect of the form. And above all, work with piety, even if in your opinion the subject has no appeal.

Flood large areas, or planes, with light and limit the shadows to a minimum. It is advisable to restrict the use of highlights (which can be achieved with white chalk on top of charcoal) to one area only. A drawing will look overworked if it shines with numerous highlights. The brilliance of the eyes or the moistness of the lips can be conveyed less dramatically, by softening the tones or heightening contrast.

Observe closely the shell-like outer part of the ear (the pinna). Be very exact and delicate in your drawing of it, and keep the form in harmony with the rest of the head.

The hair should also be simplified. When the main mass has been blocked in, sharpen your piece of charcoal and, following the example of the Renaissance draughtsmen, draw thin, sharp lines into it. They are not intended to represent individual hairs but to capture the quality of the hair and the way it falls.

Keep the basic shape of the head and subordinate the details to it. Go back over the strong forms determined by the skull and the muscles, and retrace the important lines. Do not be afraid of making bold statements with the line. The aim of your study is not to obtain a photographic likeness but to make a drawing that will justify its existence as something in its own right.

Do not let the perspective of the nose deceive you. In a three-quarter profile the bridge of the nose and the cheek behind are in the same light and the dividing line is indistinct. The most important thing is to capture the essential form by searching into even indistinguishable forms. Use simple line or define the planes by modelling to prevent the nose from protruding out of the drawing plane in an exaggerated way; make it an integral part of the entire structure projected in two dimensions. The drawing should delineate and discover what that head means to the draughtsman.

Subdue the furrows and smile wrinkles in young faces and the furrows on the forehead above the nose that can be sometimes seen even on young people. When drawing old people limit the wrinkles only to those that are most pronounced. Capture only the essential characteristics. In portraiture there is always a certain risk that the drawing will become congested and if you do not work

17
François Clouet (circa 1510—1572)
Portrait of a Young Man Wearing a Ruff
Black chalk and sanguine, 324 × 222 mm
Graphische Sammlung Albertina, Vienna

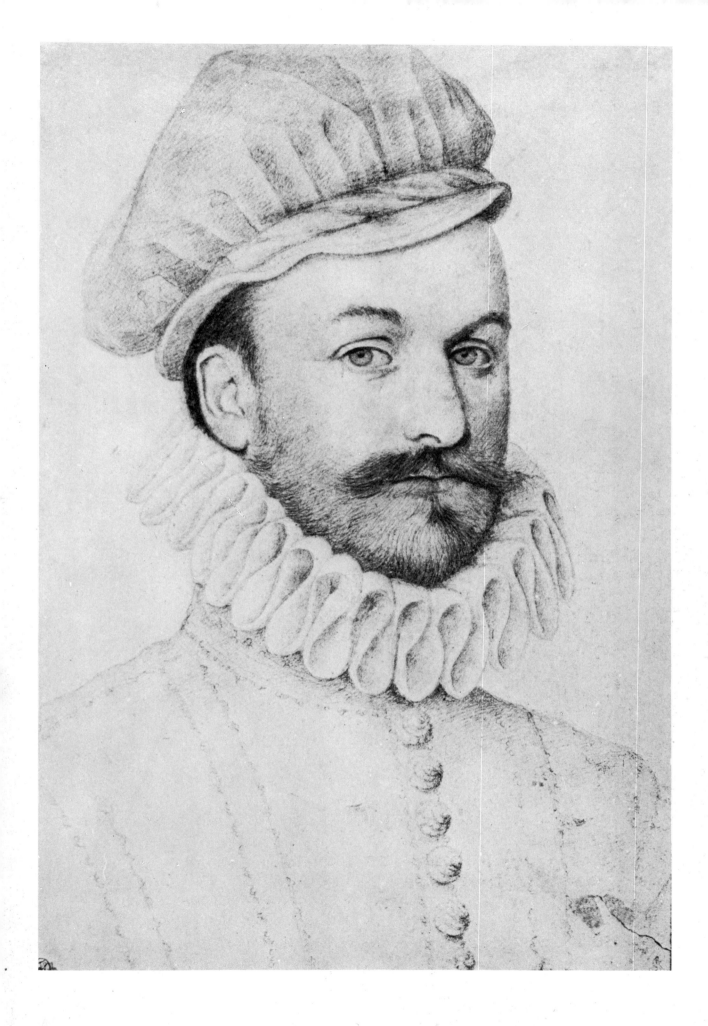

18

Tintoretto (Jacopo Robusti; 1518—1594)
Study from a Roman Bust, so-called Emperor Vitellius
Pencil and white paint, 283 × 233 mm
Staatliche Graphische Sammlung, München

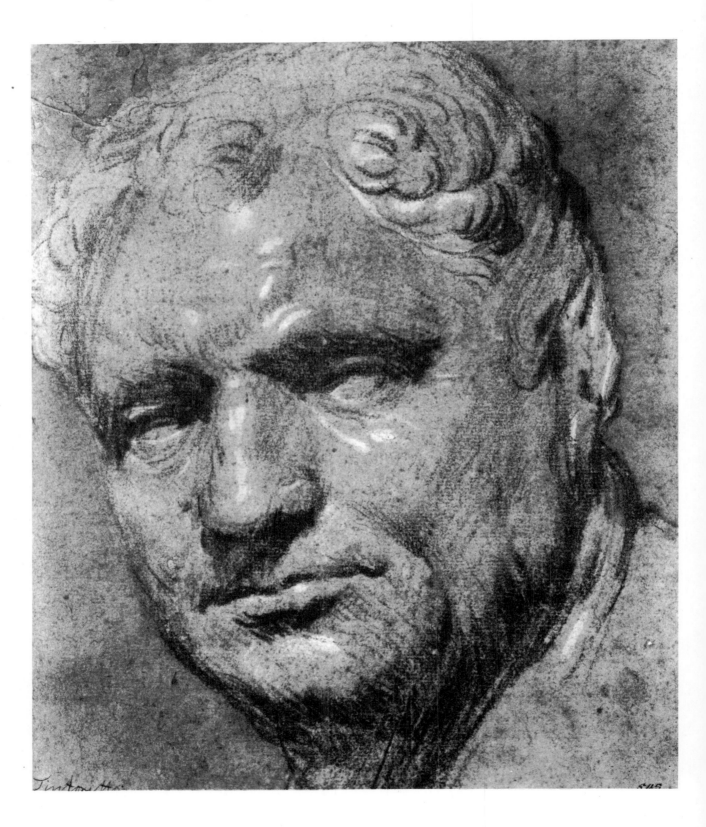

sparingly the resulting face will seem older than it actually is. The importance of simplification is vital and cannot be stressed too much.

On the other hand, you must not be afraid of exaggeration or overstatement. By all means retrace even several times the outline of a protruding chin or the relief of a fine, high cheekbone if it intensifies your artistic interpretation.

Now draw the eyes. Bear in mind that the eye is in fact a sphere over which the upper and lower eyelids are stretched; the eye has its profile and it may look different from various angles. Naturally, all that can be seen is an almond-shaped section which includes the iris and the pupil. Do not forget to place the tear sac correctly in relation to the bridge of the nose and to establish the distance between the eyes (which varies as the head is turned).

The mouth is also a very expressive feature. Draw it sensitively — convey its firmness, or the feebleness of the lip, or the slack character of the jaw. Search for the form and find a way to render three-dimensional forms convincingly in two-dimensions. The translation is complicated. The eye perceives a three-dimensional form; the hand and the mind must suppress it to two dimensions on the paper, but with enough information to allow the eye to see again the implied real volume and character.

Facial expression can be determined by the distribution of lights in the face, a technique observed by the Baroque portraitists. It may be less complicated to follow the example of the Renaissance draughtsmen and portraitists, such as Hans Holbein, who sought a pure form undisturbed by the atmosphere and illusion of the dramatic lights and shadows. If you do use modelling, be sure to keep the shadows transparent and use them as sparingly as possible. Limited use should be made with a plastic eraser or kneaded putty rubber to lighten the tones or make corrections. Take time to observe the form to avoid making mistakes.

Try to accentuate the tendencies of the form. If the girl posing for your drawing has a long, slim neck that is slightly bent in a graceful curve, do not be afraid to emphasize this feature, and even to exaggerate it. Look for anything which may not be apparent at first sight but which is typical; do not do a copy of the model but explain it thoughtfully. Remember that a portrait does not try to emulate a photographic likeness.

Once you have done a number of studies you will begin to acquire a concise drawing style that will permit you to achieve a certain degree of perfection in portraiture of live models. Lighting helps to give an understanding of the form, defining the head as a spherical body within a certain space. This leads to problems concerning the background and the general environment of the model. Try to limit these elements to a minimum to avoid diverting the viewer's attention and weakening the effect of the drawing. The background could be generalized by laying in a mid-tone with a weak ink or watercolour tint. In the past convention demanded that the part of the background behind the illuminated cheek of a three-quarter-view portrait was shaded and that the shaded side of the head and neck was contrasted with an illuminated background. This method aimed at creating an illusion of plasticity. However, it is a method that contradicts somewhat with our ultimate aim of producing a linear drawing with reduced, lightly rendered plastic and spatial values.

Timing a portrait study

A drawing of this kind can be finished in one sitting of about three or four hours or broken up into several sessions of two hours each. In this case be sure that the model resumes the same position. It is helpful to mark the position of the chair and of the model's feet on the floor with a piece of chalk.

From modelling to line

By now you have done a number of studies. Try to limit gradually the use of modelling and develop a linear style. You will be surprised to see that even the most economical

19
Josef Šíma (1891—1971)
Study for the Portrait of S. Haas, 1928
Pencil, 545 × 381 mm
Graphic Art Collection, National Gallery, Prague

linear drawings still retain an illusion of space. This new approach reveals that it is not only shadows and lights that comprise the external symbols of modelling.

What you are about to do now is to tackle a new and very difficult problem. You want to be able to transfer to the white paper the simplified outline of a human face by purely linear means in order to emphasize the self-suffiency of the drawing. The aim is to convey a message through a self-contained linear system, without reverting to optical illusion. This faces you with a new task requiring discipline and concentrated determination. Train yourself by constant drawing of anything that comes to mind, such as simple still-lifes of objects on a dining table, but do not rely on using any modelling. Deliberately distort the spatial arrangement of the objects and try to squeeze the outlines of the objects into a single plane. This will lead to a greater assertion of the role of the two-dimensional surface area. It is not easy, especially in view of all that you have already learned and must forget for the time being.

Draw with a free-flowing line that may even be distorted by a lack of discipline. Leave incorrect lines as they are, do not erase them. The line which you consider most suitable should be executed firmly and with certainty. The network of lines will give the drawing a certain subtle charge; it may even look more open and unpretentious, and will allow the viewer to witness the creative drawing process through its trials and errors.

Any two-dimensional depiction of a portrait or the figure is a complicated matter of graphic invention and a sensitive employment of skill. It can be compared to the work of a composer who starts improvising on his theme and discovers new, fresh progressions and variations. At this point one has entered a realm where the imagination and invention open the door that leads to an intensely personal expression.

Jean Auguste Dominique Ingres (1780—1867)
Portrait of Niccolò Paganini, 1819
Pencil, 298 × 218 mm
Cabinet des Dessins, Louvre, Paris

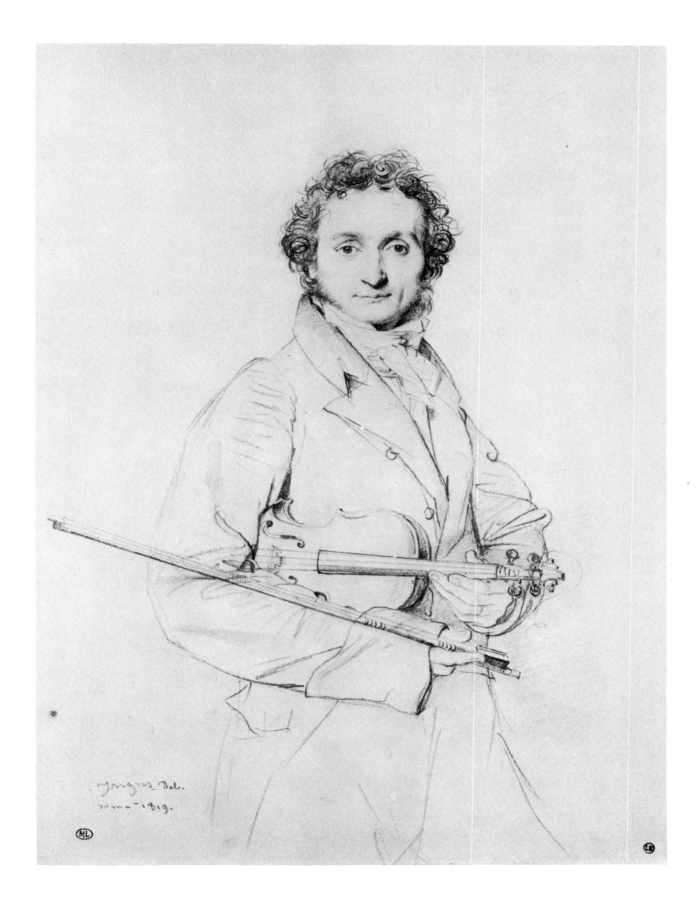

Hans Holbein (1497 — 1543)
Portrait of Anne Boleyn
Pencil, 280 × 191 mm
The Royal Library, Windsor Castle

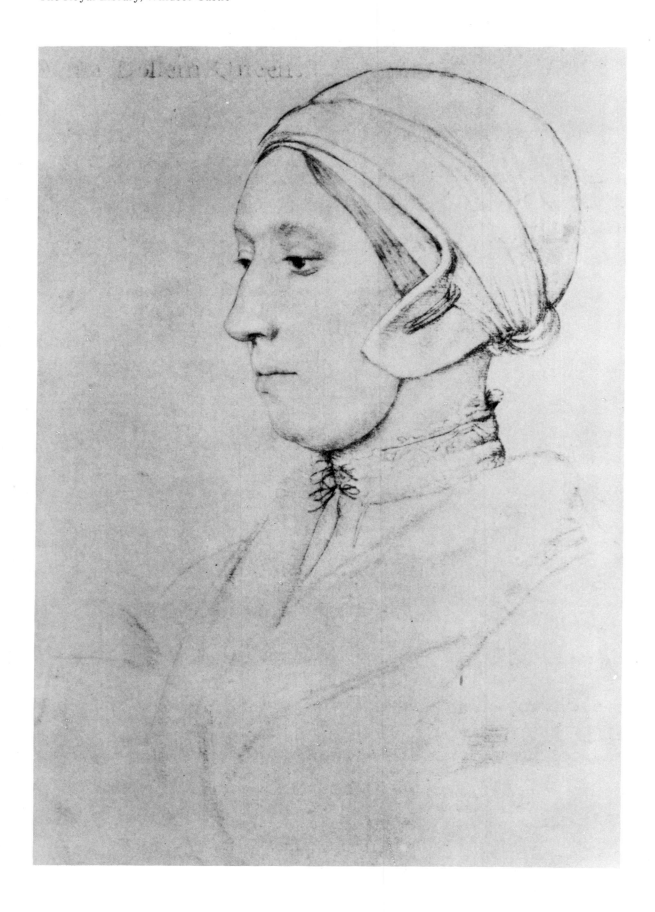

Self-portraits

Self-portraiture has several advantages for the beginner. It is perhaps the best way to learn how to render a figure in a linear manner, and to make that difficult step from modelling to linearity. Another advantage of self-portraiture work is that it is less inhibiting; there is no place for modesty or even fear of the social implications of a failure in capturing a likeness. Self-portraiture can be very free and independent in character; it does not have to please anyone but the sitter — the artist.

Self-portraits constitute a visual biography of the artist. Many an artist has kept such a record of his physical and psychological development through this unique and revealing art form. Look, for instance, at the self-portraits by Albrecht Dürer, Rembrandt van Rijn and Vincent van Gogh.

In early times when drawing had not yet been acknowledged as an independent, self-sufficient art, an artist's decision to do a self-portrait must have been undoubtedly motivated by the simple fact that the model was always available. Self-portraiture later suited a more utilitarian purpose because a portrait, together with a description of the bearer, constituted an inseparable part of a passport or similar document of identification. Self-portraits were also often presented as gifts to other artists, particularly in the 16th century when albums of works were exchanged.

In the following centuries artists in Italy paid great attention to the pure and material character of the drawing and to the maximum clarity of the contour; a dark background was often used to set off the forms. The main objective was formal purity and perfection rather than an effort to express the specific and unique features of the sitter. Realistic representation — even at the cost of the formal beauty of the work — became characteristic for the artists of northern Europe where the psychological approach predominated. It may be said that the best portrait drawing originated north of the Alps. As technical skills were developed and art was being liberated from its former medieval restrictions the psychological undertones gradually gained ground. Unrestricted by considerations of vanity or of the whims of the buyer or patron, self-portraiture relied solely on the artist's talent and his ability to face the truth. In this the northern artists excelled themselves and created some of the greatest masterpieces in the art of drawing. The most outstanding example is Rembrandt, although there were scores of others after him who also made a great contribution to the development of the art.

In modern times self-portraiture is still considered to be a very significant part of the artist's message. The best example of this type of artist is Vincent van Gogh, whose self-portraits are as decisive for the development of modern art as Rembrandt's were for the earlier periods. Among other modern artists who deserve to be mentioned are Max Beckmann, Egon Schiele, Käthe Kollwitz, Oskar Kokoschka and, of course, many, many others.

One's own face is the perfect model for the draughtsman, whatever his or her capabilities. In his short essay called *Exactitude is not Verisimilitude* (1948), Henri Matisse wrote: 'Among the drawings that I have carefully selected for this exhibition are four that perhaps represent portraits of my own face as I saw it in a mirror. I would like to draw the viewer's attention to these four pieces.

'In my opinion these drawings embody all that I know about the quintessence of drawing; it is a knowledge that I have been deepening for many years. I have come to a realization that the unique character of drawing does not lie in the exact transcription of form found in nature nor in any patient accumulation of keenly observed details but in a profound feeling with which the artist approaches the chosen subject on which he concentrates all his attention and the quintessence of which he penetrates ...

'The four drawings in question show the same subject, the same man and the delineation apparently shows the same freedom of line, contour and volume.

'However, should we superimpose the four drawings on each other, we would necessarily discover that the contours are different rather than identical. While the upper half of

the face is the same in all four drawings, the lower half is different. Once it is angular and massive, once elongated in comparison with the upper part, once protruding and pointed and the fourth is composed of entirely different elements. And yet all four drawings show the same face. Notwithstanding all their differences, they are bound by one feeling with which they pulse, which holds the individual elements together and fuses them into a whole. It is the way in which the nose juts from the face, the way in which the ear is attached to the skull, the way the lower jaw droops or the glasses rest on the nose and the ears; it is present in the alert attentiveness of the eyes, in their firm look. This is what the four drawings have in common although the mood is different. Without any further explanations one can see that the sum of all individual elements still represents the same man, his character and personality, his view of things, his attitude to life and the reservations with which he approaches it, which prevent him from succumbing to it involuntarily. Indeed, it is the same man, ever the astute observer of life and of himself. The essential core, the inborn truth of the man captured in these drawings has not been at all distorted by anatomical inexactitude; on the contrary, the latter helps to illuminate the former.

'But are these drawings portraits or are they not? What actually is a portrait? Is it not a statement about the sensitivity of the man portrayed? Rembrandt was known to have said: 'I have never painted anything but portraits.'

'Does the portrait of Jeanne d'Aragon by Raphael, now in the Louvre, really constitute what we generally consider to be a portrait?

'These drawings are not the results of chance. If they were, we would not be able to recognize that the subject is always the same person, that everything is permeated by this man's character, that everything is flooded with the same light, that the plasticity of all his features — the nose, the transparency of the glasses, the feeling of the gravity of mass, all that which is difficult to express verbally but easy to show and point out, all that can be distributed over a piece of paper by

a simple line and a practically unchanging pressure — is always the same. To this unique discovery each of these drawings owes its existence. The artist has penetrated his subject to such an extent that he has fused with it; he had discovered himself in it and his view of it has thus become a statement about his own innermost, essential self. And although the drawings originated under completely different circumstances, this basic condition has remained unchanged. The inner truth is manifested by the flexibility of the line and the freedom with which the line is subordinated to the requirements of the structure of the image. It absorbs light and shadow according to the artist's will and its life is a testimony to the agility of his spirit. *L' exactitude n'est pas la vérité.'*

Matisse suggests a number of general truths concerning self-portraiture and portraiture. Once the 'ABCs' of drawing have already been mastered it is advisable to return occasionally to these basic truths and let them guide you.

Your intermediary in self-portraiture, at least in the early stages, will be a mirror. Later you may dispense with it or use it only occasionally. In time you will know yourself so well that you will not need a mirror at all. This is art at its freest — to draw actual things and likenesses from memory, by heart. If you use one mirror only it will show a reversed image; you will see yourself holding your pencil, pen or brush in the opposite hand. This view will reveal other unexpected details, such as an assymetrical smile, differently shaped temples, or the fall of the hair. Bear in mind the fact that one cheek of your face is likely to be totally unlike the other and that every element is unique.

It is also possible to work with two mirrors: the extra mirror will revert things back. In fact, if you want to draw a full or a three-quarter profile self-portrait, the extra mirror is a must. Fix a large, rectangular mirror on to your empty easel and hold a second mirror (an oval-shaped one with a handle is best) in your left hand. It will reflect the true image in the first mirror.

Over a period of time, do a series of self-

Josef Mánes (1820—1871)
August Alexander and Isabella Tarouca
Pen, pencil and watercolour, 302 × 257 mm
Graphic Art Collection, National Gallery, Prague

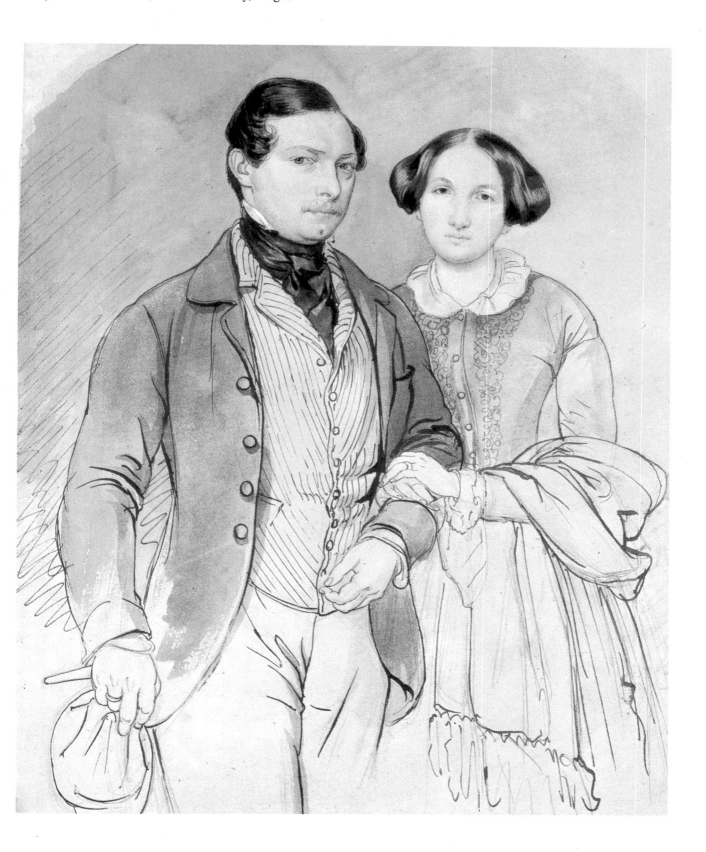

23
Frans Pourbus the Younger (1569—1622)
Female Double Portrait
Pen, brush, bistre and gold, 392 × 298 mm
Graphic Art Collection, National Gallery, Prague

24 *(opposite)*
Egon Schiele (1890—1918)
The Artist's Wife, 1917
Pen and gouache, 460 × 305 mm
Graphic Art Collection, National Gallery, Prague

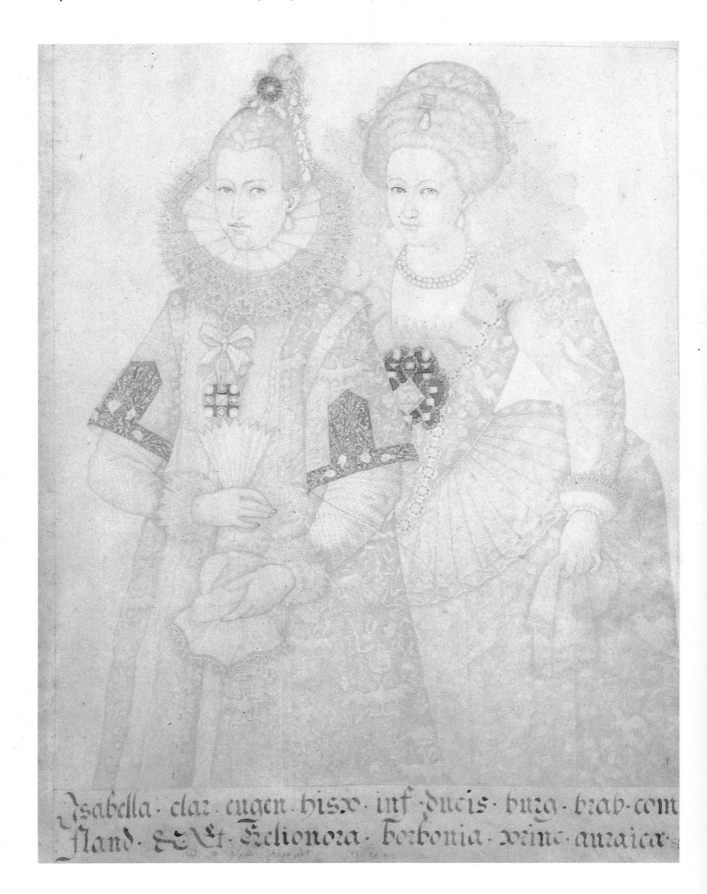

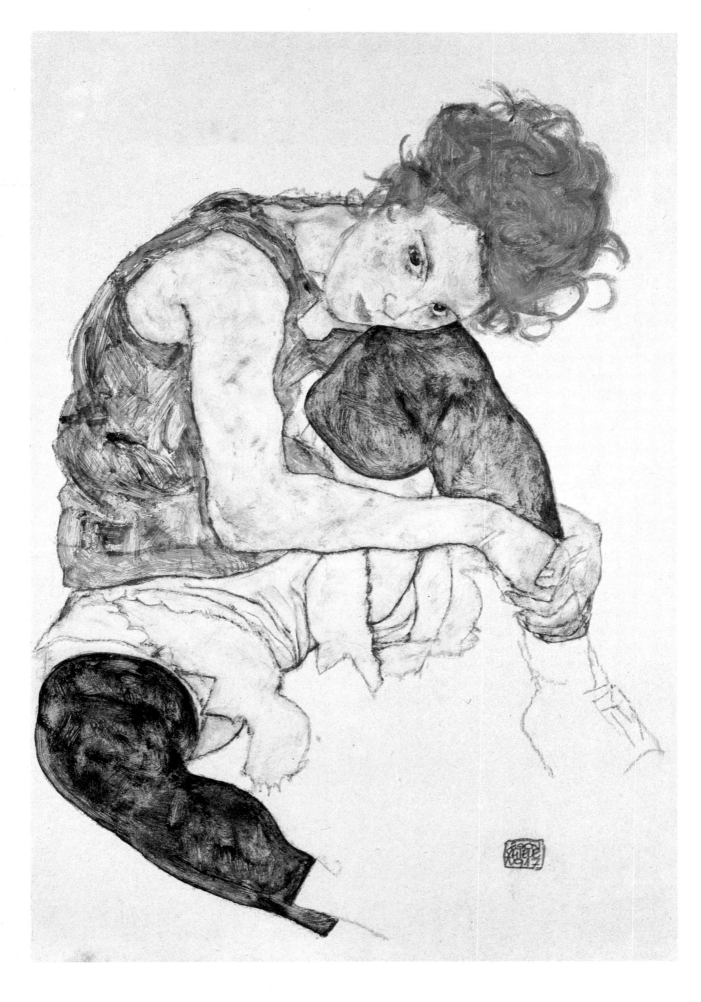

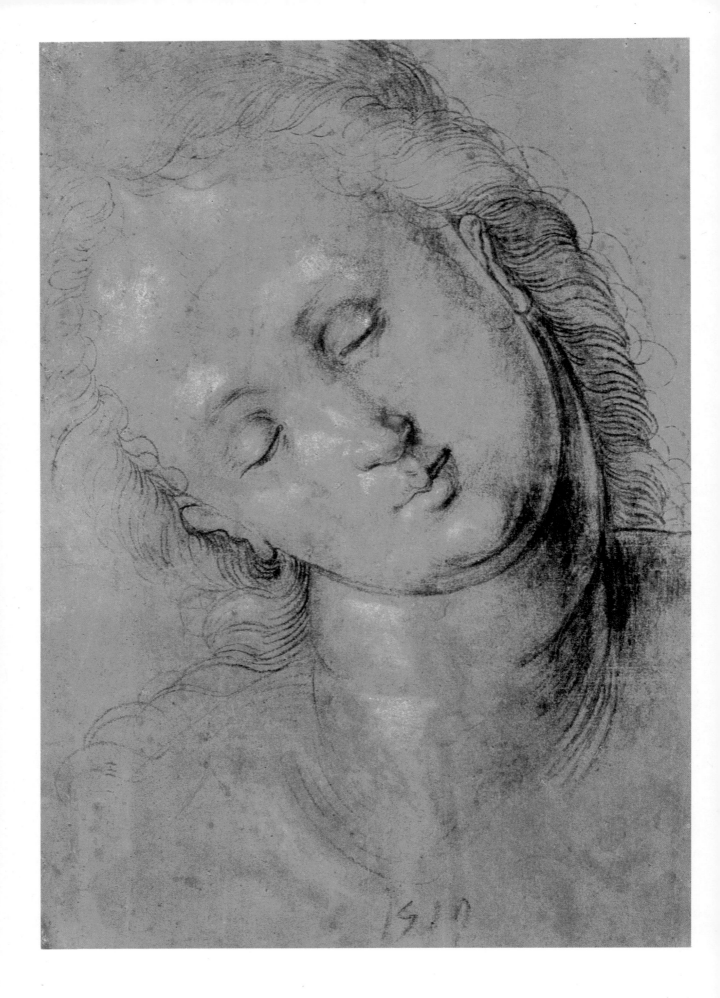

portraits and keep returning to them. Try to keep to a linear style and retain a fresh approach. Your drawing may be also modelled to give a more sculptural feel, but the modelling should be reduced to a minimum.

Now you can stop using your easel. Sit at your desk or at your drawing board and have a good stock of paper to hand so that you can work freely and without interruption: simply lay the used papers to one side. Use inexpensive paper and pin it to the board without stretching it. For this exercise use a soft pencil (4B, 5B or 6B) or a thick fibre-tipped pen, a soft wide-nibbed steel dip pen or a cut reed pen. Do not attempt to merely transcribe the image you see in the mirror but try to interpret what you see.

Try to invent appropriate symbols for the head, nose, eyes and all the other details of the face. While form should be observed the main force in your drawing should be your concept of what you want to say and an awareness of what you know about yourself. Draw with ease and total freedom. Trust your hand to reveal its own truth and let the line flow freely.

At the beginning of this chapter we have discussed how a feature, such as the nose, can be seen in terms of form revealed to the eye through light and shadow. Now try to characterize it by inventing a witty, fresh and intimately personal symbol to represent it. Be prepared to draw simple lines that are not visible in the mirror. In an attempt to understand this relate its shape to the way contour lines on a map are used to represent a mountain range — and the nose can be considered as a mountain range of sorts. You must select one contour that would at the same time also represent all the others, or you must make transitions from one to another to draw the nostrils, the bridge and the tip of the nose, all by means of a mere line.

25
Albrecht Dürer (1471—1528)
Head of a Woman
Black chalk and white paint, 280 × 192 mm
Graphic Art Collection, National Gallery, Prague

There are, of course, many methods and approaches. You may even resort to stylization. The cheeks may be done in dots, the hair in dashes and the background seen as flat, decorative pattern. Find vivid, fresh and unique elements that will allow you to say what you want about yourself.

Keep on making new drawings. Twist or hunch your shoulders to capture an attitude that reveals more than just what can be seen, that says something about the way you walk or sit. Try drawing the background first: draw a chair, and then draw yourself sitting in that chair.

Make faces at yourself — try the grimaces of laughter, scorn, sorrow, contempt, and capture these expressions quickly in a linear fashion. Put on a hat, a peaked cap, wear a scarf on your head and draw yourself in these funny costumes — they may provide a fresh impulse for novel variations. The rough texture of a heavy, knitted sweater can be explored with expressive, rhythmic marks.

Now place a bottle of ink on the table in front of you; it will make an interesting shape in the composition of the picture. The bottle may have a decorative label which will introduce pattern. Place two sheets of paper on the table, one plain, one marked with ink blotches and contrast the two in your drawing. Then add a lamp to the composition.

Now turn from this linear treatment to a different kind. Trace the ridges and hollows in your face with short, abrupt stipples following the form radiating out from the base of the hollows. Try drawing with a wooden stick dipped in black or sepia ink. The line will be very intense at first, then, as the ink starts running out, the line will become progressively paler and dryer. Allow this to happen and recharge with ink only when really necessary. Try to achieve an effect of counterpoint: draw fully those parts that are flooded with light and generalize the forms that are in shadow. You will be surprised to see the discoveries you make and how emphasis can be changed. Be consistent, however, in your intentions; carry out our drawings with sincerity and conviction — concentrate on all that you do.

26
Max Švabinský (1873—1962)
Portrait of Mrs A. Š., 1922
Pencil, 424 × 290 mm
Graphic Art Collection, National Gallery, Prague

27 *(opposite)*
Albrecht Dürer (1471—1528)
Self-portrait, 1484
Silver point, 275 × 196 mm
Graphische Sammlung Albertina, Vienna

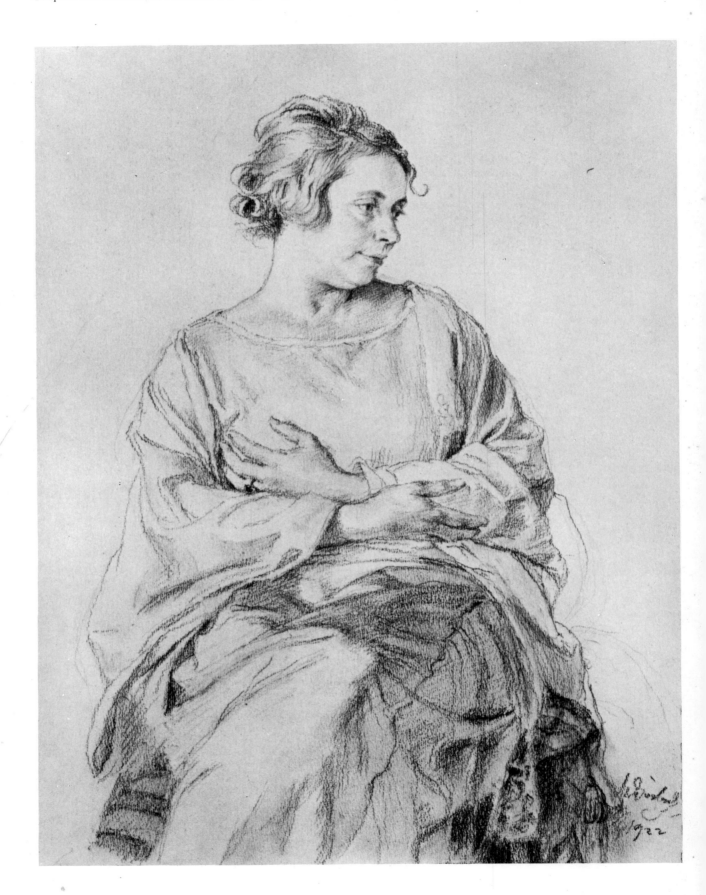

This advice is designed to help you to find your own expression, your own personal manner of drawing. Some may have to struggle to develop their talent, but they will be learning something all the time; their results will be deliberate, certain and self-assured. Others who are more naturally gifted will tend to be over-adventurous and may face many disappointments before reaching their aim.

At the end of the session you should have amassed a great stack of drawings. Look them over carefully and keep those you consider most successful. Those that are not — and there will be always a lot of failures if you use these methods — should be sifted out and thrown away.

The most common objection on the part of the sitter — unless he has an intimate knowledge of the problem — is that familiar cry: 'Why, it's not like me at all!', the banal protest of somebody who, although he may like the drawing, still expects to see a representative likeness. Portraiture, however, is concerned with more than a mere objective transcription of the model's likeness and an exact representation of things.

It is quite obvious that there is no such thing as an objective pictorial representation of a human being. In fact, it is a contradiction in terms since each individual has a unique personality manifested both in the external features and by a deeper, inner quality. A plaster cast would seem to provide an opportunity to make an objective representation of the human form and yet it is far removed from reality. The problem is accentuated by the very fact that a casting appears smaller than the model used to produce it and that a change in the light that falls on the subject radically alters its appearance. Besides, a cast acquires a new meaning which alienates it from the model from which it was taken, a fact that is illustrated by results obtained from casting live forms as practised by the Super-realists.

It is well known that a photographic representation of reality, with a frozen frame of an instant of time limited mechanically to a fraction of a second with its stylized lighting, will often distort a familiar face virtually beyond recognition.

It is extremely difficult to give advice on how to capture suggestively the likeness of a model. Rules are hard to formulate since the secret of success lies in the realm of emotional understanding, empathy and creative activity.

Portraits do exist that describe the general form and particular details of the sitter with an objective exactitude; they do not depart in the least from reality and do not exaggerate anything, but they can hardly be said to be genuine portraits. Perhaps the reason lies in the very fact that these works do *not* depart from reality, that they do *not* overstate anything: the real means of an artistic represen-

Rembrandt Harmensz van Rijn (1606—1669)
Portrait of Baldassare Castiglione
Pen, bistre and white paint, 162 × 207 mm
Graphische Sammlung Albertina, Vienna

tation is metaphor rather than mere transcription. This discipline can be applied to the art of portraiture despite the fact that on the surface the problem in hand seems to concern the nature of the reality of the subject.

Any internal state, whether it is sorrow, calm, cruelty, terror, pain, intoxication or joy, is manifested by the facial expression, which is physically determined by the facial anatomy and the individual features. The facial features trap the light which models them and delineates the most highly illuminated as well as the most shaded parts. A record of the distribution of light and shadow then provides a visual depiction of the likeness.

However, the selection of a means of graphic expression must be determined by the artist's interpretation of the model. It is an individual, artistic choice, not merely a technical matter.

If the search for the adequate means of expression were a straightforward problem that followed a natural course, artistic development would need little explanation and the documented early works of famous artists would make little mention of their influential predecessors. What is important is not so much the fact that the early van Dyck was under the strong influence of Rubens, or that Raphael was influenced by Leonardo, but that Manet's mature work reveals quite consciously the influence of Frans Hals and of the Spanish artists in general, or that the very early works by Picasso repeat and develop

29

Käthe Kollwitz (1867—1945)
Study for a Poster for the 1906 Berlin Heimarbeit
Exhibition
Pencil and chalk, 388 × 393 mm
Szépmüvészeti Museum, Budapest

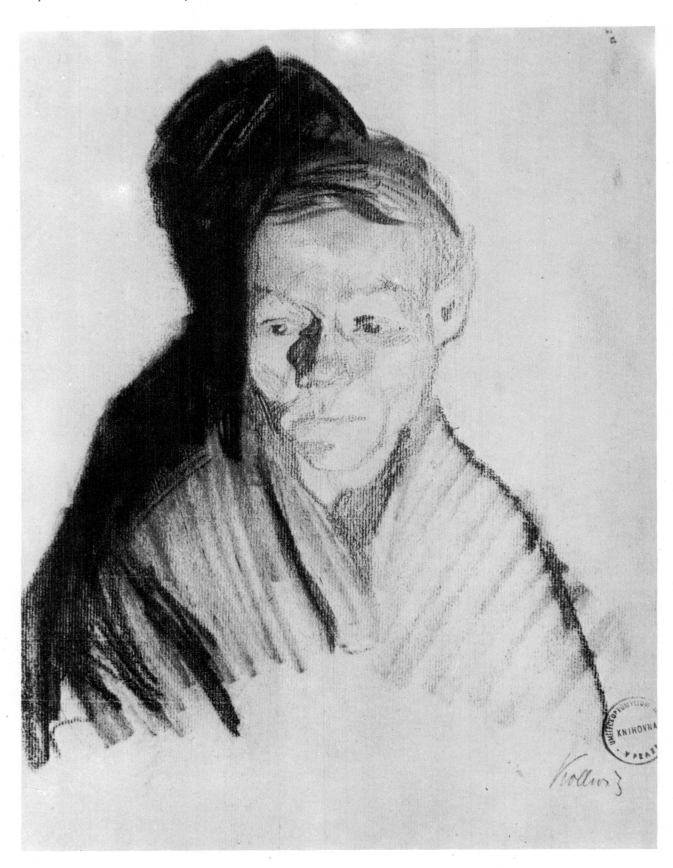

Henri de Toulouse-Lautrec (1864—1901)
Mlle Marcelle Lender
Pencil, 336 × 253 mm
Szépmüvészeti Museum, Budapest

Pablo Picasso (1881—1973)
Study for a Portrait of a Man and a Woman
Coloured chalks, 126 × 179 mm
Regional Gallery, Ostrava

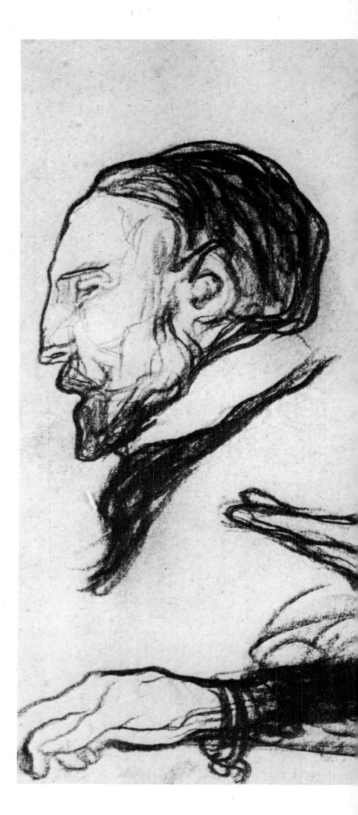

methods used by Toulouse-Lautrec. In this way, partly subconsciously, partly of his own volition, one artist becomes a follower of another. Thus Picasso in his late years interprets in his own unique way artists like Poussin or Velázquez while Dufy paraphrases Titian or van Gogh, Millet and Daumier. Yet all of them remain themselves, while at the same time being unable to resist the urge to verify the principles of those whom they consider close and whom they admire. This will serve to remind you that it is so valuable to learn from the example of others and from the past in general. It should form an integral part of the training of all contemporary artists.

We should not forget the existence of the commissioned, official portrait. Such works often require a rather cosmetic or flattering retouch of reality which may, or may not, go against the grain of the artist's integrity. It is a common trait that most official portraits tend to be quite boring.

However, a portrait can never evoke the model so poignantly as a caricature, which exaggerates to an almost disturbing degree the aspects of the sitter that most fascinate the artist. A good, penetrating caricature requires a special talent, a greater degree of specialization which surpasses the general precise drawing requirements of a portraitist. It is a well-known fact that good caricaturists can capture their subject from memory and do not need the model to sit for them. They do it by overstatement and by deliberate distortion.

It would perhaps seem logical that people one has known well for a long time would be the easiest ones to portray. This, however, may not be always true. In fact, one has a tendency to perceive the physiognomy of people seen for the first time much more sharply. One is not too bothered with minor details nor confused by personal perception and knowledge of the subject, and is usually much more sensitive to the typical physical characteristics. After too many sittings there is a certain danger that the draughtsman will become too 'absorbed' in the portrayed model and lose the ability to see things sharply. The draughtsman will often be influenced

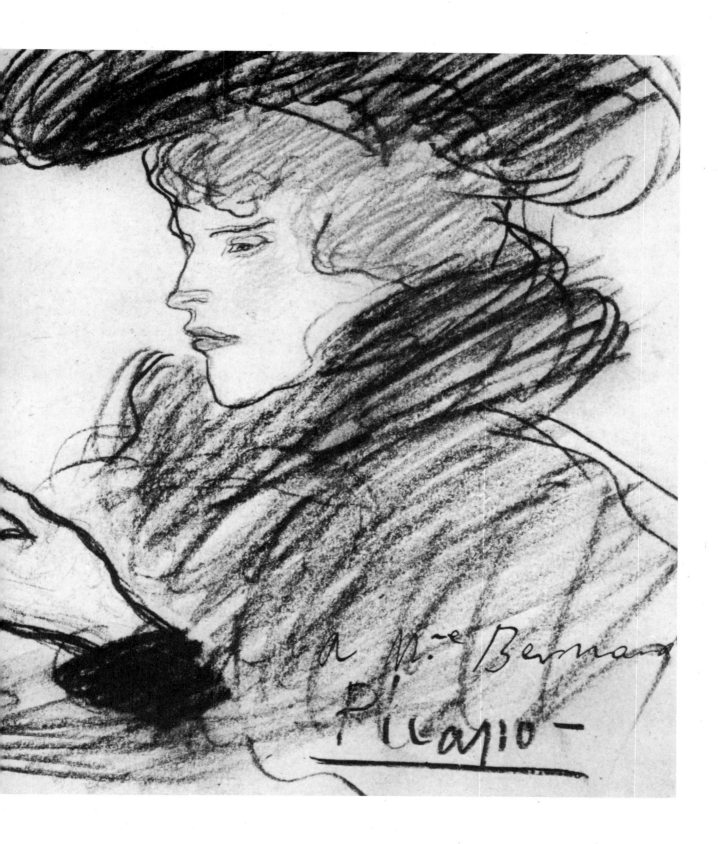

Charles Le Brun (1619—1690)
Sorrow
Pen and black ink on a preliminary sketch in black
chalk, 117 × 103 mm
Cabinet des Dessins, Louvre, Paris

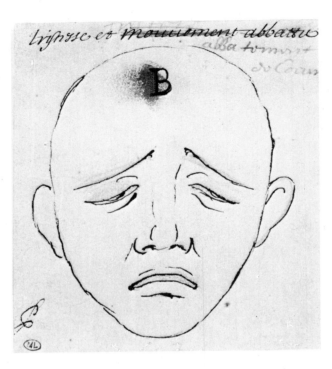

33
Charles Le Brun (1619—1690)
Aversion
Pen and black ink on a preliminary sketch in black
chalk, 126 × 106 mm
Cabinet des Dessins, Louvre, Paris

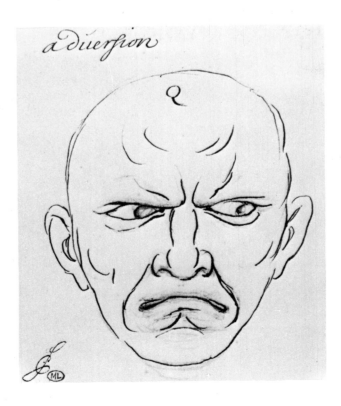

misguidedly by his own unsuccessful work
and will only realize the error of his judge-
ment at a subsequent sitting. In such a case
there is nothing to do but to wait to create
a certain distance from the work and if it
comes to the worst, to start all over again,
this time trying a different view of the model.
If one obstinately kept drawing the model in
the original position — and this is usually
done to prove that one *can* cope with the
task — there is a danger that the same mis-
takes would be repeated. Changing the posi-
tion of the model will usually bring a greater
freshness and truth to the drawing. Some-
times the fault may lie in the lighting or the
position of the model. Be sure to make time
to find the best position which is nearly al-
ways found by the sitter himself who will re-
lax into a characteristic pose.

Try to discover the expressive values of
a work, to make a forceful and urgent state-
ment with the medium and the technique that
you have selected. We are back to the fact
that the art of portraiture is an art of sensi-
tive overstatement and certain distortion,
which gives the art its expression.

It can be said that there are in fact two
different categories of expression in portrai-
ture. The first is the graphic expression that
we have already discussed, the second is the
convincing expression of the face.

Where does their credibility lie? A portrait
(the expression of the sitter) should reveal to
the spectator a convincing awareness of the
emotional make-up of the model. The mes-
sage should always reveal something special,
something that the artist has read from the
live face and translated through his drawing.

Portraiture necessarily involves an inter-
ference in the objective meaning of the
make-up of reality, which relies on the impor-
tance of overstatement.

What is meant by distortion in graphic re-
presentation? It involves an interference in
the objectivity of the shapes, forms and col-
our during the process of their organization
leading to the representation of the model. It
is illustrated by perspective representation,
which is, in fact, a distortion of spatial reality.
Perspective, no matter how dutifully obedient

Charles Le Brun (1619—1690)
Heads Inspired by the Camel
Pen, black ink and grey wash on a preliminary sketch in
chalk, 230 × 327 mm
Cabinet des Dessins, Louvre, Paris

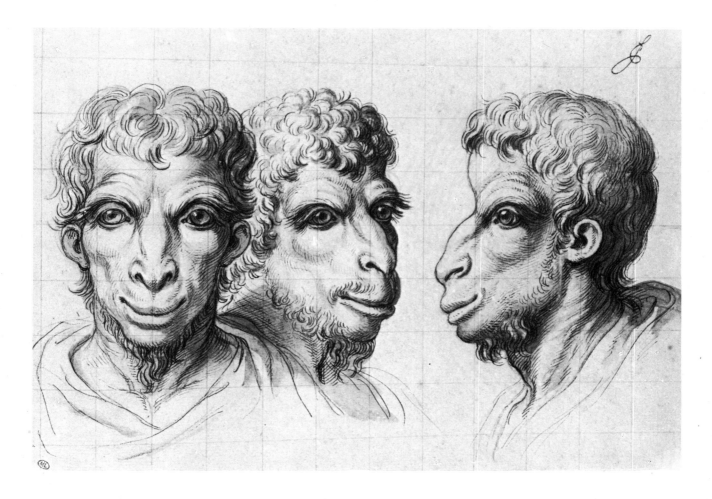

to the optical laws, is nothing but a universally adopted set of conventions concerning the artificial spatial arrangement in the representation of objects. Yet both primitive and naive art prove that the method is neither the only, nor the absolute one. The pictures of animals that the prehistoric hunters depicted on the walls of the Altamira Cave emphasize through distortion those characteristics of the animals that most concerned the hunters' existence and that they knew intimately from their hunting experience: the dramatic action of attack and retreat, the smell and the character of the animal.

The nature of a two-dimensional surface has never readily accepted the illusion of optical perspective but has had to be overcome by means of graphic distortion. At the same time this solution both lends credibility to the representation and also helps to create autonomous values of a purely graphic character which are capable of an independent existence as an aesthetic phenomenon.

Distortion is an interference, a violence committed on the depicted reality of the subject which has to be organized under a certain pressure or emotional tension in an innovative way in order to render the imagined message more precise, more profound and unambiguous. It does not merely stylize; it also harmonizes the represented objects with the concept and character of the work, its rhythm and graphic structure. This interference is necessarily mainly due to the fact that what is involved is a transformation into a different material state. Yet although the sculptor works in three dimensions, he too cannot do without employing distortion.

Everything that has been said here so far (including elementary principles, such as the transposition of spatial relations into a two-dimensional plane) constitutes an intentional intervention of reality, or rather the creation of a new reality which results in the need to organize things in a work of art according to its possibilities and restrictions.

In the 19th century academic art tried for a sort of pseudo-objective interpretation of reality, but what it really managed to convey in its message was a report on academism rather than on reality.

Even the most modest of draughtsmen who attempts to capture the face of a live model is constantly faced with having to make decisions. He must evaluate, reject, re-evaluate and ultimately decide what to do and how to successfully transcend the psycho-physical totality of the model into an organically descriptive drawing. The artist must have a thorough understanding of his subject and discover the means to interpret the form for the viewer.

To sum up, distortion, or exaggeration may be tentatively termed as an organized intentional licence in the approach to conveying form, a licence which aims at a personal, urgent and convincing message.

In the past, when style was universally binding, a certain distortion even constituted a sort of general stylistic attitude. If the spiri-

35
Charles Le Brun (1619—1690)
Heads Inspired by The Tawny Owl
Chalk and white paint, 256 × 420 mm
Cabinet des Dessins, Louvre, Paris

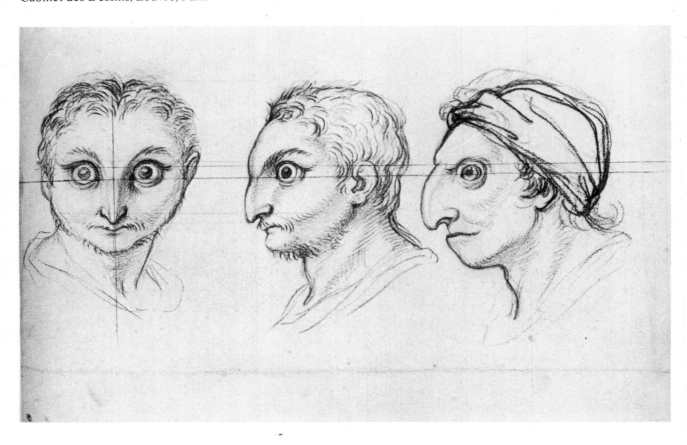

tual charge of the Gothic age was determined by the profound faith that this life is futile, temporary and ephemeral and that everything that lives on this earth should be related to heaven, the world of the eternal after-life, then Gothic art is a perfect manifestation of this philosophy. In architecture, the slender arches and high vaults reach high towards heaven; in painting, the faces, hands, shoulders, entire figures and draperies are ascetically narrowed. All this forms a universal style achieved by means of a characteristic, stylistic distortion.

In early 17th-century Toledo, El Greco (Domenikos Theotokopoulos), an artist of Greek origin, painted extremely visionary pictures. His portraits and figurative compositions are characterized by a tapering distortion, yet it is an exaggeration of a different type than that of the Gothic artists. Some 19th-century critics erroneously attributed this distortion to some flaw of El Greco's eyesight. This, however, would not be enough to explain El Greco's influence on some Post-Impressionists, such as Cézanne, whose figures are also constricted and narrow. Like in El Greco's work, Cézanne's tapering distortion of figures is intentional and serves the descriptive structural objectives of his work. It is a conscious decision, determined by the intentions of the artist.

At the beginning of the 20th century Picas-

36
Charles Le Brun (1619—1690)
Human Heads and Heads of Ravens and Owls
Chalk and white paint, 225 × 406 mm
Cabinet des Dessins, Louvre, Paris

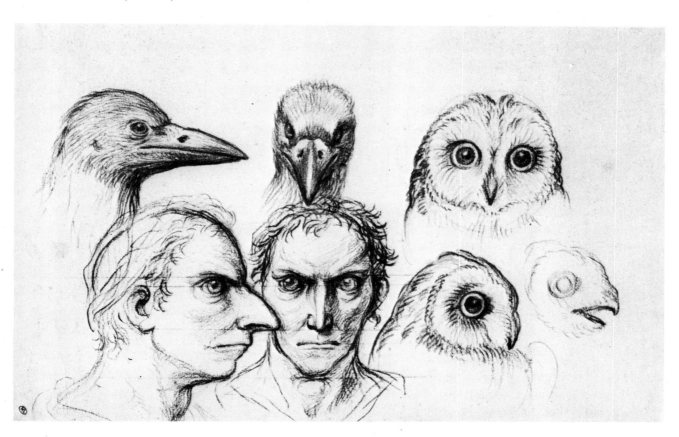

so and Braque founded the Cubist movement. Cubism not only explored an objective pictorial construction through geometrical shapes (inspired by the work of Cézanne), but also found the conventional single-viewpoint perspective insufficient. Cubism attempted to show things simultaneously from numerous viewpoints. A human face seen from the front might be given features that are depicted from another viewpoint, such as the nose seen in profile to give a composite view. Abstract art does not present things as the artist sees them, but rather with respect to what he knows about them.

One of the best examples applicable to what we try to illustrate here is the work of Toulouse-Lautrec. His exaggeration is a subjectively psychological one. This modern type of distortion can also be found in the work of Edvard Munch, which has a more literary flavour (and has had a great influence on 20th-century art).

The faces of individual figures in Toulouse-Lautrec's compositions can all be considered as portraits which reflect in them the subject matter of the work. These figures are archetypal, their grand concept raises them above the level of mere genre.

Lautrec's attitude to portraiture stemmed from his soul-seeking, psychological interests. The figures are stripped naked under his gaze and the artist reveals their psycho-physical existence with sarcasm and irony behind which one can feel compassion and suffering. However, this penetrating look is never allowed to slip into mere cliché. In his mapping of human faces Lautrec concentrates mainly on the asymmetric and irregular, paying special attention to the essential character, captured in a fixed expression. He records the entire emotional and ethical history of the person. The means that he employs are terse, inventive and concise, unbound by any preconceived ideas or plans. He tends towards caricature and the grotesque, yet this never hides the artist's awareness of the pathetic dignity of human existence. It seems as if Lautrec was a disbelieving draughtsman who tested the hitherto accepted methods of representation. Note, for example, his treat-

37
Lutobor Hlavsa (born 1924)
Female Nude, 1965
Pencil, 540 × 404 mm
Private Collection, Prague

38
Raphael (Raffaello Sanzio; 1483—1520)
Two Nude Studies, dated 1515 by Dürer
Silver point and sanguine, 401 × 281 mm
Graphische Sammlung Albertina, Vienna

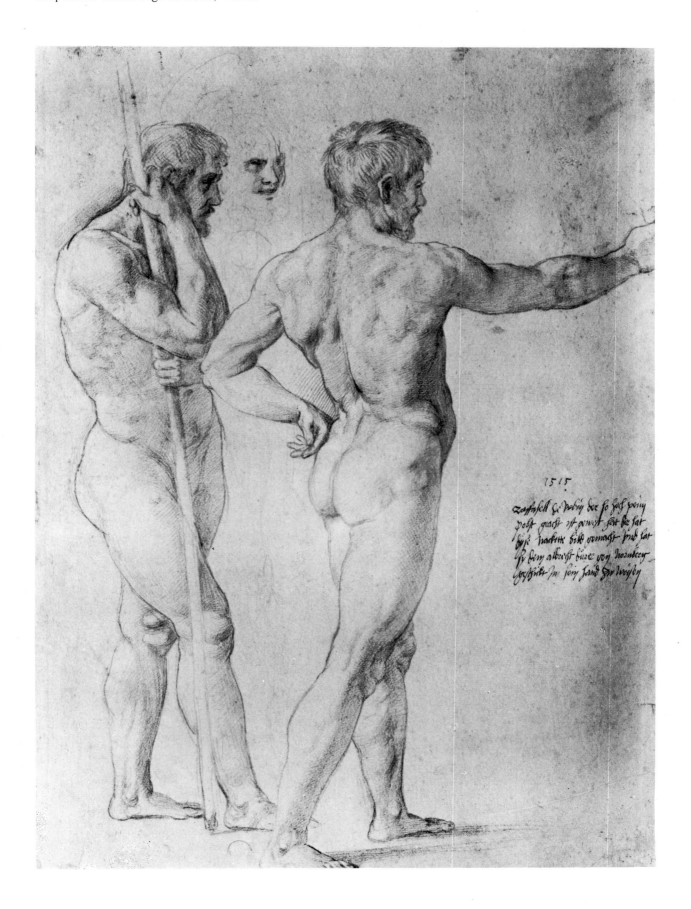

ment of the face: it is as if the artist were rediscovering it again and again, eventually arriving at an exaggeration of the form which suddenly, unexpectedly reveals the soul of the sitter.

The work of Vincent van Gogh reveals not so much an intellectual attitude as an essentially emotional response. His portraits are exaggerated in a way that tends towards unsophistication. Van Gogh's enormous emotional capacity is expressed not only through his terse, frenzied hand, stuttering rhythmically in an arabesque across the picture, but also in the typically distorted faces and hands that can be seen in his portraits and self-portraits.

Art grows from resistance to convention in searching for a discovery of beauty and from an internal justification for distortion (manifested by the seeming lapses in perspective and modelling). However, an uneducated grasp of these ideas results in unusual interpretation. The work of the primitive and *naïf* artists — Henri Rousseau (Le Douanier) in particular is very instructive because it shows an innocent use of distortion which is an inevitable manifestation of unsophistication and a desire to render things with absolute truth.

Distortion has been dwelt on here at length because it seems to be one of the most relevant means of expression in modern art. The problem is particularly relevant to portraiture, since it is in this subject that distortion has most uses in capturing a likeness. It is not something that has been only recently discovered by the modern artists; it has always been a fundamental part of any visual representation. Anybody who attempts to try his hand at drawing should bear in mind its frequent paradoxes, its endless possibilities, and should understand its function.

The development of the pictorial representation of the naked human figure and its efforts to have it accepted as one of the liberal arts can be traced back to the end of the Gothic period. The chance to express freely the subject matter of the naked human body was closely associated with painting and sculpture as creative disciplines equal in status to other arts and sciences. It was only once this equality had been accepted that artists were acknowledged the right to study publicly the human body in its most essential form to be used as subject matter for the majority of art forms. This, however, does not mean that works of art had not shown naked human forms before. Religious subjects, such as the Crucifixion, The Last Judgement, the Temptation and other Old Testament episodes, required nude bodies as one of the basic prerequisites. In these cases, however, the drawing was never based on direct observation. Artists of these periods most probably had to depend on their observations from public baths, the only places where naked people could be seen.

These pre-Renaissance nudes are but symbols of the naked body; they do not reveal any effort to grasp the anatomical or physiognomical details of the human form. Religious and social taboos were still too strong an obstacle. Only once artists of the late Gothic period had realized that further progress could be achieved only on the basis of a thorough understanding of the external world, were these taboos gradually removed and the road leading to a new, free expression of human nudity was finally opened.

In drawing the first nudes appeared somewhat later than in painting and sculpture. It is generally thought that the drawing on which such works had been based were destroyed by frequent use and handling. That they ex-

39
Jan Preisler (1878—1918)
Study of a Female Nude
Black and white chalk, 290 × 250 mm
Graphic Art Collection, National Gallery, Prague

TO 21015

Auguste Rodin (1840—1917)
Kneeling Female Nude
Pencil and watercolour, 277 × 230 mm
Graphic Art Collection, National Gallery, Prague

Jan Preisler (1878—1918)
Study of a Young Girl's Head and Hands
Charcoal, 314 × 480 mm
Graphic Art Collection, National Gallery, Prague

isted may be safely presumed if one only looks at Masaccio's frescoes (completed after 1420) in the Brancacci chapel of Santa Maria del Carmine, Florence, or at the figures of Adam and Eve on the Ghent altarpiece by Hubert and Jan van Eyck (completed after 1430).

In the latter half of the 15th century drawings of nudes start to appear more frequently both in Italy and in the countries north of the Alps. In the north (where the public baths remained the chief place where the artist could study the naked human form) the characteristic interest in truthful and realistic expression forced artists to study nature even in its most unattractive forms. Judging by some of the depictions of the Crucifixion or the Last Judgement one cannot but think that the northern artists studied nude corpses.

The professional nude model, however, appeared much later in these areas: in the Netherlands it was not until the early 16th century, while in Germany the first nude models appeared at the Nuremberg academy as late as 1703. By then Italy had already progressed much further in the theoretical formulations and justification of the artist's work: the first professional models had appeared during the latter half of the 15th century and drawing nudes had been firmly established as an integral part of the academic curriculum. Leonardo da Vinci devised a number of rules concerning the drawing of nudes which have remained essentially valid till the present day.

There were two barriers, however, that had to be overcome. The first existed in the artist himself and stemmed from deep-rooted inhibitions, while the second concerned the mod-

42
Alfons Mucha (1860—1939)
Portrait of a Little Girl, after 1930
Coloured chalks, 460 × 313 mm
Graphic Art Collection, National Gallery, Prague

el or rather the question of who was going to sit for the artist. The first models were veteran soldiers and sometimes also painters' apprentices. As Italian art strove for the absolute ideal, a search had to be made for the models who would meet the highest aesthetic demands. Artists are known to have despaired at the imperfection of their models. Raphael once stated that he had to compose an ideal figure from a number of models and still he leant fully on his imagination to achieve the desired result. Ideals were naturally prone to change with the times, bringing about new requirements on the appearance and proportions of the model: Leonardo's requirements differed greatly from those of Michelangelo.

At first the models employed were almost exclusively males. This was not only due to the fact that painters and draughtsmen were men and that the taboos concerning nudity applied even more strictly to the opposite sex, but also because it was believed that only the male torso had well-balanced proportions. Cennino Cennini in his famous theoretical work *Trattato della pittura* (1437) states that he does not give the proportions of the female body in his treatise as women are not built symmetrically.

The first female models were recruited from among bath attendants and though there is no direct evidence to substantiate the charges there are many indirect indications to suggest that female models were supplied by brothels (to be found in any of the larger towns). Artists were also known to have their wives or lovers pose for them as models.

A boom in drawing from nude female models occurred in the 18th century, particularly in France. It continued into the 19th century and was given total freedom in the 20th century with the advent of the 'sexual revolution'.

Originally, nudes were drawn only to study the make up of the human body, its anatomical peculiarities, the transitions and juxtaposition of the individual parts. Models were made to hold static poses and to remain in the desired position with the help of supporting apparatus like canes, sticks and sus-

pended ropes. Drawings that were originally intended as mere working studies sometimes show these aids. The effect is comical if one sees a drawing of a young man with one foot resting on a pot and remembers that the same artist is famous for his painting of the triumphant David stepping in the same way on the severed head of Goliath. These insights into an artist's work can be amusing.

As the static concept of the early Renaissance painting gradually gave way, the model was required to represent graceful movement. The study of locomotion and the techniques employed to convey it, the description

43
Auguste Rodin (1840—1917)
Two Female Nudes
Pencil and watercolour, 325 × 250 mm
Szépmüvészeti Museum, Budapest

of flexed and relaxed muscles and the increasingly complicated poses led artists to a deeper understanding of the human body and its dynamics. The poses that the artist sometimes required on his model for the purposes of his composition were so complicated that the model was physically unable to sustain them for a long period. The artist therefore had to make some rapid sketches to capture the essential characteristic of the gesture and then develop more detailed studies from wax or wooden mannequins arranged in the required position.

Subsequent generations of artists developed a repertoire of infinitely varied standard poses that could be applied to any conceivable situation, and thus the live study of complicated poses became superfluous although nudes continued to be used by beginners to grasp the basic knowledge of the human body. Life drawing became recognized as a fully independent genre.

The importance of life drawing today

Nudes are an important part of art school studies — they help the draughtsman to become familiar with the human body and to learn how to capture it through drawing. Drawings of static poses and action studies should be a constant part of the artist's activities throughout his or her career, since it is the best training to develop technical ability. Drawing nudes is also recommended as a form of preparation for any autonomous artistic creation which uses the human body as its subject regardless of the concept or material employed. It is particularly relevant for the sculptor.

Something has already been said about a precise method of study. Let us recapitulate the major factors that are to be observed when working in such a way.

The nude study should be primarily of a matter-of-fact character; it should be motivated by an effort to achieve an accurately interpreted transcription. Use a large sheet of paper: the most appropriate height for figures is about 90—100 cm (2—3ft). The drawing should be concerned with generalizing

44 *(jacket flap, front)*
Bartolomeo Passarotti (1529—1592)
Study of a Nude and Three Female Heads
Pen and bistre, 300 × 176 mm
Staatliche Kunstsammlungen, Weimar

45 *(opposite)*
Nicolas Poussin (1593—1665)
Castor and Pollux
Pen and brush, 245 × 180 mm
Musée Condé, Chantilly

46 *(opposite)*
Michelangelo Buonarroti (1475—1564)
The Dead Christ Supported by St John, Nicodemus,
Joseph of Arimathea, Mary and the Holy Women
Sanguine and black chalk, 320 × 251 mm
Graphische Sammlung Albertina, Vienna

47
Eugène Delacroix (1798—1863)
Study for the painting 'Liberty Guiding the People'
Sanguine, 324 × 228 mm
Cabinet des Dessins, Louvre, Paris

what is seen and detail should be suppressed. It is almost superfluous to go into describing facial expression; what is most important is the position of the head on the torso. The head may be outlined as an egg, main features or the hair may be added later, if desired. The most important thing that must be respected in life drawing is the correct relations and proportions. These can be determined by measuring the individual features as discussed in the chapter on portraits by using a scaling stick.

What is vital for a successful result is the proper placing of the figure: it should be positioned on the paper in such a way as to make its centre of gravity relate to the position of the feet — it must not be top-heavy. You can check the correct placing of the standing figure by making sure that the first cervical vertebra is truly perpendicular to the heel of the weight-bearing foot. Generally it is thought that the height of the head can be inscribed seven times into a standing figure. In the past this rule was strictly adhered to but it is best to compare individual measurements. The nude will retain a better pictorial balance if the head is made slightly smaller in relation to the size of the body so that the figure appears slightly larger than in reality.

Start with the head and continue recording the distribution of the main masses of the body in general terms. These masses are in fact cylinders seen from different angles. It is helpful to simplify all the parts of the body into elementary geometric shapes in order to establish proportions.

Once you have organized the main masses of the body you may start with a more detailed interpretation of the model. Always aim at maximum simplification. If you decide to define the form by modelling with shading, do it lightly and attempt to give some translucence to the shadow closest to the contour of the form which receives least light. This will enhance your modelling. The feet and the hands should be generalized; observe the main tendencies of the larger elements, such as the juxtaposition of the fingers and the back of the hand, the qualities of the palm and the back of the hand, as compared with

the wrist. Do not hesitate to retrace a contour with a heavier line to emphasize the weight-bearing limbs. Exaggerate certain dynamic tendencies of the figure which are especially characteristic of the model or which tell something of its physical type or even its erotic nature. The drawing must be an apt and truthful interpretation of the model. Naturally, a drawing of a nude young girl will be quite different from that of a nude old woman. All these aspects must be projected into the drawing, and will be manifested by the inner tension of the work. The fine musculature of a young girl with its perfectly taut, firmly attached skin will look quite unlike the skin of an old woman whose skin is loose and flabby and wraps around the flaccid muscles and fragile bones. From an artistic point of view, youth and old age are of the same interest, but if you have a choice, always pick a more robust model rather than a slimmer one. The large forms of the model, such as the bosom, the hips, the fleshy thighs and arms, will make a better subject for a large drawing. On the other hand, exceptionally thin models also have their advantages because they can evoke certain social aspects and have therefore a specific power of inspiration. Models with the fashionable figure of the day (who correspond to the measurements of ready-made clothes) seem to be the least suitable of all.

In the same way that you should always draw with a natural approach free of any affectation, so too should the selection of the pose be determined. Affectation and artificiality in arrangement must be avoided; select poses that are logical and express the model's character and those that are appropriate to your style of drawing. A nude drawn in full profile is somewhat hard to portray because this position obscures the organization of the structure. This can be at least partially remedied by having the model raise her arms or stand with her legs slightly apart. The model should pose on a platform about 50 cm (1 ft) high to give you the best view. Using a platform is also suitable for seated nudes and for portraits as the head of the model will be approximately at the same level as the eyes of the artist. Keep a sufficient distance from the model: the minimum should equal the total height of the model including the dais. Do not forget to have enough free space behind you to be able to step back and survey both the model and your work. Now find the best position for the model. Ask the model to move about slowly and stop her in a pose that you find especially interesting or worth drawing. Try also various interesting positions of a seated nude. Studies of nude model with her back turned to you allow you to concentrate on the character of the forms without being distracted by the facial features which are only secondary in this type of work. If the model has long hair ask her to pin it up and do not let it cover the neck. If you cannot see the nape of the neck it is very difficult to place the head properly on the torso yet it is extremely important to portray this part of the figure convincingly.

It is best to draw the model in normal diffused daylight. However, life-drawing classes so often take place in the evening. In this case use a fluorescent tube to give indirect lighting. A direct light (such as that cast by a spotlight) is too sharp — the shadows would be too black and you would find it very difficult to understand the masses of the body and their correct proportions.

The best medium for life drawing is charcoal. To begin with use strong cartridge paper stretched over a drawing board or a frame. Later you may use any other appropriate paper; Ingres is particularly suitable.

As regards the interpretation, develop an expression that suits you best. Some parts of the nude figure may be merely suggested and some implied, while other parts may be emphasized. This will depend on the overall concept of your drawing. Care should be paid not to define the colour of the hair too much; a rule which holds for all minor details which should be suppressed in life drawing. Concentrate on the body posture and the mass captured in a certain motion or situation.

Your drawing should be finished in two or three hours although sometimes it naturally may take longer. After every 50 minutes'

48
Albrecht Dürer (1471—1528)
Hands Folded in Prayer
Brush, ink and white paint on blue paper, 291 × 197 mm
Graphische Sammlung Albertina, Vienna

work give your model ten minutes to rest. Ensure that the model resumes the same position by marking the position of the model's feet on the floor.

Another approach to life drawing is that of the quick sketch from shorter poses. This might take up to 15 minutes, but no longer. The next pose might be different, or, if it is the same then start work on a fresh drawing. For this type of work you will naturally use smaller sheets of paper; a sketchbook is ideal. The media used should also differ. Try out pencils, pens, reed pens, quills, brushes, fibre-tipped pens and ball-point pens. Sit down to draw and hold your sketchbook on your lap. The best support for the sketchbook are your crossed legs. Be sure to have a sketchbook with a firm backing to prevent the paper from bending while you draw.

The same effect as changing the model's position will be achieved if you change your drawing position while the model holds the same pose. This method is perhaps better because the direction of the light changes and this makes the work more interesting. You will also be able to check on the model's position from different viewpoints, which is also valuable. In this type of work you should not be bothered with the minor details at all: your main objective is to capture briefly the essentials of the pose and to convey something of the physical features of the model, such as the lyrical or sensual quality of the body. Use a free line — used economically it can be both bold and concise and it will reveal the personal style of the artist.

It is traditional to use the paper on which a life drawing has been made for some of the details that the draughtsman wants to come back to and study again in greater detail and with a greater degree of exactitude. Details are best understood by drawing them on a larger scale.

The areas of paper surrounding the figure should be left empty for these studies. (It is superfluous to provide the figure with a disturbing background except, perhaps, for a few symbolic attributes like a chair, a wash-basin, or a towel, which may be used to supplement and clarify the model's action or pose.) Return to those parts of the figure that you are not satisfied with or try out a different approach to the rendering of a detail. For instance, if your large drawing is executed in bold, sweeping lines, try to draw some parts with a greater respect for modelling or detail.

The most difficult and the most important details in drawing are the human hands. They should be drawn separately and at life size. One of the greatest ambitions of every draughtsman is to master thoroughly this extremely difficult subject which requires a vast amount of background anatomical knowledge and a familiarity with the complex structure of the hand which is composed of numerous bones, muscles and ligaments. The difficulty of the subject stems from the rapid and complex changes caused by different positions of the fingers, knuckles, the palm and all the other parts.

The best way of studying the human hand is to draw your own. Draw your free hand in various positions from a direct view. Any inaccessible angle can be seen in a mirror (which will, of course, reverse it).

Although I usually warn against excessive modelling, an exception should be made for drawing the hands. Every draughtsman should complete several perfect studies of hands. By the word perfect I do not mean a virtuoso masterpiece but a humble, honest constructive study which would sum up the character of this living organism, its locomotive functions, its wrinkles, knuckles, veins and nails. This kind of drawing requires great patience and devotion. Thorough, detailed

49
Raphael (Raffaello Sanzio; 1483—1520)
Study of a Kneeling Woman
Chalk, 332 × 215 mm
Ashmolean Museum, Oxford

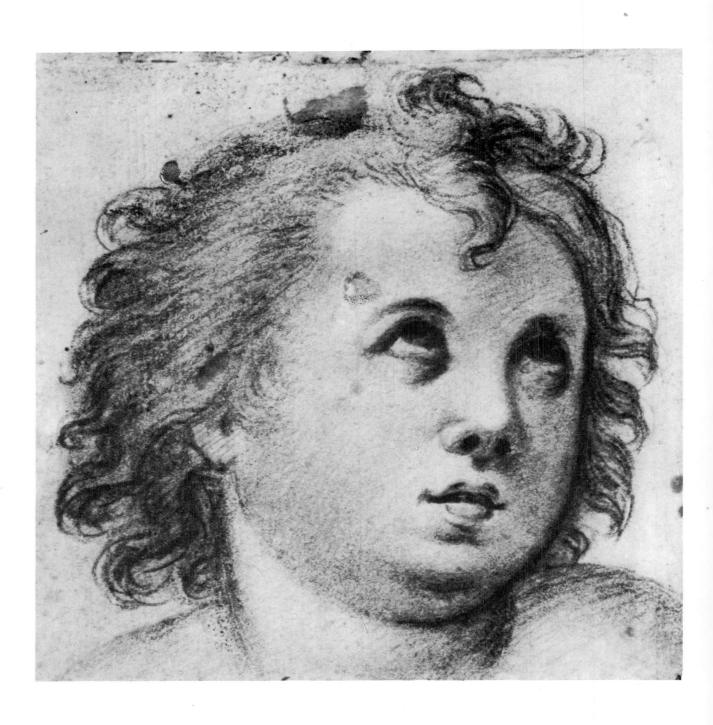

50
Wendel Dietterlin (1550/51 — 1599)
Study of a Child's Head
Black chalk and sanguine, 120 × 118 mm
Graphic Art Collection, National Gallery, Prague

51 *(opposite)*
Liberale da Verona (circa 1445 — 1526/29)
Two Studies of a Sleeping Woman with an Infant at her Breast
Pen and bistre, 203 × 279 mm
Graphische Sammlung Albertina, Vienna

modelling is necessary because various positions of the thumb, the fingers and the palm result in such complicated spatial arrangements that a purely linear execution would be probably quite insufficient. Do not forget that what you do now is nothing but a true study of a primarily practical nature. Your medium for these studies should be charcoal, possibly accentuated with pencil, red chalk, or a quill or pen and diluted ink. Charcoal alone is usually too bold for such a complex detail.

Try to discover what the hands reveal about the model's character. They will tell a lot about a person. Why are the nails broken and chipped, why are they dirty, why are the palms hard and calloused, the fingers crooked and the veins protruding? What is the message in a pair of slim, pale hands with almost indiscernible knuckles and long almond-shaped nails? Have you ever noticed the hands of Leonardo's *Mona Lisa?* Look at Dürer's study of praying hands. They are

highlighted with white paint in short, economical brush strokes on the blue paper.

The most vital thing is the observation of the correct proportions. The result would otherwise resemble a pair of shapeless gloves rather than animated human form. It is therefore best to start with a tentative, yet precise light sketch of the general outline and only then to add sensitively the individual details, concentrating on emphasizing the major components.

If you hold up your hand with its back towards you, the fingers pointing towards a light source, you will notice from the way the light falls on the flesh between the fingers and on areas of the back of the hand that the angle of certain parts is identical. This is balanced by the opposing angle of adjacent areas which are now shaded. If you emphasize the contrast of these tiny planes you will find that you can understand the subtleties of form more easily.

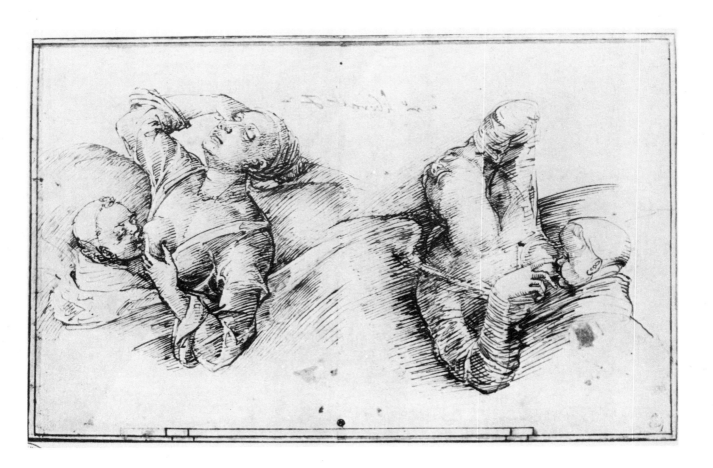

Children

What you have already learnt about portraiture will be useful for this type of drawing, although children's portraits generally portray more than just the head and shoulders and sometimes show the entire figure.

To draw a young child by observation would require a still, frozen pose; this really demands too much of the child. Even a minute tilt of the head results in a total change of all the outlines of the drawing. It is therefore very important to develop a powerful visual memory (this, of course, is valid for all the subjects you tackle) to be able to keep in mind all the changes of position that the model makes. It is not a good idea to change the drawing each time the child shifts position. But equally do not upset the child with constant reprimands or force him to resume the original position.

In these difficult circumstances you will have to rely on your drawing abilities, a thorough knowledge of the anatomy of the head and the body, together with a well-trained memory for shapes. Capitalize on your ability to lay out the drawing with a relative rapidity.

When working on a child portrait you should always bear in mind that children have certain anatomical differences as compared with adults. The head is larger in relation to the body; in a child portrait or a nude this will be noticed in the relation of the head to the width of the shoulders. The typical childish features will be emphasized if this relation is exaggerated by drawing the shoulders to appear more narrow and fragile. Notice too how large the eyes are, and the characteristic shape of the skull which should be carefully delineated.

Children between the ages of two and six are popular subjects. When working on a portrait, everything depends on your ability to sketch quickly and precisely the basic bearing of the head and the facial features which are fresh and unformed. Make good use of your time at the beginning of a sitting when the child is inquisitive, alert and not bored. As the sitting progresses, be tolerant and allow the child to play a little. The only thing you have to do is to make sure that the child does not leave your field of vision too much. If you can depend on your memory, you can execute minor precise details even under such circumstances. You will soon notice that as the child is playing from time to time it resumes the original position or one which is quite similar to that of your first basic sketch. Anticipate these moments and when they come, use them to add information to the drawing.

52
Abraham Bloemaert (1564—1651)
A Bishop
Sanguine and white paint, 275 × 198 mm
Graphic Art Collection, National Gallery, Prague

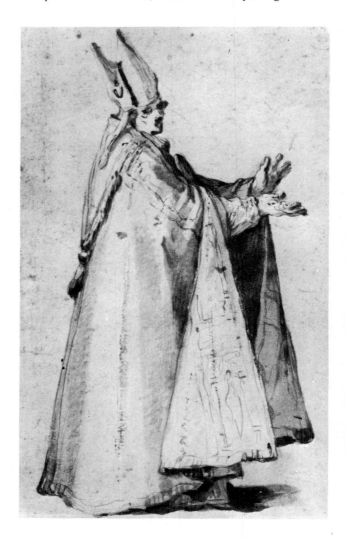

This way of working has several advantages. The child will keep its temper and retain a fresh, interested expression while you can remain calm and enjoy the peace necessary for your work. You can also make the child sit still by asking his or her mother to take the child on her lap and tell an absorbing story. The mother might also hold the child's head lightly in the required position.

'Sanguine' conté crayon, similar to the red chalk used in the past, is highly suitable for child portraiture as its tone reflects the freshness of youth and offers all the other advantages which will be discussed in the chapter dealing with techniques and media.

The head should be drawn slightly larger than its true size. All facial features should be reduced to a minimum (a rule that is even more important with drawing children than adults). Avoid particularly all furrows, wrinkles or folds — they can produce a disturbing effect. A successful portrait is essentially concerned with a portrayal of the shape of the head, lightly sketched hair, a pure outline of the face with a mere hint of modelling, prominent eyes, and a lightly sketched nose. The mouth gives clues to expression. It is easier, when drawing children to play down the individual features and instead to convey the more general 'childish' qualities of the face.

If you are drawing the whole body of the child the head should remain the most important part of the drawing although the hands might also be drawn in some greater detail.

The character of the portrait is determined chiefly by the emotional involvement which should be captured in the drawing and is most obviously reflected in the large eyes. Every conscious decision made by the artist to include or ignore, to emphasize or suppress is a positive step towards a successful drawing.

When drawing the hair, be sure to preserve the distinctive shape of the skull; this also applies to the drawing of heads of models of every age, but it should be stressed especially in this context. The anatomy of a child's body is less well formed than that of an adult. It is therefore more difficult to understand and the draughtsman is well advised to rely to a greater extent on what he knows of the subject, since he must record not only what he sees but also what he knows. Knowledge of the subject is an aid to developing technique and it also reveals an investigative attitude. The creative process of drawing will teach you to think and it will lead you to exciting and unexpected discoveries.

53
Jacopo da Empoli (1554—1640)
Man in a Cloak
Sanguine, 396 × 260 mm
Graphic Art Collection, National Gallery, Prague

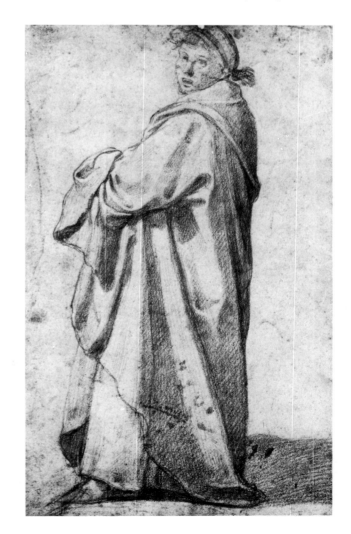

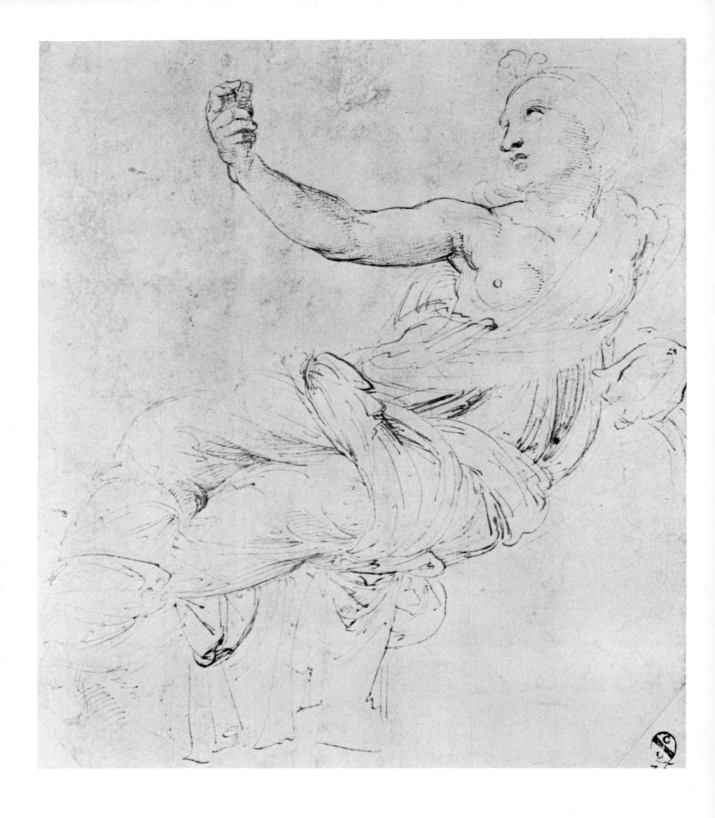

54
Raphael (Raffaello Sanzio; 1483—1520)
The Muse Euterpe
Pen and bistre, 244 × 217 mm
Graphische Sammlung Albertina, Vienna

55 (opposite)
Titian (Tiziano Vecellio; circa 1490—1576)
Two Kneeling Boys in a Landscape
Pen and bistre, 236 × 213 mm
Graphische Sammlung Albertina, Vienna

Drawing Fabric

Drawing fabric involves, above all, the representation of light and shadow on a complex form, so a certain degree of stylization is unavoidable. It is a useful exercise to draw a piece of cloth in the traditional way, that is, illuminated from the side. In this way the contrast of light and shadow in the deep relief of the fabric is most accentuated.

An old school textbook gives the following advice: the cloth should be rinsed in water and paste and then hung to drop into folds. When dry the deep folds of the material will be stiffened by the glue and it can be used again and again as a drawing model.

A similar kind of study can be made to depict the sharper creases made by a crumpled piece of paper. Notice the different properties of the substances and the nature of the folds.

Costume design in previous centuries gave the artist the opportunity to depict rich draperies but current fashions are more figure-hugging. Clothes, however, say a lot about

a figure and help to reveal shape. The nature of the material and the hang of the folds can be studied as part of a still-life and can often form an important part of the composition.

Drapery studies require great patience and a meticulous approach. Attention must be paid to the direction and arrangement of the folds and also to the quality and texture of fabric. The drawing must express the uniformity of the material, and at the same time describe it under different lights and define its complex and subtle curves, angles and planes.

Material is tricky to draw for another reason: its thickness or thinness should be conveyed. An edge of a hem that rest on the ground will give clues to the weight of the material.

When drawing material, whether in a portrait or on a clothed model, try to simplify the planes and develop a schematic representation of the main direction of the folds.

56
Parmigianino (Girolamo Francesco Mazzola; 1503–1540)
Martyrdom of St Paul
Wash drawing with pen, bistre and white paint, 175 × 287 mm
Cabinet des Dessins, Louvre, Paris

57
František Tkadlík (1786—1840)
Head of a Girl
Sanguine, black and white chalk, 297 × 245 mm
Graphic Art Collection, National Gallery, Prague

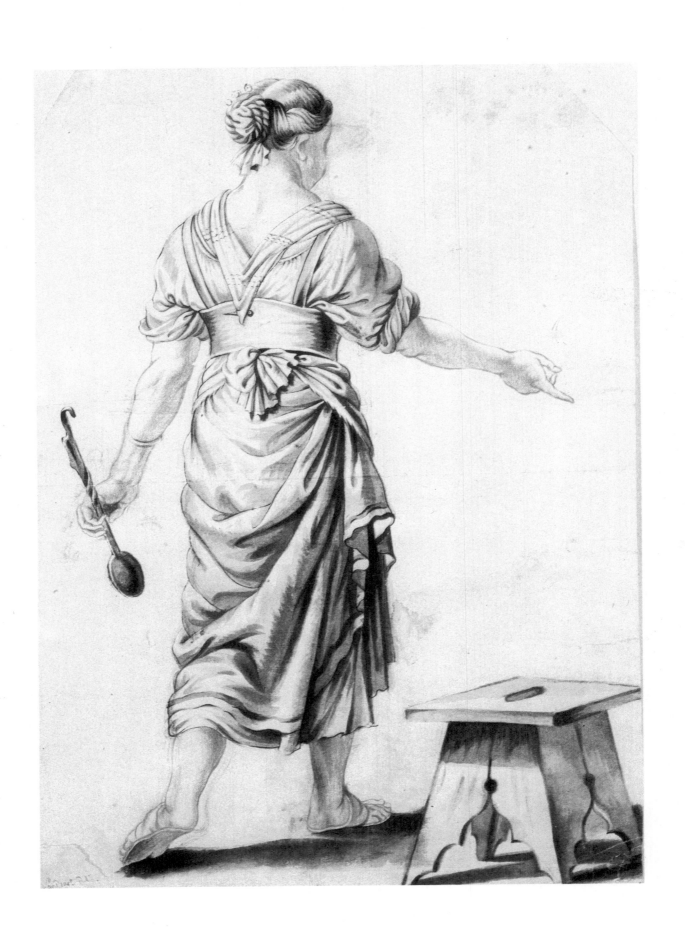

Landscape

59
Rudolf von Alt (1812—1905)
On Lake Gmunden
Watercolour, 160 × 219 mm
Graphic Art Collection, National Gallery, Prague

58 *(opposite)*
Johan Heiss (1640—1704)
Study of Martha for the painting 'Christ with Mary and Martha'
Pen, ink, sanguine with grey wash, 415 × 290 mm
Graphic Art Collection, National Gallery, Prague

The chapter on the drawing of landscapes, seascapes, nature studies and townscapes has been placed intentionally after those dealing with figure drawing since anyone who has mastered the intricacies of portraits and human figures and has learnt the art of precise, accurate drawing will cope relatively easily with any landscape. In landscape drawing the requirements of exactitude and precision are not as strict as in portraiture. The slightest imprecision in a portrait would be intolerable (for example, a minute shift of the pupil of one eye is enough to make a model look cross-eyed). It follows that a draughtsman who has undergone a stiff training in drawing the figure will never allow such inaccuracy to occur even in a 'portrait' of a landscape.

It is less exacting to concentrate on the

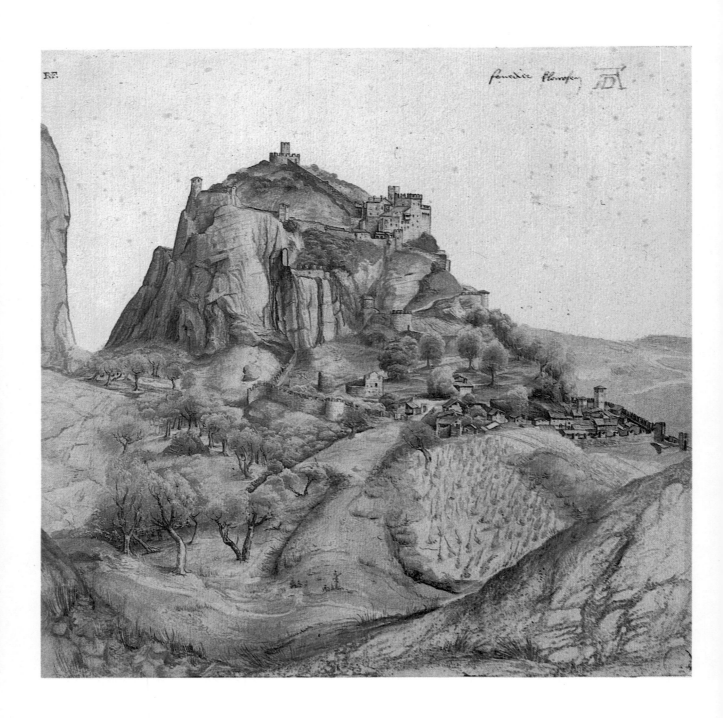

60
Albrecht Dürer (1471—1528)
View of the Arco Valley
Pen, black ink, watercolour and gouache, 223 × 222 mm
Cabinet des Dessins, Louvre, Paris

structure of a landscape than of a portrait and one therefore can afford to be carried away more by the mood and atmosphere. The basic prerequisite of any representation of a landscape — as in any portrait or figure drawing — is the correct establishment of proportion. Cityscapes naturally involve drawing buildings, which is impossible without at least a basic knowledge of the laws of perspective although the emphasis on exact descriptive representation does not have to be so strict as it was in the past since the chief aim is to achieve a unique, personal and emotional interpretation.

A fertile imagination will provide you with inspiration for endless subjects. Imagine a beautiful coastal scene. The fishermen have towed their colourful boats beyond the breaking waves which roll unceasingly towards the shore. Suddenly there is an irresistible urge in you to capture this experience in your sketchbook, to freeze the moment, to eternalize the feeling brought about by the ever-changing sea. You have your subject!

First you must select a view. This can be made easier by using a 'viewfinder' — a rectangular cut-out cardboard frame. The viewfinder isolates sections of the view in the way it will be seen on paper. This method has been used through the ages; so too has a device which serves as a viewfinder and colour-filter, a rectangle of glass, tinted blue or green, which changes the colours of the landscape into a scale of blue or green hues. In this way the tonal values of the landscape are simplified and more readily defined. It is interesting to see what this kind of filter reveals, but with experience you will be able to sort out tonal variation (without being distracted by local colour) with your own eyes.

If you are prepared to carry with you a light-weight sketching easel you will benefit from being able to step back and review your work as it progresses (but remember to attach the paper firmly to the drawing board). More portable (and with its own distinct advantages) is a sketchbook. Find a vantage point; sit on a rock, or on a stone wall, on a chair in a café or carry a folding stool with you. No matter where you sit, do not forget

to check on your work from time to time by holding the sketchbook at arm's length away from you to survey your work.

All that has already been said about figure drawing also holds true for landscapes and cityscapes. The rule of thumb is to simplify as much as possible, to summarize all the shapes, subject details to the whole, to emphasize what is particularly important and to suppress what is unimportant. The success of your drawing lies in that great ability to omit the inessential, to express your personal experience through drawing, and to grasp with a sixth sense the attractiveness or the dramatic character of the landscape and the mood it evokes. In landscape drawing, all these elements (or the one that you have decided to be strongest of all) are expressed by the style and technique that suit your temperament best. You must adapt to suit the landscape that is before you.

It is not a difficult matter to make a landscape recede convincingly into space on the paper. A feeling of depth can be achieved by means of a proper perspective projection of converging lines into space, or, more simply, by the weakening of the tones and blurring of distant areas towards the horizon. Remember that it is not necessary to adhere to these traditional conventions: the near as well as the far parts of the landscape may be drawn in a line of the same intensity and a mere diminution of objects in the distance will be enough to create an illusion of depth.

However, for a beginner it is advisable to select only spatially restricted elements. Even the endless sea should be depicted as a vertically suspended curtain vibrant with rhythmic pattern, rather than attempting to create an illusion of horizontality. Take time to observe the sea, let it engulf you. The surface is always alive even if it is perfectly calm and still; it is full of opalescence, motion, ripple, dramatic breakers — it is alive with rhythm. After long and sensitive deliberation find a means of conveying this rhythmical phenomenon in a linear fashion to express what the sea evokes in you. An expressive rather than an instinctive approach may be more successful. Attempt greater stylization and ornamen-

Claude Lorrain (1600—1682)
Sunset on a Harbour
Pen and bistre wash, 139 × 250 mm
Musée Condé, Chantilly

tation in depicting the waves; use figures-of-eight, S-shapes and other more personal linear symbols that reflect your feeling and translate your experience on to paper.

Similarly, a field or a meadow (which are, in fact, often poetically referred to as a sea) should be also viewed as a vertical curtain given rhythm by vegetation, arabesques of plants, corn and other grasses and solitary trees and shrubs.

The purest example of what we have in mind are landscape drawings by Vincent van Gogh. If his landscapes are viewed without any attempt to decode their reality, they appear as a maze of differently angled lines, dashes, arches, curves and dots of varying thicknesses and intensities. Their sequences translate perfectly the feeling created by the ever-changing surface of a wide, flat landscape of meadows and fields. The juxtaposition of a densely hatched area with another

filled with dots immediately evokes in the viewer the feeling of a change in the terrain, in its rugged or gentle, rolling character. Although the stipples are often rhythmically repeated, nothing is employed mechanically. The artist has captured perfectly the predominant mood of the individual parts of the landscape and translated it into the abstract marks produced by his reed pen given life by pulsations generated from the observed landscape. You cannot expect to be able to achieve something of this kind easily, but you will not find a more instructive example of the draughtsman's transition from a concrete impression through abstract expression to convey a new and intensified reality.

Vegetation, trees and shrubs are an important part of any landscape. To capture the shape of a tree it is important to see the crown not as a silhouette but as a structured mass that is composed of smaller masses,

Josef Šíma (1891—1971)
A Tree in Carona, 1924
Pencil, 485 × 320 mm
Graphic Art Collection,
National Gallery, Prague

which in turn consist of even smaller forms and individual features. The leaf is the smallest element and each species has its own peculiarities. It is interesting to note that the contour of a tree often echoes the character of the leaf. The drawing of an individual tree should not be overworked even if the rest of the drawing is recorded in some detail. It is more important to convey the significance of the tree in relation to the entire environment. Individual masses may be indicated with a rhythmic line to suggest the structure; a few individual leaves can be drawn to suggest

symbolically their continuation over the whole form.

Art is said to be a beautiful lie. Indeed, it *is* a lie in the sense that the artist can never compete with nature. He or she could try to describe it faithfully, but would rather interpret it by means of lines and light, which enable the artist to arrive at that deeper truth concerning nature and reality.

A similar approach can be adopted for drawing townscapes if the aim is to convey the emotional impact of architectural structures. A more detailed representative study

63 *(opposite)*
An 18th-century German Master
Study of an Interior with a Kneeling Figure
Pen and grey wash, 338 × 238 mm
Graphic Art Collection, National Gallery, Prague

requires a more deliberate approach and far greater technical accuracy: a thorough grasp of scale and perspective (which involves determining the horizon line and the points on that line to which all parallel lines converge as they recede).

For your first attempt at a more evocative drawing select elements that are less structured and do not worry too much about the perspective. In fact, pretend that this *seeming* lack of precision and the general shakiness is intentional. Start with the general shapes and try to simplify things. Place the dominant shapes side by side rather than arranging them in depth to give the drawing the appearance of disrupting structures. The spaces between the main shapes should be filled with rhythmic ornamentation which should reflect and echo the character of linear details of the façades, and of the walls and foliage between the buildings.

Do not hesitate to add figures into the drawing but do not let them assume the character of traditional pageant-type stage extras. Make them an integral part of the entire street scene, which might include cars, buses and pedestrians. Instill the drawing with life to reflect a feeling that is evoked by the street or city-square scene. However, all

64
Rembrandt Harmensz van Rijn (1600—1669)
Landscape with a Canal
Pen and bistre wash, 960 × 213 mm
Graphische Sammlung Albertina, Vienna

Max Švabinský (1873—1962)
Morning on the Elbe, 1921
Pencil, 190 × 280 mm
Graphic Art Collection, National Gallery, Prague

these elements must always remain subjected to the main concept of the drawing to ensure that the work retains its fresh and vivid character.

The best medium for this type of drawing is a sharp pencil, a pen, a fine fibre-tipped pen or perhaps a ball-point pen. A different approach is required if you intend to do a wash drawing. The techniques employed for this kind of drawing are discussed in greater detail in the following part of this book which deals more specifically with individual techniques and media. What should be emphasized here is that this technique is at its best if a great deal of simplification governs the drawing. When using wash the individual elements in a townscape or landscape must be generalized into larger forms and depicted in broad areas of light and dark.

It can be helpful to look at the subject you intend to draw through a glass viewfinder tint-ed blue or green, which will translate the multicoloured masses of the landscape into a graduated scale of tones of the same colour, organized as they would appear in a wash drawing. It is best to wet the paper first and then to apply broad, diluted tints with a well-saturated sable brush. Do not worry if the edges of different areas tend to blur if it enhances the effect you want to achieve to capture the mood or character of the landscape. This technique has a translucent effect which can be used to enhance the subject matter of your drawing.

A wash can be applied directly to the paper, or if the drawing is more complicated, a preliminary pencil sketch can be made. It is also possible to apply a wash over a pen drawing or to add detail to a finished wash drawing by using pen and ink on top. However, it is best not to overwork the whole drawing — leave some areas white where

there is more light. This kind of drawing is naturally more concerned with defining the spatial planes of the landscape than a linear drawing.

The traditional classical landscape drawing was divided into three distinct planes. The foreground was always the most detailed part, the background was light and airy, and the middle ground formed a transition between the two. It is still a useful convention to respect. When selecting a view to draw make sure that you include some solid, solitary forms in the foreground, such as trees and rocks. These should be clearly defined and arranged so that they frame the composition and set the stage for the view into the distance. The sky should be kept light and airy; if necessary the horizon should also be made lighter to distinguish it from the nearer horizontal planes of the landscape.

When laying a wash the paper can either be totally covered by using a heavily loaded brush, or its surface texture can be revealed by first shaking out the brush and then drawing it lightly across the paper. It will catch on the raised particles of paper and leave the minute hollows as flecks of white. This is a useful technique to convey light catching on objects such as old masonry and rocks, but there can be a risk that the drawing will feel too dry. A combination of the two techniques will give good textural contrast.

66
Annibale Carracci (1560–1609)
River Landscape with Two Boats
Pen and brown ink, 199 × 300 mm
National Gallery of Scotland, Edinburgh

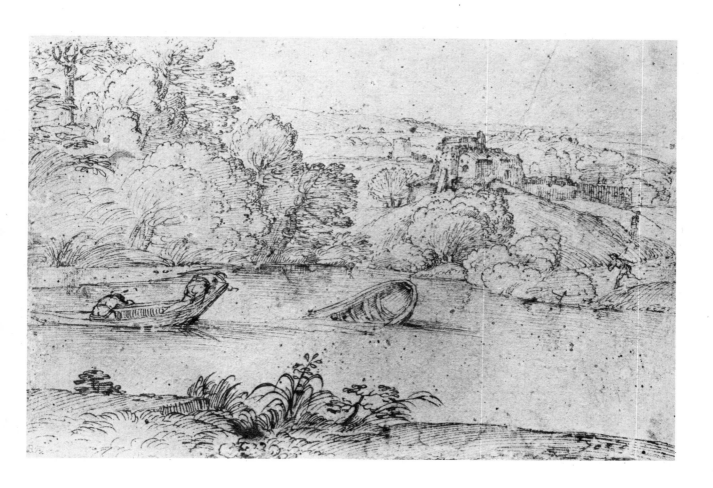

vincent.
La Crau
Vue prise à Mont major

MATERIALS AND TECHNIQUES

Your selection of a medium and a technique cannot be arbitrary; it must be based on your creative attitude, but it must also respect the intended graphic style, the subject matter and the content of the envisaged finished drawing.

Drawing media can be divided into several groups. The first is composed of broad-line media such as charcoal and chalks; the second group of narrow-point media includes graphite pencils, silver point, steel pens, ballpoint pens, reed pens and quills; the third group is formed by liquid media.

67
Vincent van Gogh (1853—1890)
Landscape at La Crau
Reed pen and black chalk, 490 × 610 mm
Stedelijk Museum, Amsterdam

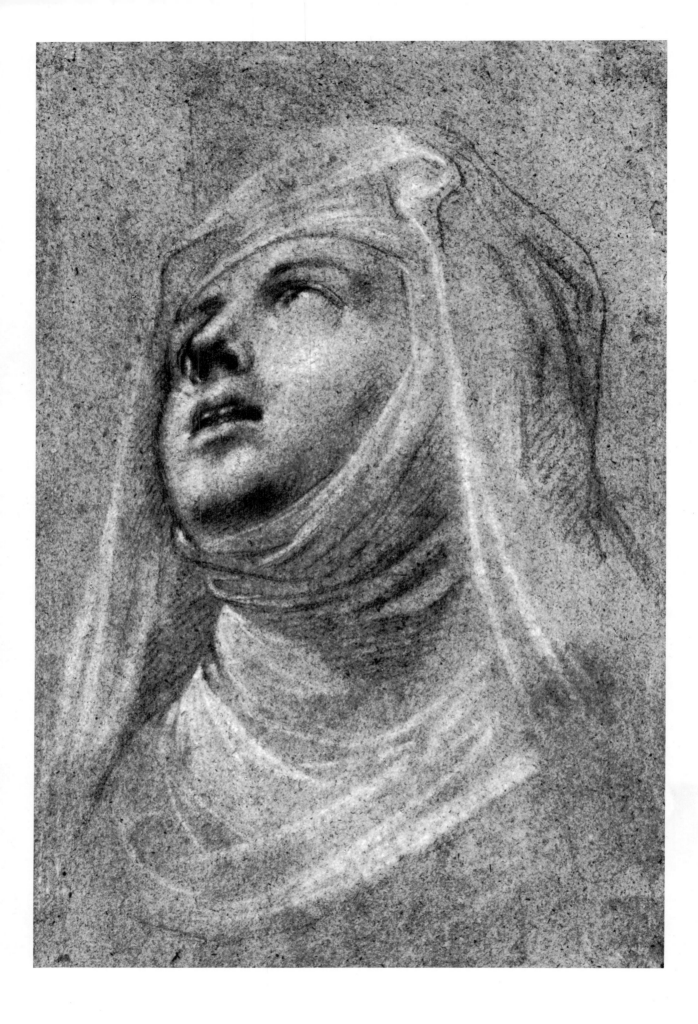

Drawing with natural charcoal has always been a classical discipline of the draughtsman's studies. Charcoal has much to recommend it: it is perfect for studies of heads, nudes and clothed figures as well as for preliminary sketches for more fully developed compositions. Its great advantage is that it can be easily blown off the paper so that there is no need to rough up the paper surface with erasure where corrections are made.

Charcoal is the softest drawing medium of all. It is a form of carbon, produced by charring willow or vine twigs. They retain their original shape and, depending on the degree of charring result in a range of different degrees of softness. The greyish-black mark that it makes can be finely nuanced by varying the pressure applied.

Artists' suppliers stock several sizes of natural charcoal including thin, round sticks about 3—4 mm ($\frac{1}{8}$ in) thick; round charcoal with a diameter of between 5—10 mm ($\frac{1}{4}$ in); and scene painter's charcoal, made from irregular-shaped twigs about 20 mm ($\frac{3}{4}$ in) thick. Scene-painter's charcoal is perfect for large drawings where a thinner stick would produce too tiny a mark and would tempt the draughtsman to draw the details in too early, generally hindering any grandeur and simplification.

For medium formats (such as for studies of sitting figures or life-size half-figures) it is best to use round natural charcoal sticks, about 5—10 mm ($\frac{1}{4}$ in) thick. The stick should be sharpened to form a long point by the method already described. Always use medium grain emery paper or a sharp safety-razor blade to sharpen your charcoal. If you use a blade be sure not to cut the stick but to scrape it to obtain the required point and facet. In drawing, the flat mark produced by the facet is alternated with the sharp line produced by the tip which is usually rounded.

Take a few sticks from the box and try out their quality and softness on the edge of your drawing paper. In time you will gain enough experience to be able to tell the quality and softness of your charcoal by sight or touch only. Place the sharpened sticks side by side

68
Carlo Dolci (1616—1686)
Head of a Nun
Sanguine and white chalk, 349 × 225 mm
Moravian Gallery, Brno

on the ledge of your easel so that they can be selected as they are needed. It is also possible to hold two or three sticks in your free hand and use them according to the requirements of softness or hardness and various edges. For instance, a drawing of drapery might require a more faceted stick with a rather dull edge while a drawing of an ear or the contour of a profile will be done with a sharper edge.

The narrower sticks, with a diameter of 3—4 mm ($^1/_8$ in) are reserved for fine detail work. There are also super-thin charcoals resembling wires, but their use is somewhat beyond the scope of ordinary drawing studies and this type of charcoal is suitable for works of a very distinct, highly detailed character.

When working in charcoal always have to hand a soft, clean cotton rag, a kneaded putty rubber or a ball rolled from fresh bread crumbs to create spots, dashes, lines, or larger areas of light in the darker tones. A kneaded putty rubber is pliable and can be modelled to form a point for fine work.

Stumps (tortillons, or torchons) are cylinders of tightly rolled absorbent paper or finest chamois. They are used to soften charcoal lines to form regularly modulated tones to express volume. However, it is easy to overwork a drawing when using this technique. Forms tend to become too smoothly polished and the drawing loses its linear quality.

Some people, particularly those of a more sensual disposition, do not hesitate to use their bare hands to achieve a stronger sensual effect in their drawings, by rubbing certain parts with bare fingertips. In this way the tactile senses are also employed in the process of drawing. The method can hardly be objected to, but it might be better not to depend on it, especially in studies. There is a risk that your work will lack sharply defined construction and volume and this should be your primary aim.

When drawing with charcoal, take care not to produce an excessively black effect; keep the drawing open and airy in character.

Charcoal is also used for tracing off from sketches, especially for large cartoons. The procedure is as follows: the main contours of the sketch are pricked with a needle or a pin and a muslin bag filled with finely crushed charcoal is shaken above the punctured outline. In this way the sketch will be transferred onto the cartoon.

Finished charcoal drawings are extremely sensitive and must be preserved by a fixative, a varnish solution which will prevent the drawing from being wiped off. Only then can the drawing be stored safely. Fixing must be done lightly and carefully. When the first layer of the fixative has dried, another is applied over it. This should be repeated about three times. The drawing must be placed horizontally. Be careful not to spray too strongly because you might dislodge a part of the drawing before the spray reaches the paper. Droplets could form and damage the drawing — they should be removed quickly with blotting paper. To prevent paper warping due to the application of the fixative, it is advisable to glue the drawing to a cardboard mount.

69
Michelangelo Anselmi (circa 1492—1556)
Mythological Scene
Sanguine, 187 × 289 mm
Graphic Art Collection, National Gallery, Prague

This type of charcoal is fabricated from finely pulverized, high-grade, hard charcoal, bound with vegetable glue and compressed into round sticks about 12—13 cm (5 in) long. This charcoal is extremely brittle and must be therefore stored in wooden boxes filled with fine sawdust. It has an even, deep velvety-black tone but its gradation properties are limited when compared with natural charcoal. It is produced in two grades of hardness; the softer grade is more suitable for general work.

Since compressed charcoal is so brittle, it is advisable to break each stick in half and to sharpen each half individually. The shorter sticks do not break so easily and are easier to hold. There are holders, or *portecrayons,* available on the market, which are generally made of plastic (although you might find a brass or wooden one). These tubes have a clutch mechanism to hold the charcoal stick firmly in place, which will protect the brittle sticks of compressed charcoal (they are less suitable for natural charcoal because of its irregular shape). This protects the hand from getting dirty, but at the same time lessens the sensitivity of the touch. Experience has shown that it is the contact of the bare hand with the medium which is extremely important. Besides, charcoal held freely without a holder gives you a better control over the line.

Compressed charcoal is not recommended as a suitable medium for life drawing although it must be said that it does offer certain advantages that are best used for a purely graphic approach.

The drawing media used by the artists in the past were almost exclusively of a natural origin, such as black, red and white chalks,

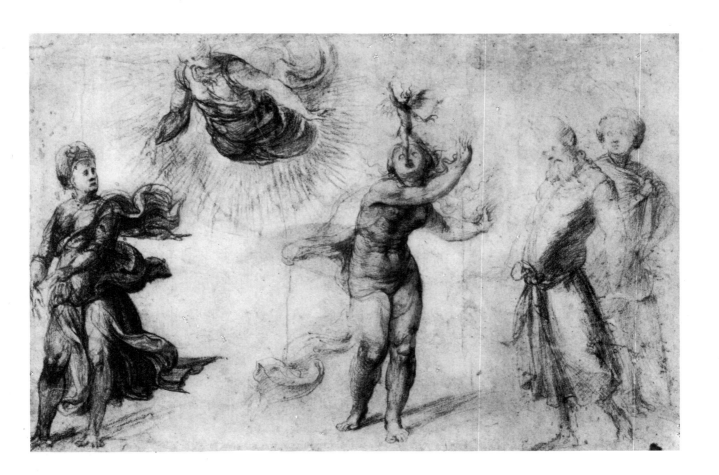

Bartolomeo Veneto (active 1502—1530)
Portrait of a Young Man Wearing a Cap
Charcoal and white chalk, 380 × 286 mm
Graphische Sammlung Albertina, Vienna

lead or silver point and, of course, the most readily available material of all — natural charcoal. You should follow their example and do your studies of nature in natural charcoal. The medium offers pliability and softness and is of an organic character.

The drawings of the Old Masters illustrate the range of quality that could be obtained with the variety of chalks that were available to them. Sanguine, sepia and black and white chalks each had their own distinct properties and characteristics, which were exploited to suit the subject and the mood of the drawing.

These chalks are no longer available and the 'school chalks' that are on the market are a poor substitute. However, conté crayons (made from a mixture of graphite and clay, available in various degrees of hardness) have a range of subtle colours including sanguine, sepia, bistre, black, white and several tones of grey, which emulate admirably the materials used by artists in the past. Soft pastels, or coloured chalks, include black, white and sepia in their wide range of beautifully pure colours.

It is interesting to investigate the materials that were used by the Old Masters, to understand the properties of the various chalks and the way their colour and tone was used to best effect. Apply this knowledge to the equivalent materials that are available today so that you will learn how to get the best out of them.

71
Ottavio Leoni (circa 1578—1630)
Bust of a Man
Black chalk, 222 × 148 mm
Moravian Gallery, Brno

Sanguine, also known as red chalk, was made of a mixture of kaolin clay and ferrous oxide, ranging in colour from dark brownish red to terracotta. It was a supple medium with a brittle grain. A soft, grainy paper shows to best advantage the sand-like character of the medium while retaining its own qualities to fuse the image in the viewer's eyes into a homogeneous optical whole which lends the work a particularly provoking character. Its warm red and brown tones are also exceptionally pleasing to the eye, making it particularly suitable for portrait drawing since its warm hue reflects the human skin. Its pliability permitted a highly graphic interpretation as can be seen in the numerous portraits in this medium first popularized during the Renaissance. Leonardo created his famous *sfumato* effects with this chalk.

Sanguine is perhaps the oldest graphic medium to be used by man. It was known to the Paleolithic cavemen. In the history of drawing it appears first before 1500; the Italian artists used it for its broad-line trace as a contrast to the narrow-point trace of silver and lead styli. At the end of the 16th century Francesco Imparato in his treatise *Historia naturale* dealt with the artistic effects of the medium, valuing it for its precise delineation, its attractive, harmonious tone and generally praising it as a highly recommendable drawing medium.

Sanguine was often used in combination with natural black chalk as a colouring medium. Combined with black pencil on white paper it yielded effectively the warm tones of human complexion, but this combination of media presented a risk of excessive naturalism and stylistic impurity. Its greatest possibilities lay in the combination of the fine toning of the surface and the sharp lines incised into the paper.

As early as the 16th century the Italians noted that blue paper in combination with sanguine produced some additional effects quite independent of those produced by the subject matter of the drawing, an effect caused by the unique harmony of the chromatic values of the drawing and the ground.

Sanguine was an excellent medium for drawing from nature and was also used for preliminary sketches of oil-paint portraits. Its pink tone did not penetrate the applied paints disturbingly, but made a very pleasant, warm ground for cool, transparent tones.

Sanguine drawings are best preserved under glass. Fixing is known to cause a considerable darkening of the finished work.

72
Paul Cézanne (1839—1906)
Mont St Victoire, Aix-en-Provence
Watercolour and pencil, 308 × 495 mm
Graphische Sammlung Albertina, Vienna

73
Václav Rabas (1885—1954)
Landscape at Krušovice I
Watercolour and pencil, 470 × 680 mm
Graphic Art Collection, National Gallery, Prague

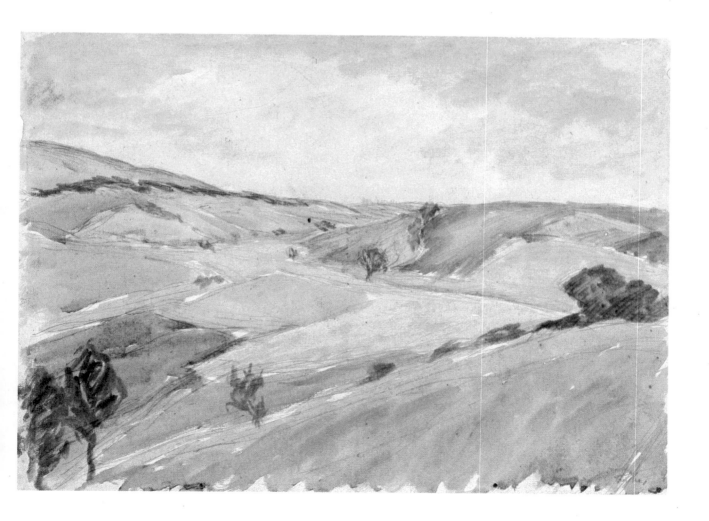

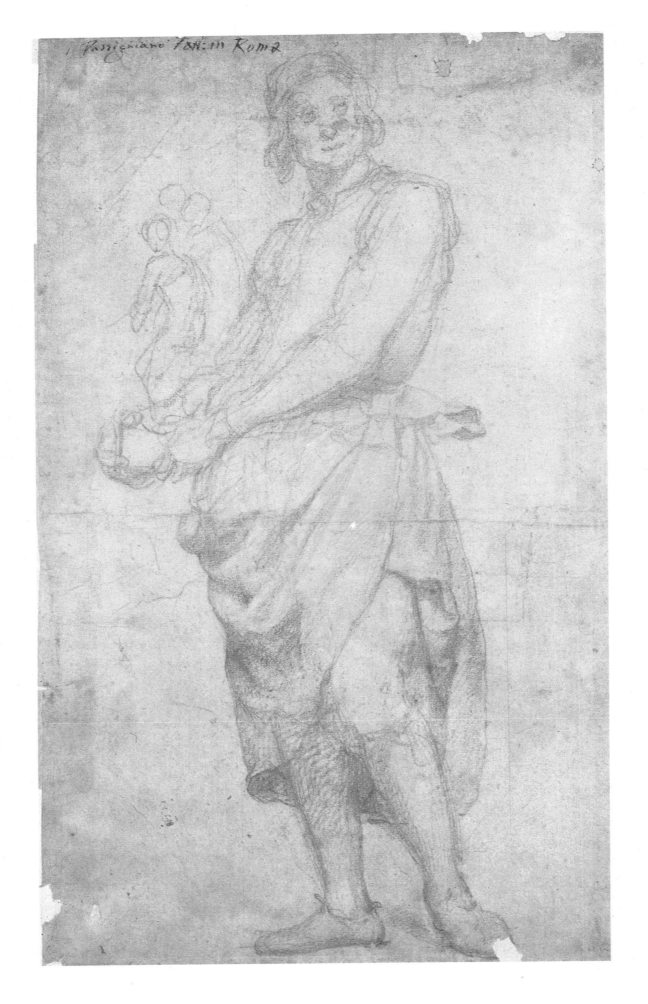

Passignano fecit in Roma

74 (opposite)
Domenico Passignano (circa 1560—1636)
Man Holding a Modeletto
Sanguine, 423 × 254 mm
Graphic Art Collection, National Gallery, Prague

75
Cristofano Allori (1577—1621)
Portrait of Alessandro Allori
Black chalk and sanguine, 206 × 151 mm
Moravian Gallery, Brno

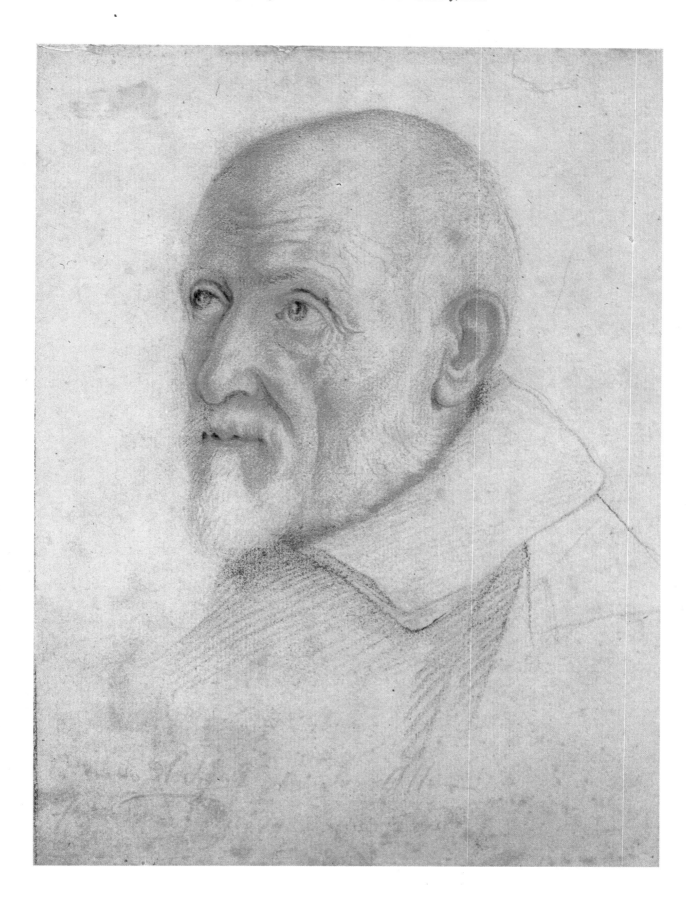

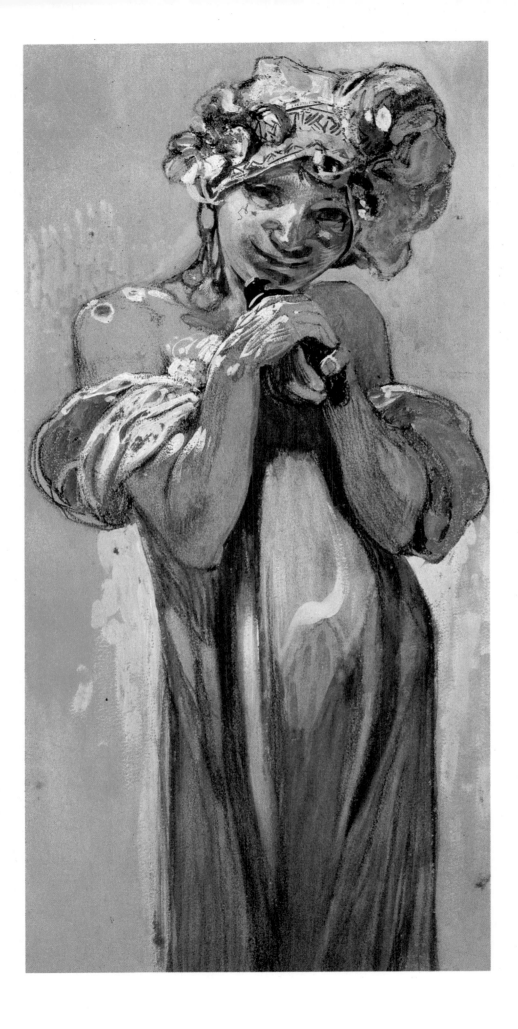

This close relative of sanguine has a dark brown tone produced by its pigments made from the ink sacs of cuttle-fishes. It was made from natural clays as well as artificial materials. Generally speaking, it was used in the same way as sanguine although it was somewhat harder in tone and composition. It was used mainly for landscapes studies (while sanguine was more suitable for portraiture). The dark hue of the medium was successfully used to express something of the atmosphere of an environment.

It had a remarkable bi-tonal property which could be achieved by rubbing the lines or hatchings with a bare finger to produce slightly different tones. This characteristic made the medium very useful for drawing interiors, townscapes, street scenes and landscapes to capture subtle nuances of atmosphere.

Sepia chalk was also washed or combined with sepia ink applied with a brush, a pen or a reed, although the purity of the graphic style was generally best preserved by limiting the combinations of various media.

The earliest record of chalk usage is that of Cennino Cennini: 'I have discovered a black stone suitable for drawing; it is imported from Piedmont and is exceptionally soft. It can be sharpened with a knife and its colour is deep, rich black. One can work with it as truly as with charcoal.' Cennini naturally does not claim any mineralogical discovery but merely wants to state that he was one of the first to use black chalk for drawing. In fact, craftsmen must have known the material for years. It was the Italians who started using chalk as a substitution for charcoal: the medium was extensively used by the artists Botticelli, Signorelli, Ghirlandaio as well as the young Raphael.

Natural black chalks were essentially clay with a carbon content of a blackish-grey hue. Apart from natural chalks there was a range of artificial chalks, the so-called French or Italian chalks known as *Carbona* or *Negro*. These were prepared from ground, carbonized bone which was extended with a vegetable-glue binder, made in different grades according to the amount of binder and pigment used. They were quite brittle and could not be sharpened easily. The *Carbona* types were somewhat drier and very black and completely matt in character. The greasier *Negro* types gave a glossy mark. Chalks could be rubbed in to the paper with a finger, paper or chamois stumps (or tortillons).

Until the 16th century black chalk was used exclusively on white paper. A neutrally tinted ground started to appear once silverpoint drawing had become obsolete. The colour of the neutral ground facilitated the play of lights and shadows rendered in white and black chalks and enhanced the plastic character of volume in height and depth.

The paper was toned with a broad, flat brush, or the entire surface of the drawing paper was carefully wetted with a sponge saturated with a tint. Later all kinds of tones were used for drawing grounds — yellowish, brown and even pink. This original tinting was later substituted with genuine coloured papers tinted during manufacture. The toned ground allows for positive as well as negative drawing in black and white chalks. Blue or

76
Alfons Mucha (1860—1939)
Study of a Figure for a Decorative Panel, circa 1905
Black chalk and gouache, 470 × 225 mm
West Bohemian Gallery, Pilsen

77
Antonio Allegri Correggio (died 1534)
Young Man Raising a Bowl
Sanguine, 282 × 205 mm
Graphische Sammlung Albertina, Vienna

78 *(opposite)*
Camillo Procaccini (circa 1551 – 1629)
Head of a Man
Sanguine and black chalk, 322 × 264 mm
Moravian Gallery, Brno

[*100*]

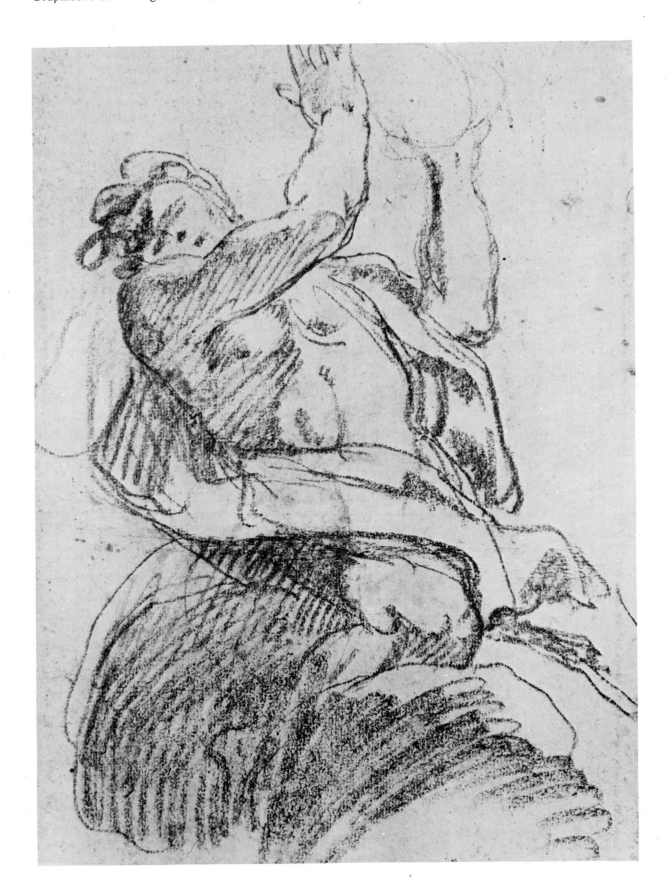

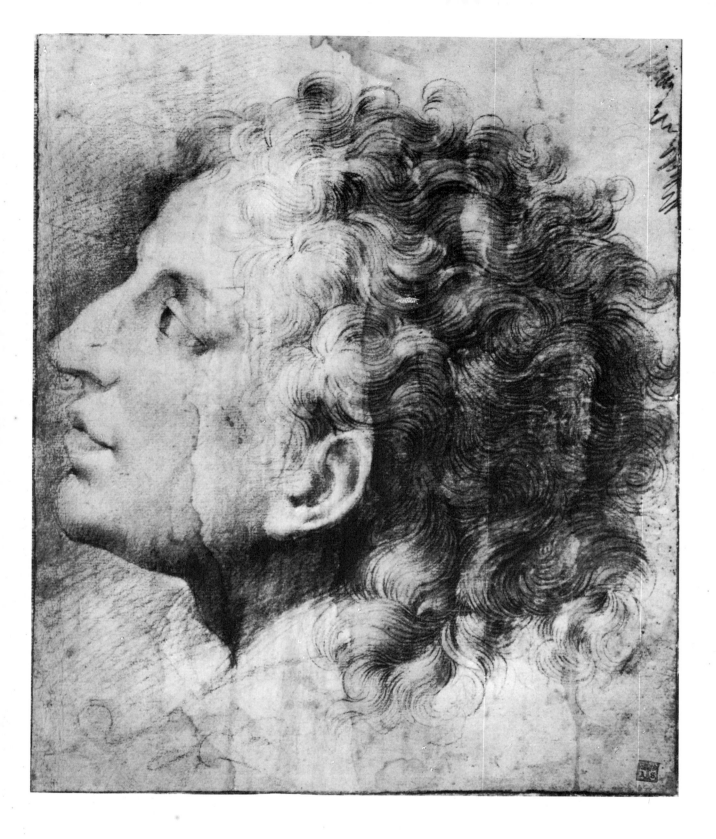

dark grey papers appeared first in Venice in the early 16th century and their popularity later spread to Florence, Milan and to the northern parts of Europe.

In 1599 Francesco Imparato wrote about white chalk: 'White clay is cut to sticks which are as suitable for drawing as black chalk. It is a material that dissolves easily in water, is not hardened by firing, tastes strongly of lime and is used for drawing on slates in the same way as gypsum pastel ...'

The oldest white drawing medium is tail-

Giovanni da San Giovanni (1592—1636)
Man Holding a Skull
Black Chalk, 398 × 255 mm
Graphic Art Collection, National Gallery, Prague

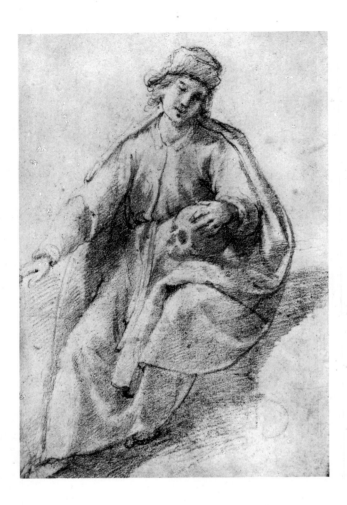

Any drawing (with the exception of those in ink and other drying liquid media like a fibre-tipped or ball-point pen) is liable to be more or less wiped off when rubbed. Every drawing medium with the exception of oil pastels and wax crayons does not adhere to the surface of the paper due to the action of a binder (as in oil paints) but due to entirely different processes. The finely ground particles of the drawing medium penetrate deep into the pores of the paper, they adhere to each other and to the ground and remain in this state due to the laws of adhesion and mutual attraction of particles.

However, untreated drawings will not be stable because once the adhesion of the particles of the medium is disturbed, the drawing will be damaged. Drawings must be therefore artificially stabilized, or fixed by means of a fixative. However, although this rather tricky operation provides a greater stability for the drawing, experience has shown that the tone will be affected to certain degree. The reason for this is that an untreated drawing reflects and diffuses light quite differently than a fixed one. Once the fixative is applied, the surface of the drawing undergoes certain transformations. The places uncovered with the medium and the interstices between the medium particles are penetrated and filled with the fixative binder which affects their composition. The greater the degree of fixing, the more distinct is the change in the appearance. No matter what type of fixative is used, the surface of a drawing will always change and the only difference between various fixatives is in the degree of the darkening that takes place after the application.

Fixatives based on alcohol, or pure spirit

ors' chalk, which was actually mineral talc. Fragments of cast and hardened plaster of Paris were also frequently used for drawing. The material was fired to make it harder and adhere better to the paper.

Today, white chalk is a poor, scratchy substance. It is better to use a white pastel or a conté crayon.

The use of white chalk for highlighting has already been discussed, but there is another unique effect that can be produced with this medium. If very dark or even black paper is used the white chalk can be used to define only the light parts of the subject and the shadows are left to peter out on the dark ground. A nude figure makes a suitable subject for this kind of drawing 'in reverse'.

80
Jacques Bellange (active 1600—1617)
The Three Marys at the Tomb
Sanguine, 218 × 175 mm
Graphische Sammlung Albertina, Vienna

Pieuue delange.

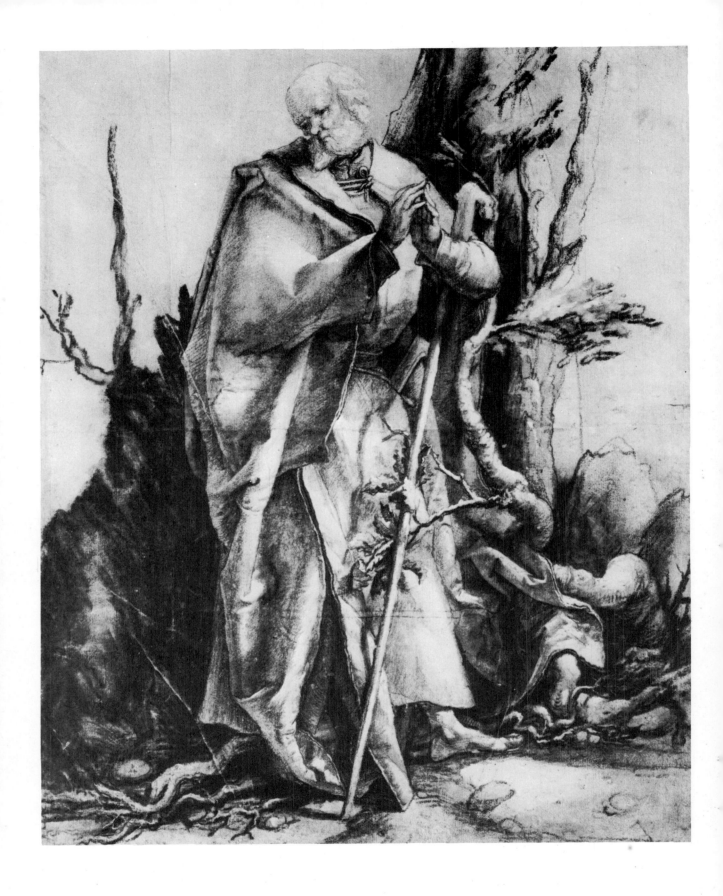

81
Grünewald (Mathias Gothardt, Neithardt;
circa 1470/75—1528)
Unfinished Study of a Standing Saint
Chalk and white paint, 362 × 293 mm
Graphische Sammlung Albertina, Vienna

and other rapid vaporizers do not fill the interstices between the paper particles as much as a slower-evaporating water-based solution, and therefore do not affect the surface of the drawing so markedly. On the other hand, they penetrate the pigment and the paper pores much more easily and darken them. Therefore the greater the stabilization given by a fixative, the greater the darkening caused.

It follows that the existence of a fixative that would not affect the tone of the drawing would be, in fact, contrary to physical laws.

Cows' milk is a natural solution of casein (which will fix drawings without any other additives). However, the fat contained in the milk would make the drawing greasy and therefore must be separated prior to application. This can be done by allowing the milk to stand for some time. Pour off the clear liquid and add clear water to it to make this natural fixative easy to spray in a fine mist. A milk fixative is suitable for fixing drawings in pencil, graphite and greasy chalk.

Casein fixatives can also be prepared by adding about 15 grams powdered casein to

82
Max Švabinský (1873—1962,
Jan Štursa, 1924
Black chalk, 526 × 430 mm
Graphic Art Collection,
National Gallery, Prague

Antoine Watteau (1684—1721)
Standing and Sitting Girl
Red, white and black chalk on brownish paper,
269 × 214 mm
Graphische Sammlung Albertina, Vienna

Ottavio Leoni (circa 1578—1630)
Portrait of a Young Man
Black, brown and red chalk, 237 × 166 mm
Graphic Art Collection, National Gallery, Prague

an aqueous solution of ammonium carbonate, made from 750 ccm (25 fl oz) water to 10 grams (⅓ oz) ammonium carbonate. Mix well and allow to stand in a warm place. Stir occasionally and check whether the casein has dissolved. The solution will be yellow and turbid. When the casein has dissolved completely, add 550 ccm (18 fl oz) pure spirit and stir repeatedly to prevent the casein from separating out of the solution. Your fixative is ready. After long storage a sediment is produced at the bottom which should not be disturbed when the fixative is poured. This mixture is especially useful for pastels.

A gelatine fixative is prepared by mixing a 2 % solution of gelatine with 10—30 % white spirit. The spirit contained in this aqueous fixative helps to dissolve the tiny particles of the gelatine. This type of fixative is recommended for charcoal drawings; it produces minimum darkening.

The procedure can also be reversed. Before

starting to draw, the paper is treated with ge-
latine and allowed to set to a film. When the
drawing is finished, it is passed several times
over a jet of steam (from a kettle, for in-
stance); the gelatine will soften and adhere
firmly to the charcoal particles from below,
increase their adhesion.

These fixatives make the process easier be-
cause they atomize readily when sprayed.
However, the paper often darkens and after
some time, especially if the drawing has been
fixed excessively, it develops dark spots sur-
rounded with traces of tiny droplets. The
problem is that one usually tends to apply
more fixative to places covered with the me-
dium. The thicker film of the fixative renders
these parts even darker and they tend to take
on a greasy feel. It is therefore vital to apply
a film that would be as uniform as possible.

Spirit-based fixatives are the most widely
used. They are marketed commercially and
are best for charcoal drawings.

You can prepare a spirit fixative in the fol-
lowing way. Place a muslin bag filled with
crystals of bleached shellac in a glass jar con-
taining white spirit (about one part shellac to
15 parts pure spirit). The vessel should be left
in a warm place, out of direct sunlight, until
the shellac dissolves. Pour the solution into
dark glass bottles and store.

Applying a fixative

A spray diffuser is used to apply home-
made fixatives. However, spirit fixatives can
be bought in aerosol cans, which give a uni-
form application of the highly volatile fixa-
tive solution over the drawing surface. They
must be used with care: first test the pressure
by spraying a little away from the area to be
fixed and then squeezing the nozzle with
a steady, medium pressure re-direct the spray
onto the drawing and continue covering it as
with a conventional atomizer.

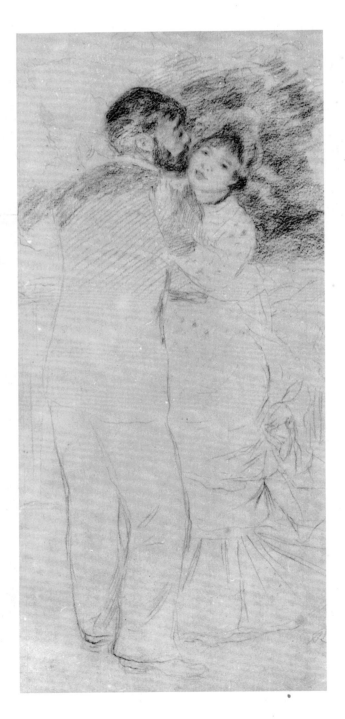

85
Pierre Auguste Renoir (1841—1919)
Urban Dance, 1883
Chalk, 490 × 345 mm
Szépmüvészeti Museum, Budapest

Antoine Watteau (1684—1721)
Girl Playing a Guitar
Lead point and sanguine, 175 × 135 mm
Musée Condé, Chantilly

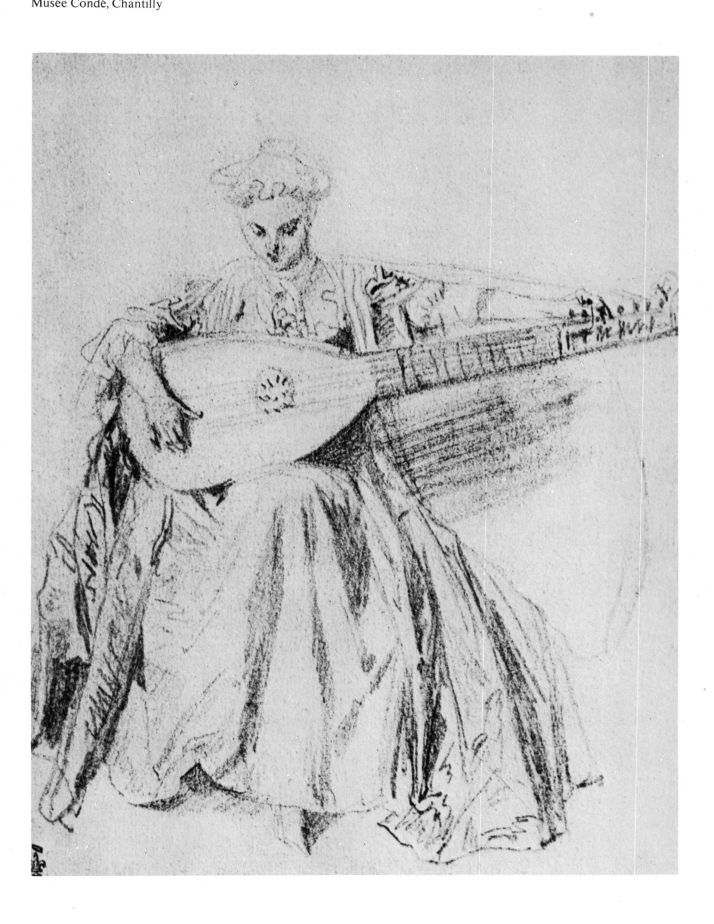

Narrow-point Drawing Media

Graphite and Pencils

Among the oldest drawing media, now long out of use, were various metal points such as lead, silver, gold, copper or brass. Yet even today one cannot but admire the Old Master drawings executed in these media for their refined, sophisticated and gracious character. Lead point, popular namely in the 15th and 16th -centuries, was used for the preliminary sketches of drawings in pen, brush, red or black chalk. Unlike other metal points like silver, which requires a prepared ground, lead will mark untreated paper easily. The medium was revived for a short time at the end of the 18th century for miniature drawing for which it was ideal due to its perfectly thin, hard drawing point, but today lead as a drawing medium is practically unheard of. The most common narrow-point media in use today are graphite and pencils, and more recently, fibre-tipped and ball-point pens.

One of the oldest reports (in 1599) on the advantage of the then new drawing medium comes from the pen of Francesco Imparato: 'It (graphite) is to be preferred to all other media used for preliminary sketching; if used cautiously and wisely, it may be easily erased, yet if erasure is not desired, it adheres well to the paper.'

It is not known where graphite was used first. Some scholars think that it was Spain or England, others that it was Belgium. The term *plumbum hispanicum* would perhaps point at a Spanish origin. The graphite stick — confusingly called a 'lead' — appeared only after 1790 when the French inventor Nicolas-Jacques Conté developed a process which facilitated the use of graphite and clay mixtures as a drawing and writing medium. Graphite completely replaced both lead- and silver-point tools.

Graphite is made from a natural product, a kind of crystalline carbon which is mixed with other materials. It is marketed in thin rods in the form of wooden pencils, or uncased as 'leads' for use in mechanical propelling and clutch pencils. Pencils, respectively graphite leads, are graded according to hardness or softness, described by numerals and letters (H means hard; B — black). They range from the softest 8B to B, HB and F; the harder pencils (from H to 9F) are chiefly for technical drawing. Top-quality graphite leads are not jet black but rather dark grey and the mark they make, especially if some pressure is used, is rich and glossy. Hard pencils leave a more glossy mark.

Pencil drawings are best done on white, well-sized papers. Pencils do not have a great range and are therefore best suited for smaller formats. A life-size head is probably too large for pencil. Generally speaking, the medium is characterized by its great diversity; it is suitable both for rapid sketches as well as for highly detailed, precise work.

Pencil drawings created as finished works of art first appeared as late as the last decades of the 18th century in France and Germany. Jean Auguste Dominique Ingres developed a new type of pencil drawing of a truly modern character. The French miniaturist

87
Pieter van der Weyden (1437?—1514)
The Kneeling Mary
Silver point and chalk, 224 × 159 mm
Schlossmuseum, Weimar

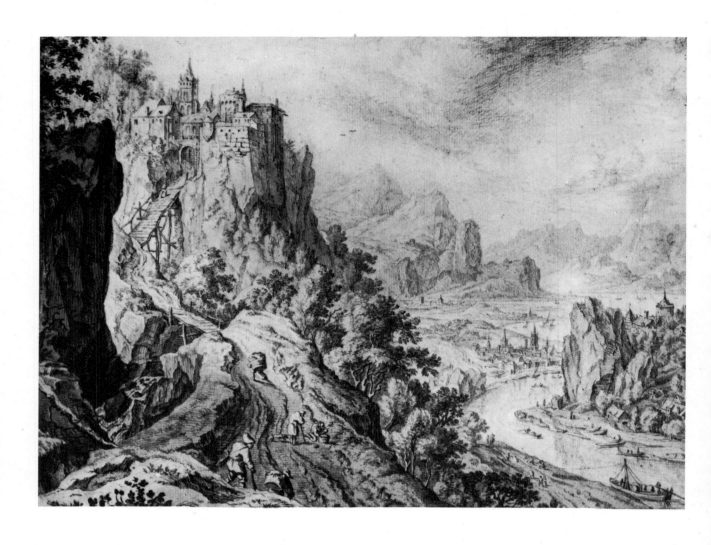

88
Herman Saftleven (1609—1685)
Rocky Landscape with a Castle
Pencil and grey wash, 330 × 440 mm
Graphic Art Collection, National Gallery, Prague

Jean-Baptiste Isabey and the German artists who formed the Brotherhood of St Luke, the basis of the Nazarenes, were also working at this time.

Here should be mentioned yet another method of graphite usage that was originally developed in France, known as *manière à l'estampe*. The method, which rejected the linear approach to drawing, was adopted by Gustave Doré for some of his outstanding illustrative cartoons. Doré scooped up graphite powder on a stump and worked to subdue contours and build up tonal values. The so-called *Graphit-Malerei* went even further to use a palette and soft brushes with graphite powder. For deep shadows the pith from frozen twigs of the elder tree were used to produce airy or opaque graphite tones.

Soft pencils will smudge easily so the drawing must be therefore fixed. The best is a casein fixative although a spirit-based shellac fixative can be used effectively.

For the draughtsman, pencils are one of the most useful and most popular tools. They are particularly suitable for quick sketches of a model in action.

For fine, even linear life drawings it is better to use a harder pencil which produces lines of uniform thickness and tonal intensity. Soft pencils are quite sensitive to variations in pressure and the line is characterized by uneven width and tone.

But even the softest pencils, such as a 6B

89
Jean Auguste Dominique Ingres (1780—1867)
The Forestier Family
Pencil, 233 × 319 mm
Cabinet des Dessins, Louvre, Paris

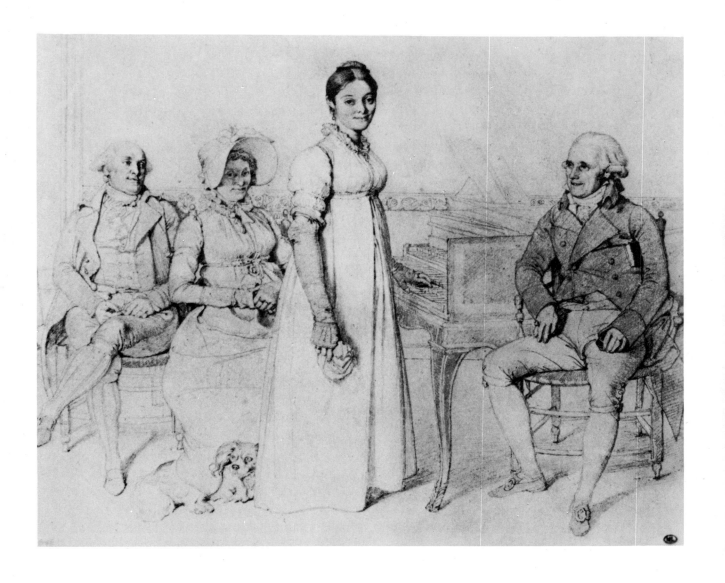

may be used for linear work if a constant pressure is applied. The pencil will almost incise a thick black line into the paper. In this case the pencil should not be sharpened but used with a round, naturally worn point. Such drawings permit practically no correction and the result will be of an *alla prima* (the first stroke holds) character.

There are numerous brands of fibre-tipped pens. They are equipped with felt or nylon tips and filled with transparent, highly volatile, instantly drying inks. Some are available with interchangeable tips of various profiles. They provide an instant medium, useful for graphic work.

The first fibre-tipped pens came in black only, but later manufacturers started marketing the entire rainbow of colours. However, attractive as the medium is, one should always remember, its major shortcoming — the inks are not colourfast and even indirect light will fade them in a relatively short period of time and the colour will often change completely. Despite this drawback, the medium is a sheer joy to work with. Black fibre tips tend to be more colourfast than other colours, but even the black ink will turn 'rusty' in time.

Another considerable disadvantage is that the fibre tips turn fluffy quite rapidly, they

90
Josef Šíma (1891—1971)
A Plain in the Brie, 1938
Pencil, 317 × 478 mm
Graphic Art Collection, National Gallery, Prague

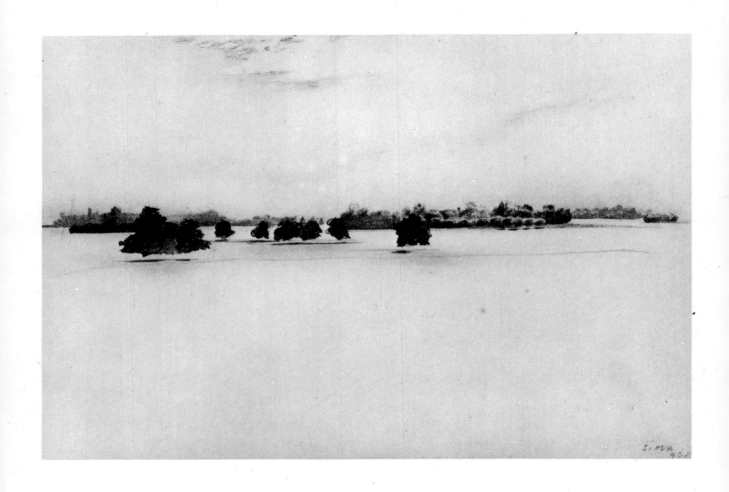

91
Moritz von Schwind (1804—1871)
Marsh Landscape
Pencil, 122 × 240 mm
Graphic Art Collection, National Gallery, Prague

lose their sharpness and rigidity and one must accept the fact that the trace will turn progressively wider and change its character, unless it is replaced.

Although the medium has been characterized here as having a full, regular line, it can also be used to advantage for light sketches and its full tone can be reduced to a half or a quarter of its intensity. This method often produces excellent results, but its speciality lies in its rich, thick line which only occasionally — due to the short life of the tip — loses its full force and turns somewhat grey and thus introduces a more lyrical note to the drawing.

The medium offers no possibility for correction. If the line is retouched with process white, the ink will ultimately penetrate even

92
Josef Mánes (1820—1871)
Caroline O'Hegerty, 1856
Pencil and white paint, 306 × 292 mm
Graphic Art Collection, National Gallery, Prague

93 *(opposite)*
Alfons Mucha (1860—1939)
Woman with Flowers, 1930
Pen and coloured inks, 421 × 290 mm
Graphic Art Collection, National Gallery, Prague

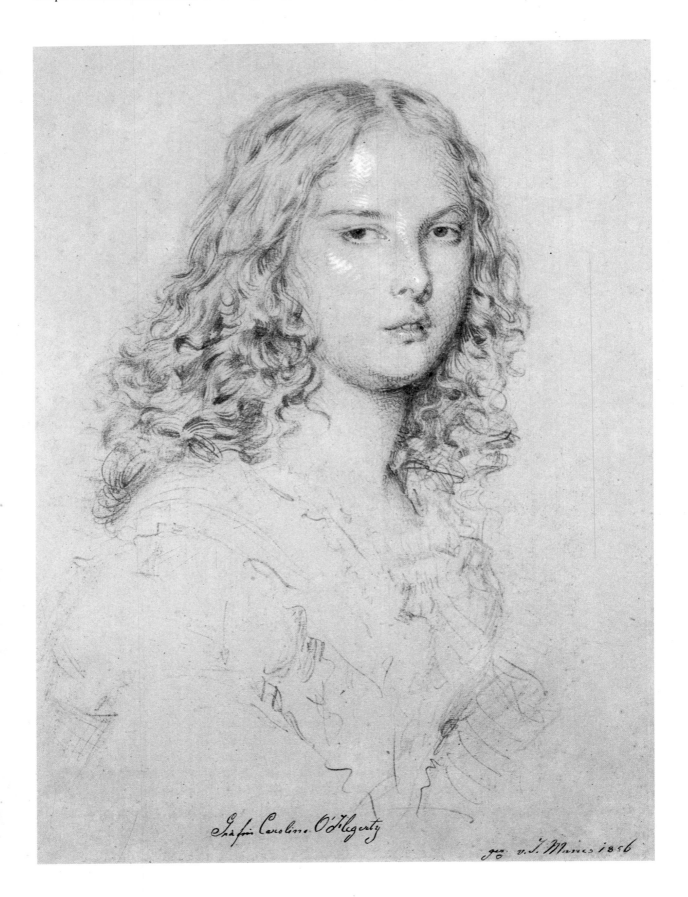

Gräfin Caroline O'Hegerty

ges v. J. Mánes 1856

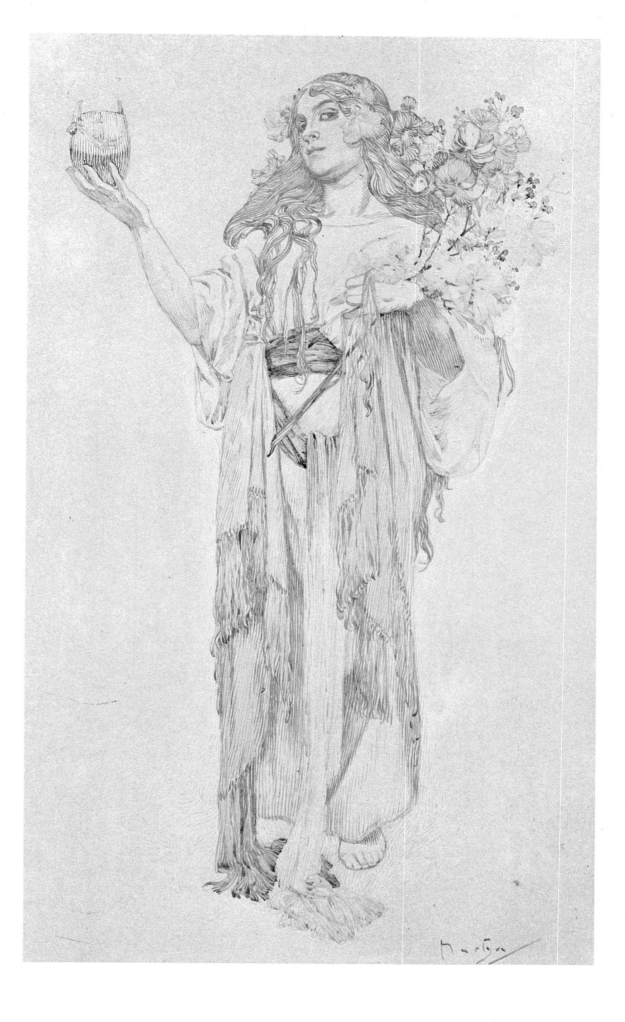

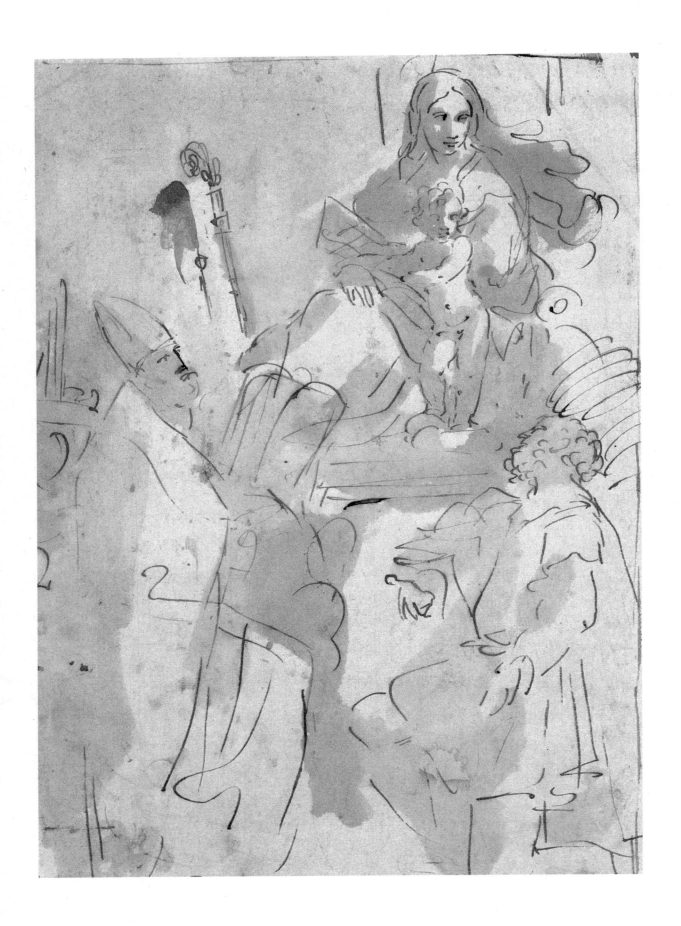

through a thick layer of the white paint once it has dried.

Fibre tips are used to best advantage on calendered (or coated) papers or thicker coated cardboard. It is also possible to use thin papers but one must be prepared that the ink will show through; in fact the image on the reverse side could be used as the final drawing. Fibre-tipped pens can be used to advantage in this way although it must be stressed here that the success is more or less a matter of chance.

Fibre tips are cleaned with special liquid cleansers. To remain soft, the tips should be immersed in petroleum spirit.

This medium can be combined with pen-and-ink drawings. The result is an interesting counterpoint of the soft, thick fibre-tip line and the sharp, exact pen drawing, yet it is interesting to note that even from a short distance it is difficult to tell that the drawing is in two different inks.

Drawing with a fibre-tipped pen requires a certain degree of simplification and stylization. Children are quick to see the immediacy of this medium, and their spontaneous gestures can serve as an example of how the fibre-tipped pen is used best.

95
Zdeněk Seydl (1916—1979)
One-Stroke Savonarola, 1970
Fibre-tipped pen, 420 × 298 mm
Graphic Art Collection, National Gallery, Prague

94 *(opposite)*
Andrea Ansaldo (1584—1638)
Madonna with Saints
Bistre wash, 283 × 194 mm
Graphic Art Collection, National Gallery, Prague

96
Zdeněk Seydl (1916—1979)
Chinese Actor, 1956
Fibre-tiped pen and coloured pencils, 287 × 211 mm
Graphic Art Collection, National Gallery, Prague

The ball-point pen line has a constant width, but variation in the pressure applied will alter the tone. A sensitive use of the medium will enhance the quality of line, lend it vibrant resonance in heavy angular lines, or melody in the light, ghostly lines that can be obtained. It is primarily a linear tool, but with skill can be used to suggest tone.

Ball-point pens are generally available in black, blue, red and green. Black is most suitable for drawing purposes. The ink is not ac-tually black but rather dark grey, with purplish or violet overtones which become more apparent with time. The more expensive, spring-loaded refill pens are better to use than the throw-away variety since they are better balanced and easier to grip.

This medium demands a more ornamental approach to the subject, or an aerial interpretation with a bold, unhesitating stroke. There is no room for correction and incorrect lines must be left as they are, next to the definitive ones; this will only serve to enhance the inner tension of the piece.

Ball-point pens can be used on thinner, smooth papers, such as writing paper. The ground may be also coloured: a black drawing on pink paper or blue on a paler blue paper can be very effective.

The main disadvantage of ball-point pen is one of colourfastness. As with fibre-tipped pens, drawing done in this medium will fade badly in a short space of time if exposed to direct sunlight.

97
Miroslav Štěpánek (born 1923)
Landscape
Ball-point pen, 100 × 140 mm
Private Collection, Prague

Ink is essentially black soot or lamp black dissolved in distilled water. It has been a classical medium for writing, drawing, calligraphy, washes, technical drawing and other purposes ever since the early Chinese civilization.

One ancient formula says that the soot of burnt resin (colophony) or cherry pits must be mixed with a solution of gum water and blended well on a marble slab, and the paste then shaped into sticks.

These sticks were called *inchiostro della China* (Chinese ink) in Italy. They were produced according to various formulas and were square and about as long as a finger. Before use they had to be rubbed on an ink-stone with water. The dissolved ink was then used for writing and drawing. Some artists simply washed the required amount of the black pigment from the solid stick with a wet brush with which they then drew directly on to paper.

Ink originated from China and still today high-quality ink is imported from China in the form of rectangular sticks embellished with gold ornament and calligraphy. This fine, expensive ink has been produced since time immemorial by the ancient method of burning of tung oil. It is used primarily for calligraphy and brush drawing.

Liquid ink is prepared from solid sticks of Chinese ink by grinding it on ground glass, in a porcelain bowl with a rough surface, or on a water-resistant emery cloth placed in a shallow bowl. The stick is rubbed against the surface with a little distilled, or boiled water until the desired amount of liquid ink is obtained.

Depending on the amount of time taken to grind the ink, it will vary in tone from black to cool grey. It has an almost bluish overtone and is non-waterproof. Other types of Chinese inks have a brownish tone and may be truly permanent.

Bottled ink needs no preparation. It is often referred to as Indian ink. It is pure black and permanent when dry. It is used both for artistic purposes as well as technical drawing and lettering. Ink for technical drawing pens can be bought in refill cartridges. Some ar-

98
Daniel Hopfer the Elder (circa 1470—1536)
Girl Wearing a Beret with a Peacock Feather
Pen, brush, ink and white paint, 433 × 320 mm
Graphische Sammlung Albertina, Vienna

tists prefer to dilute the ink to some extent with water for a better flow. If you use bottled ink, be sure to have a relatively large and heavy bottle which does not tip easily.

99
Bohumil Kubišta (1884—1918)
Portrait of a Man, circa 1918
Brush and ink, 317 × 246 mm
Graphic Art Collection, National Gallery, Prague

Bistre is a tinting or colouring medium produced from wood soot with an admixture of a brown mineral pigment, which gives it a warm brown hue. The original names of this tint in many languages seem to imply that originally it had been made from chimney soot. The term bistre is of a later origin which appeared in France in the 16th century. A catalogue from 1708 lists bistre among media commonly used for washes in the same way as Chinese ink or indigo. Bistre was also popular with the Baroque masters and between the 16th and 18th centuries it was actually used more widely than Chinese ink. In the early 19th century bistre was recommended mainly for miniatures for its force and effect in transparent layers and suitability in rendering the complexion of people's faces. This century saw the invention of a watercolour called bistre which was most commonly manufactured from soot produced by burnt beechwood. The soot was then pulverized, sifted and washed with cold water to remove all the impurities. The powder was then mixed with a small amount of gum solution, moulded and dried.

Bistre comes in different colours that range from pale, yellowish browns resembling saffron to dark, blackish browns. The actual colour depends on the burning process which in turn depends on the kind of wood used, and on the age of the soot (whether the soot comes from the top or the bottom layer of the sediment). The school of Rembrandt added a little red ochre to produce a warmer tone.

Sharp strokes with a pen or a brush wetted abundantly with bistre often show through the paper but the medium does not damage the pulp fibres.

In this century bistre is not commonly used but the bistre technique is well known from drawings of the Old Masters; its use was perfected by Rembrandt.

Bistre is best used for washes. Rembrandt used a thick pen or a brush wetted with bistre. The shadows and thick strokes have a beautiful deep brown tone which contrast with the untouched paper or with thin, transparent colour washes.

Hieronymus Bosch (circa 1450—1516)
Man-Tree
Pen and bistre, 277 × 211 mm
Graphische Sammlung Albertina, Vienna

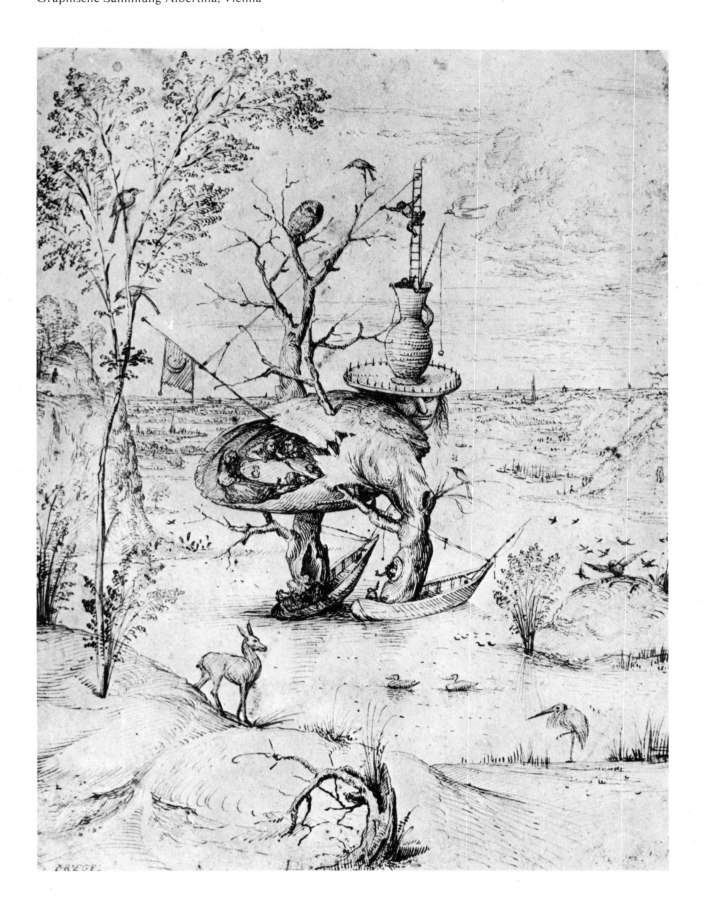

101
Martin Schongauer (circa 1450—1491)
Martyrdom of St Ursula and her Companions
Pen and bistre, in places finished by another hand
with black wash, 176 × 283 mm
Graphische Sammlung Albertina, Vienna

The term sepia is sometimes incorrectly used to encompass all brown drawing media. However, sepia proper appeared quite late in the history of art. What is called sepia today is in fact an invention of Professor I. C. Seydelmann of Dresden (1750—1829). During his stay in Rome in 1778, Seydelmann mixed the brown ink obtained from the sac of squids with bistre and developed a drawing medium perfectly suited to landscape studies of dark, mysterious atmospheric scenes.

In the early 19th century sepia washes came into fashion. In Germany, the technique was immediately appropriated both by professional and amateur artists alike, and catalogues of the period were literally flooded with popular works described as *Fleissig in Sepia.*

The period saw a great boom in the manufacture of sepia pigment sticks and since there were not enough squid sacs to meet the huge demand for sepia, it was often adulterated with Cassel earth (Van Dyck brown) or madder lake. Still later all wash techniques were often termed 'sepia manner' regardless of the medium used, whether ink, or bistre. The individual techniques are difficult to tell apart since the colour variations of both bistre and sepia are broad. But if the dating of a picture is beyond doubt, it can be said that no sepia drawings exist prior to the last quarter of the 18th century. As far as the later periods are concerned, bistre can be said generally to have a warmer brown tone (as if it contained some yellows or reds) while sepia is somewhat cooler.

Neutral Tint

A neutral tint can be made from a mixture of Prussian blue, scarlet lake and Chinese ink. These three basic colours — blue, red and black — produce a beautiful greyish violet tone which is truly neutral in character and perfect for washes. When undiluted it has a deep dark tone.

102
Willem Pietersz Buytewech (circa 1591—1624)
Street Vendor with a Dog
Pen and black wash, 164 × 104 mm
Graphic Art Collection, National Gallery, Prague

Pen drawing is a very demanding technique and the traditional pen drawing is still considered one of the most difficult disciplines, since the possibilities for corrections while working as well as on a finished piece are extremely limited.

Since the art of the early Christian period, pen drawing has occupied a very important position among other drawing techniques. The pen as a medium of a purely graphic character soon took over the function of the universal means for linear expression. The first pen drawing instruction manuals date from the time when drawing had acquired an independent existence as a genuine art discipline. Since pen drawing requires a sure hand, the manuals recommended that a preliminary sketch should first be made with lead point that could be erased with bread crumbs. Only after a whole year of this training were the students allowed to try pen drawing from preliminary charcoal sketches. At first they did simple figure studies or copied other works and only gradually progressed to compositions of their own. This system of preparatory studies that led to pen drawing proper could well be recommended today.

The first Italian pen drawings were still characterized by a very cautious form, uniform contours of the volumes and long, usually vertical, parallel hatchings used mainly to shade drapery. Some draughtsmen added the soft strokes of a thin, pointed brush to help the drawing. The transition between figures and their surroundings was not continuous and smooth; the pen-drawn figures often floated on empty paper.

The early Renaissance saw the rise of personalities who introduced greater differentiation into the development of pen drawing. Their figures become more monumental as a result of a bolder approach to the execution of the drawing. The contours are meticulously rendered in continuous lines, the silhouettes are modelled sensitively, with a great feeling, by means of airy, yet disciplined washes that observed the whole form. As a rule the finished drawing had to be firmly contoured and only unfinished works reveal any of the greater degree of freedom.

The Florentine artists, who were then opening new vistas in art, soon loosened the rigid wire-like contour line and replaced it with freer, softer pen strokes; they were not afraid to deviate from the contour and emphasize those lines which they regarded most important.

As the figure drawing was being gradually imbued with movement and life, the rigid contours became progressively looser and more liberal. Michelangelo, whose figures are literally animated with inner tension, started with sculpturally precise studies of modelled musculature shaded perfectly with cross-hatching, but in time he adopted a more abrupt, yet livelier contour that appeared to be drawn with less care.

Another step forward was the combination of delineating contours with angled hatching. The hatching which extends beyond the contour line in shaded areas, as seen in the work by Leonardo and Raphael, enriched pen drawing and gave it a capacity to render more effectively the luminous and plastic values.

The same development that liberated pen drawing from its former strict dependence on the contour line can also be observed outside Italy. The work of Dürer and van Dyck offers some of the most exquisite examples of these advanced techniques. However, the absolute and perhaps yet unsurpassed virtuosity in pen drawing was achieved by Rembrandt: his pen drawings combined with washes constitute the ultimate in the rendition of landscapes and street scenes as well as a profound philosophical comment on Man.

In the 18th century pen drawing was superseded by other techniques and unfortunately it is relatively neglected today. However, its beauty, grace and direct emotional appeal have always attracted the artist and the many pen drawings that belong to our heritage testify to the artistic genius of Man.

Two basic methods and purposes of pen drawing should be discussed briefly at the beginning. The first concerns the suitability of the pen for drawing from live models. It has been found particularly useful for quick studies of a nude model who changes her pose after short intervals. It is very handy for its rapid, smoothly flowing and even line. This means that the artist will aim to capture the linear quality of the pose and will not be concerned with defining illusive spacial differentiation.

The second concerns the suitability of the pen for drawing from preliminary sketches. It is very popular with illustrators, cartoonists and graphic designers, because pen drawings can be easily and cheaply reproduced by many of line-printing methods. However, it requires considerable skill and a clear concept. A pen illustration should be based on a preliminary rough pencil sketch. The drawing can be transferred by eye on to your final paper and then drawn in ink. A dramatic result can be achieved by maintaining a high contrast in the drawing. Juxtapose densely hatched areas with white, untouched ones, but allow the linear quality to dominate. If the three components are well proportioned, the drawing will retain the required balance. Tracing is a useful short cut but it is not recommended; it is a sure way to produce a flat, unsuccessful piece of work.

Objects should be shaded either along the form, or the volume of the form should be translated by means of parallel hatching. It is also possible to use cross-hatching or a third layer of hatching may intersect at yet another angle. This kind of hatching, if executed with bold and sufficiently continuous pen strokes, has a pleasant, earthy feeling and permits a rhythmic expression of form in terms of line. There are also pen drawings with the densely hatched areas shaded lightly with black chalk to fuse the hatchings and produce a more effective and perhaps even a mysterious contrast. Another type of hatching is short horizontal dashes laid parallel to each other or crossing each other, which gives an interesting linear system.

A beginner usually finds it very difficult to

set figures drawn with pen into an environment. The most common mistake is to congest the drawing with detail. You should always bear in mind that pen drawing is so easily congested and that as much untouched paper should be preserved as possible, because it is these white areas that allow the drawing to 'breathe'. A balance should always be maintained between the white and the marked areas in pen drawings.

The detailed technique facilitated by the use of pen does not lend itself to all subjects; portraiture from direct observation, for example. It would be better to draw from preparatory studies made in other media. The drawings of Max Švabinský must be mentioned here to illustrate the highly successful results that can be achieved with pen-drawn portraits.

Let us now digress to discuss briefly a spe-

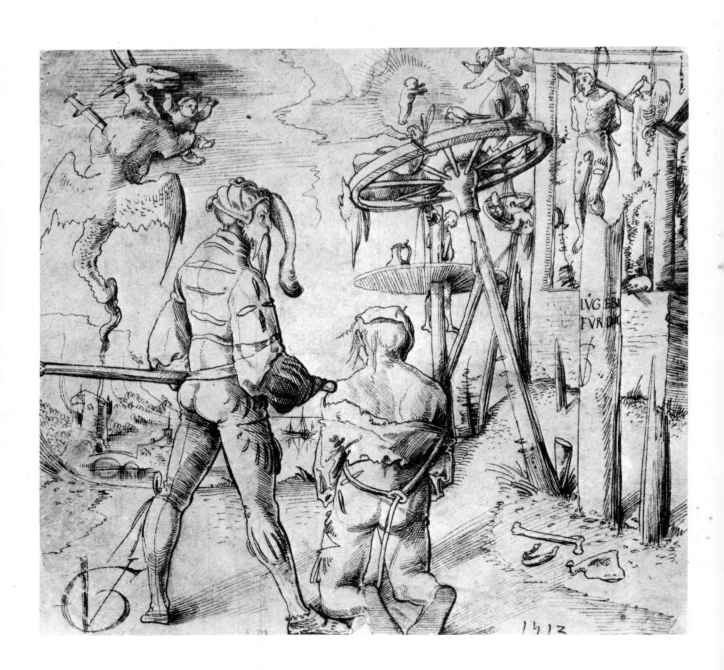

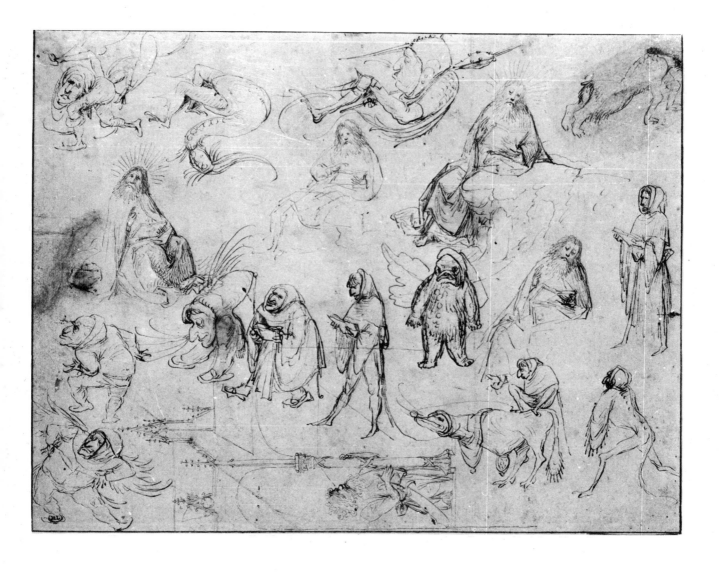

104
Hieronymus Bosch (circa 1450—1516)
Sheet with Various Studies
Pen and bistre, 207 × 263 mm
Cabinet des Dessins, Louvre, Paris

103 *(opposite)*
Urs Graf (circa 1485—1527/8)
Scaffold
Pen and black ink, 218 × 238 mm
Graphische Sammlung Albertina, Vienna

cific type of pen drawing which can be called truly academic, without any pejorative overtones. It is a technically very demanding pen drawing which observes primarily the luminous, chromatic and tonal values of the model or subject. It requires a virtuosity not incomparable to that of a musician. The artist renders his subject in a system of lines and hatchings that sensitively model the volumes. The intensity of the lines in transient areas between light and shade is so subtle that the lines fuse into a super-fine web. Only meticulous observation enables the draughtsman to capture the continuous transitions which requires the use of nibs of different sharpness and ink thinned to various dilutions for places

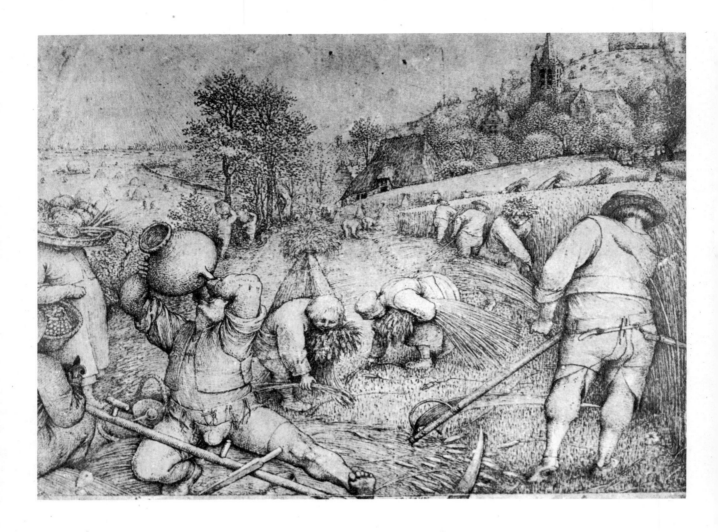

105
Pieter Bruegel the Elder (circa 1525—1569)
Summer, 1568
Pen and bistre, 250 × 285 mm
Kunsthalle, Hamburg

that are especially complex in values. Only this intricate technique will render truly the fine nuances of the transitions, will differentiate various materials and their textures, capture convincingly the dry silkiness of the hair, the lustre of the skin, or the moistness of the eye. Only this technique is capable of differentiating the glow of a lamp from that of a candle, or the texture of silk compared with wool and other fabrics. However, the method which has certain naturalist overtones is more or less a thing of the past because since the great advances of photography art has acquired other, more specific tasks than in previous periods when it also had to supply the needs that photography now fulfills.

The contribution of pen-drawing techniques to the modern *belles-lettres* and the

achievements in the field of engraving provided the impulse for the development of the stipple (or dot) technique, which is also easily reproduced by the photoprinting process. Inspiration can be found already in the Art Nouveau-style drawing of the famous English illustrator Aubrey Beardsley. Beardsley's work demonstrates the degree of stylization required for this distinct, specific technique. The volumes are built up by means of organized formations of delicate dots, and nuances of modelling (rather than shadows) are achieved by clusters of dots of varying density. All dots are of the same tonal intensity of black and they are distributed all over the paper with the same rhythm and urgency. They may form waves, spirals and other formations which may even go against the form and this will actually enhance the stylization as well as the decorative character of the piece. From this technique there is only a small step to ornamentation.

Now we should consider whether it is possible to make corrections to pen drawings. The possibilities are severely limited. Sometimes corrections can be made with a needle or scraped with a safety-razor blade; densely hatched areas can be scratched out to produce lines with a needle or blade. In this case the point of the needle is used with care to tear off the top layer of the paper that bears the marks. It can only be done on good, thick paper.

Pen drawings that will be printed can be corrected with process white. The spots to be corrected are simply covered with the paint. Process white may be also used to relieve a drawing that is too congested or clogged with excessive hatching. Even pen-drawn newspaper illustrations that have been excessively retouched with process white still feel fresh and appealing in print. On the other hand there can be no doubt that any greater degree of correction will considerably deteriorate the purity of a pen drawing.

Pen drawings combine well with transparent ink or watercolour washes. Pen may be also used to accentuate a drawing in brush and ink or a wash drawing. Pen drawing is an excellent preparation and training for genu-

ine engraving and etching techniques. It improves the firmness of the hand, the sureness of the eye and the ability to commit a positive statement to paper.

106
Bartolomeo Passarotti (1529—1592)
Devil
Pen and bistre, 338 × 233 mm
Moravian Gallery, Brno

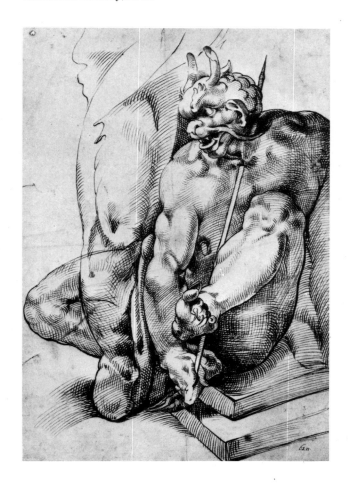

Everybody who tries drawing with a pen will sooner or later discover the mapping pen. Small, high-quality steel nibs with specially hardened points made in England (in Birmingham) and Germany are generally considered to be the best in the trade. These nibs are springy, they last well and do not tear the paper. They also do not trap too much paper fibre which can hamper the work. They produce a hair-thin line which will produce a uniform line if pressure is applied evenly.

For most work it is better to use these nibs when they are well worn. If used for some time they become soft and give a full, continuous and succulent line; they remain loaded for a longer time and therefore do not have to be dipped in ink so often. This in turn increases their range so that they permit drawings of a somewhat larger format. Brand new nibs are too hard, do not run as smoothly and their trace is unpleasantly sharp and scratchy. A new nib should be burnt momentarily over a flame to remove the protective coating, thoroughly washed with water and broken in.

Linear drawings can be also done with steel, edged pens of smaller sizes. These pens with straight or obliquely cut points are normally used for lettering. Needless to say, pens should be kept clean and ink or wash must be never allowed to dry on them. If the nib becomes caked it should be scraped clean with a safety-razor blade and thoroughly rinsed and dried.

Pen drawings require top-quality, well-sized papers. Quality papers are not prone to incisions, the nib does not catch the surface and the lines are not blurred; the best papers are naturally handmade. However, if it serves your artistic purpose you can also use papers that will produce blurred images. Generally speaking, the paper grain should be fine enough to permit continuous flowing lines although excessively smooth, glazed papers are not too good for pen drawings because the nib will slide over the surface: the best is a grain that the nib can grip.

From the 6th century reed pens and goose quills were often used for writing and calligraphy. Due to their fine touch their use soon spread to the artist's workshop. Later reed pens were superseded by other media such as silver and lead point.

Some scholars are of the opinion that the reed pen was revived as late as the time of the Age of Humanism. Evidence can be found in the portrait of Erasmus by Hans Holbein the Younger, where the great scholar is seen writing on a piece of paper with a reed pen. Nevertheless, it is quite certain that the use of the reed in Italy and particularly in the Netherlands superseded that of the quill only when steel pen drawing had deteriorated to a sterile academic virtuosity. This is quite understandable since both the quill and the reed are very pliable, soft tools capable of translating the draughtsman's imagination on to paper in a unique manner.

Exquisite examples of reed drawing techniques may be seen in the many beautiful drawings by Rembrandt (who also made use of the quill). A treasury of reed drawings has been left by Vincent van Gogh. It is quite possible that the unique, characteristic style of van Gogh's oil paintings — the short, daubing strokes with the brush — has its origin in the short dashes of his reed drawings.

You can make your own reed pens by cutting reed stalks of different thickness, ranging from 3—15 mm ($^1/_8$ — $^1/_2$ in) into lengths of about 20 cm (8 in). Using a sharp knife or a safety-razor blade cut the end to form a tip; thicker reeds may be also split in the centre of the tip to hold the ink better. The stick can be sharpened at both ends to double its use. Never let the ink dry on the tip of the reed — always wipe it clean immediately because a reed encrusted with dried ink will not work well when it is next used. Remember that both wood and reed not only transfer ink but also absorb it.

Reed pens are nice to hold because they are quite light. They produce uniform lines, yet still permit fine variation. The tool is suitable for almost all kinds of drawings from nature and can be used on practically any

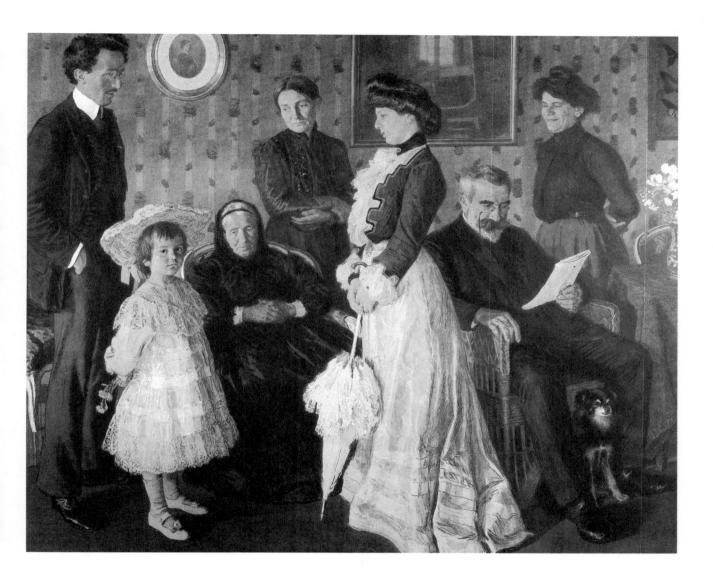

107
Max Švabinský (1873—1962)
Large Family Portrait, 1905
Pen, ink and watercolour, 182 × 206 mm
Graphic Art Collection, National Gallery, Prague

paper. It is not as successful when used with a wash.

Similar results can be obtained with a stick of wood or even a tip of a brush handle cut at the end to form a point. The only limitation is that the wood should not be allowed to become soggy or frayed.

From the 12th century one of the most common and popular writing and drawing implements was a quill, taken from the flight feathers of various fowl. Quills can be often seen depicted in illuminated medieval manuscripts. The Evangelists were often depicted holding a quill with some barbs left at the top of the shaft of the feather. Medieval scribes

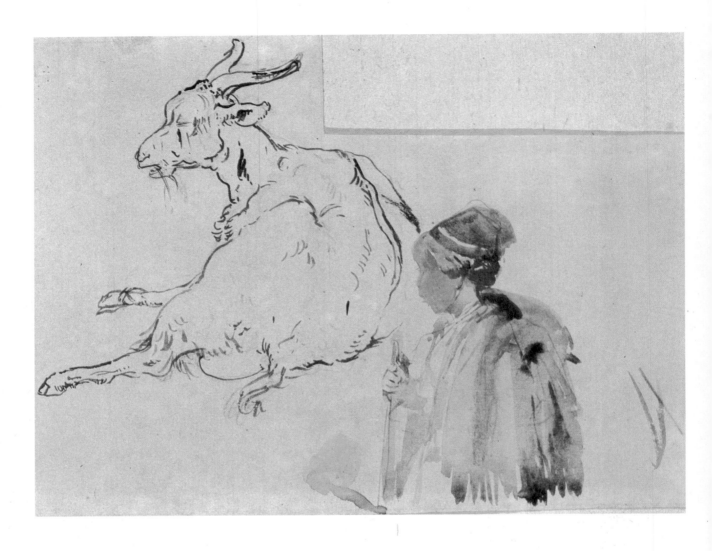

and artists used to carry a horn receptacle with a lid on their left hip to hold their quills, while an inkhorn was used for ink or colour. This kit accompanied them on all their travels.

Like the reed, the quill is also sharpened with a penknife or a blade; however, a finer blade should be used and the cut should have a shallower slant than a reed, which gives less resistance. The width can be adjusted by shaving the edge of the quill or by using it at a different angle. The line can be highly variable: it can be both succulent and overflowing as well as dry and thin. The quill is excellent for imaginative drawing, for impulsive sketches of landscapes and figures as well as for more detailed work. It is very effective when combined with washes.

108
Josef Navrátil (1798—1865)
Shepherd Girl with a Goat
Pencil, pen, sepia and watercolour, 134 × 185 mm
Graphic Art Collection, National Gallery, Prague

109 *(opposite)*
Mikoláš Aleš (1852—1913)
St George, 1878
Pen, ink and pencil with wash, 383 × 257 mm
Graphic Art Collection, National Gallery, Prague

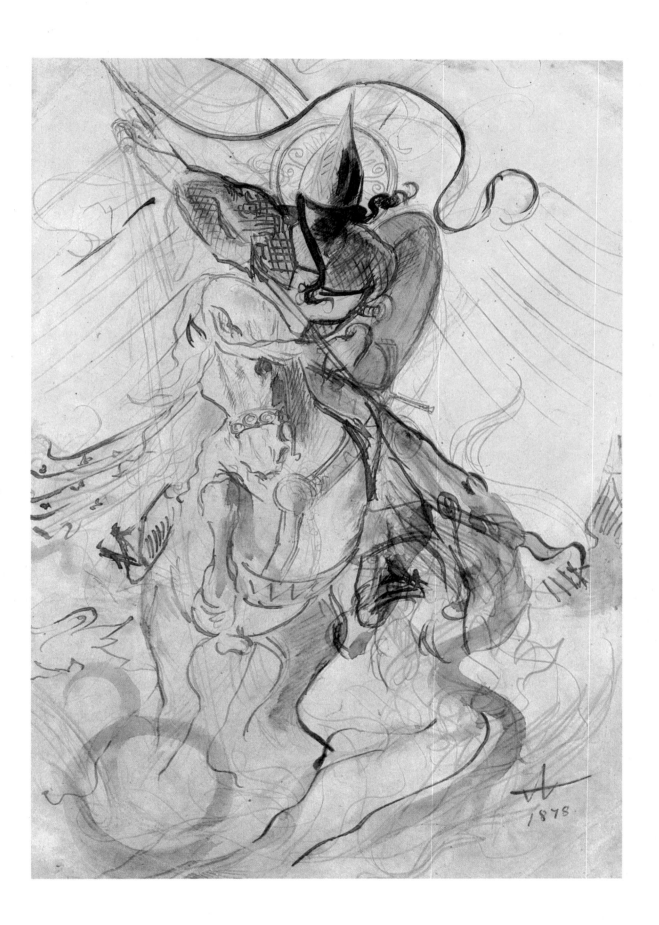

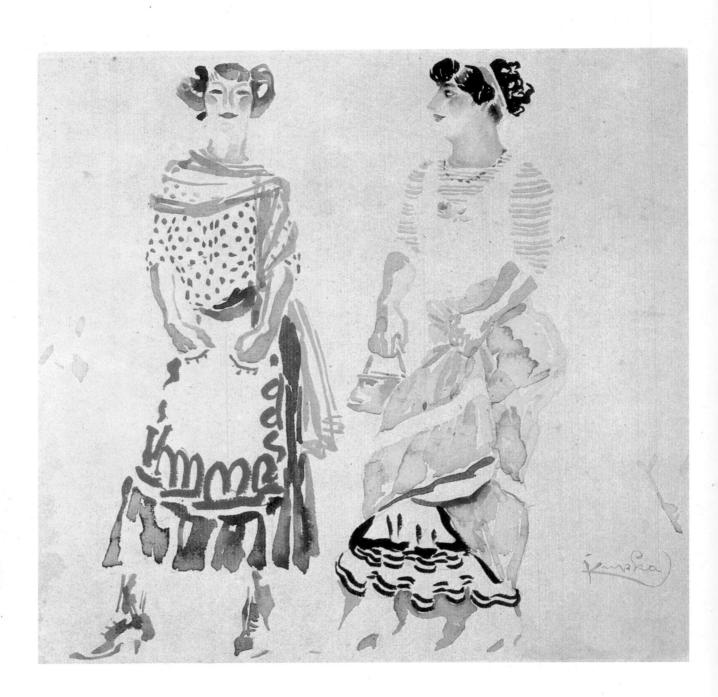

110
František Kupka (1871—1957)
Zusza and Villete
Watercolour, 250 × 280 mm
Graphic Art Collection, National Gallery, Prague

111
Adam Elsheimer (1578—1610)
Tobias Accompanied by an Angel
Quill and bistre wash, 223 × 200 mm
Städelsches Kunstinstitut und Städtische Galerie,
Frankfurt am Main

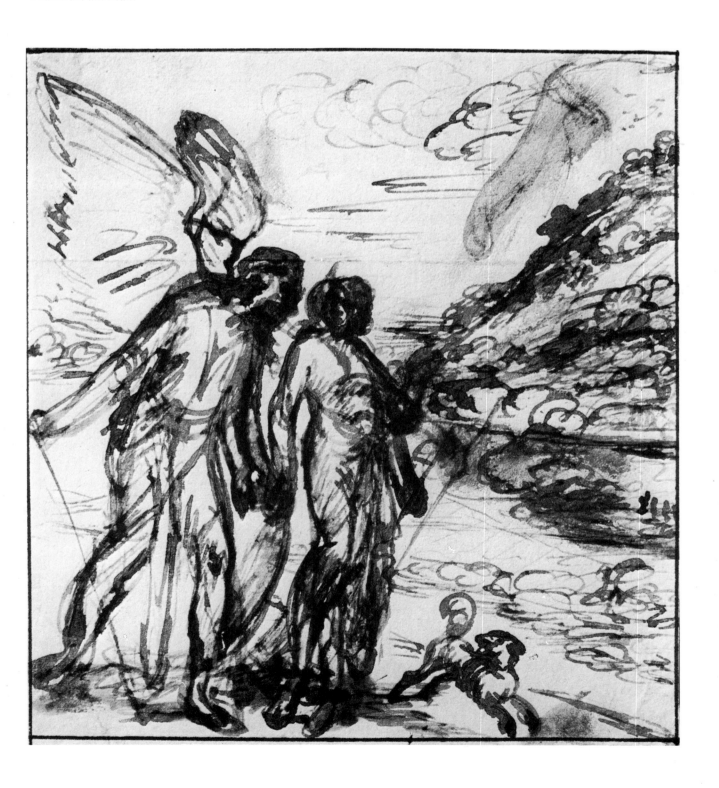

Washes can be used to supplement all drawing techniques discussed so far, especially those of a more linear character which, when combined with wash, can be said to truly constitute a genuine wash drawing. Wash is commonly used in conjunction with pen drawings. It can produce a variety of results. Sometimes it is used to achieve a simple, pale toning of the shadow; in other cases the brush works out details in the dark shades; it can also give the drawing new chromatic and luminous qualities.

The technique is highly diversified and offers many possibilities for composition

113 *(opposite)*
Eugène Delacroix (1798—1863)
St Sebastian Nursed by Pious Women
Pen and bistre, 278 × 440 mm
Szépmüvészeti Museum, Budapest

112
Guercino (Giovanni Francesco Barbieri; 1591—1666)
Dragon Observed by Spectators Behind a Wall
Pen and brown ink, 181 × 155 mm
National Gallery of Scotland, Edinburgh

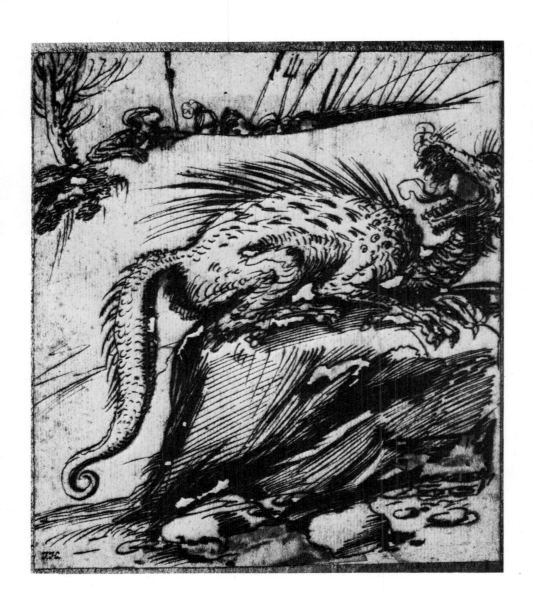

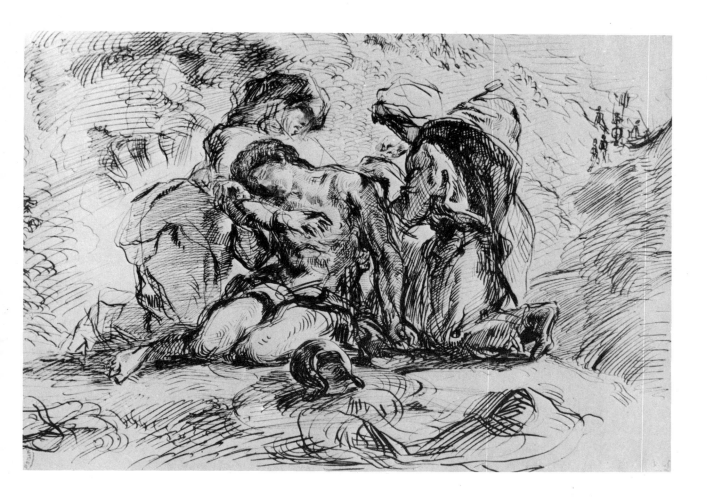

build-up, for the interpretation of the scenery, for the rendering of the atmosphere of the sky or any mood of a landscape or interior, and for the transcription of the forms of the figure. It is a technique that is known to be related to many a work of art because it is one of the most direct and relatively rapid means of capturing an instant reaction to an inspiration or stimulus, which can translate the message or idea of a work conceived originally to be in a different final medium.

From the Middle Ages, papers were prepared for washes by sizing with glue or alum. A formula from 1745 recommends either white glue (boiled or dissolved in rain-water) or fish glue. The paper sheet was either lightly sponged with the size or it was drawn through a glue bath.

Artists started using washes to achieve a greater credibility and freshness for their drawings, finishing the basic linear drawing with luminous or chromatic modelling. Their tool was a wet brush which was either dipped in a thinly diluted transparent colour or into pure water and then brushed over the soluble pigment of the drawing. The attractiveness of a wash drawing may be also enhanced by repeated strokes with a wet brush over places, either dry or still wet, that have been already toned.

Much advice on the technique will be found in Cennino Cennini's famous treatise on painting (1437): 'Using a very thin water-colour (two drops of tint per nutshell of water) wipe repeatedly the desired place but be careful not to produce sharp, caked borders. Very slowly, drop after drop, add more tint. When working with prepared papers, first

squeeze the brush a little to make it semi-dry in order not to damage the lower layer. Continue working in this manner until you produce shadows resembling light, drifting smoke, or haze.' Similar advice can be found also in German and Dutch literature of the same period.

In drawing a portrait, the wash process is concentrated on building the lights and the shadows and their play on the face. In nude studies, the brush works out the individual details within clean contours by means of compact modelling. During the Renaissance the straight-edged brush was replaced by a pointed one. The meticulous execution of the transition from the medium tones to the highlights becomes gradually diffused, the individual brush strokes becoming more independent and confident. The plastic values become more respected and finally the character of the brush becomes more freely accentuated.

Among the Italians, Guercino (1591-1666) was the great master of wash drawing. However, the technique was developed to an unsurpassed perfection by Rembrandt. The free spirit with which he succeeded in laying the wash in the 'correct' place and the way in which he graduated the saturation of the wet area is still unique and inimitable. In Rembrandt's circle grew a large number of artists whose wash drawings rank among the ultimate achievements in the discipline. Rembrandt's mastery is almost equalled by Claude Lorrain, the 17th-century French classicist. Like Rembrandt, Lorrain first quickly sketched a loose outline of the landscape with a pen and then laid a wash. During the Baroque period wash drawings remained very popular for their luminous qualities. The 19th century also saw the use of the wash as a means of modelling rather than of expression. For all the qualities mentioned, wash has remained a vigorous technique which is still widely used today.

The skill of the wash technique lies in the correct estimation of light flooding the subject. The established values must be then translated by the means of varying dilutions of one colour with water to the desired thinness. Since the values are richly gradated,

114
Felice Gianni (circa 1760—1823)
Study of Two Dogs
Bistre wash, 283 × 201 mm
Graphic Art Collection, National Gallery, Prague

a lot will depend on precise observation and a meticulous comparison of the nuances observed in the subject and, more important, on the paper. One should therefore work very cautiously and increase the intensity of the tone only after thorough deliberation. The whole work should be kept in pale, minutely graduated tones that depart from the tone of the paper as little as possible.

Generally, the most exciting wash drawings are those which have only a very basic, merely suggested sketch, while the main formal idea of the whole drawing is emphasized with more definite strokes as the work is being finished. This result will be jeopardized by an excessive, heavy-handed application of the wash: remember that the technique should always retain a very fresh, open and direct spirit.

The earth colours are most suitable for washes. Ink and watercolour can be used over drawings made in pencil, pen and ink, and with care over crayons, chalks and charcoal if a smudged effect is required.

It is useful to prepare dark and light washes in two separate bowls or palettes. This will keep a clear distinction between the values on the tonal scale and subtle variations of a particular tone will be kept in the correct range.

Wash is characteristically an additive technique, so start very carefully with the palest, most transparent tones, then gradually build up the layers of wash to increase the intensity. Remember that it is very difficult (and not recommended) to wash off the tones. The luminous effect and the velvety depths of darkness and shadows are achieved by repeated laying of a darker, but always transparent tone in subsequent layers. The underlying layer must be allowed to dry fully before the next layer is laid.

One of the greatest dangers in wash drawing is that the artist, completely absorbed in his work, is carried away and is not able to estimate when to stop and the picture will become overworked. Keep this in mind and stop while there is time! An insensitive final touch to the details is also risky and may lose the desired fresh effect. You should therefore

115
Josef Redelmayer (1721—1788)
Two Dragons
Pen and bistre wash, 226 × 195 mm
Graphic Art Collection, National Gallery, Prague

only hint at detail, preserve the highlights and let the tone of the paper shine through the wash, or the result will not be pleasing. If your finished drawing looks a bit hard, spray the entire surface very lightly with clean water using a spray diffuser: the water will slightly dissolve and blur the edges of the wash to give the drawing a softer appearance.

If you do not do a preliminary drawing in pen or pencil, it is advisable to do a very transparent drawing first with a thin, long-haired brush, then to lay on the broad, transparent washes starting from a light to a medium tone to define lights and shadows. Detail must be added last.

Drawing with wash offers limitless possibilities. For instance, it is possible to draw on wet paper with a semi-full brush to produce

116
Jacopo Palma (called Palma il Giovane; 1544—1628)
Christ Ascending
Pen and bistre wash, 159 × 157 mm
Moravian Gallery, Brno

117 *(opposite)*
Tadeo Zuccaro (1529—1566)
Ilustration from Aesop's Fables
Pen and bistre wash, 210 × 319 mm
Graphic Art Collection, National Gallery, Prague

a softly blurred line. However, you should always observe the inherent characteristics of the technique: it should be apparent in the work how the tinted water actually flooded the paper in a flowing wash. If possible, the brush strokes should be made in a downward direction.

To keep a part of the drawing the colour of the paper draw with a piece of white candle or wax crayon. The wax will repel the wash to leave a negative shape.

If you are willing to trust chance, you can wash your finished drawing under running water, particularly if you are not too happy about the result. Once the drawing becomes semi-dry again, you can use the washed-out effect as a new starting point and continue

working. Some places can be dried with blotting paper to give them a more faded, patchy appearance, or the wet surface can be sprinkled with finely crushed charcoal powder. With judicious use this may give your wash drawing a truly unique atmosphere. However, you should always bear in mind that any wash drawing will lose some of its freshness when it dries and the tones will lose their wet gloss. Allow the drying process to finalize the intended effect and do not labour the drawing or it will lose its lustre and become harsh in tone.

A wash drawing will reveal the rapidity and the rhythm of the artist's work so it is necessary to work cautiously and yet with a harmonious rhythm that corresponds to

118
Giorgio Vasari (1511 — 1574)
Hera
Pen and bistre wash, 530 × 540 mm
Moravian Gallery, Brno

your temperament. Only in this way will you achieve the desired effect.

The linear drawing should be the intermediary between the wash and the paper to convey the main source of action and inner tension. This is easier to maintain if you are using a pen, reed or quill, but if you use a brush, be sure that the entire washed drawing does not become subjected to a generalized shaded modelling. The contours, whether of the face, hands and feet or of architectural boundaries, should be sharply and concisely emphasized primarily in terms of line which forms a basis for further description with areas of wash.

Selecting paper for a wash drawing

Handmade paper is best to use, but it is

expensive; good quality mould-made and ma-
chine-made papers (which are cheaper) can
also be used. Ingres and other laid papers
give an interesting texture to the washed sur-
faces. When selecting a watercolour paper
the most suitable surface for this kind of
work is 'not' surface which has a slight tex-
ture but is not too rough. The paper must be
stretched or it will warp when the washes
dry.

It can be interesting to make use of old
scraps of paper for this type of work. Blank
pages from old books, reverse sides of old
documents or old writing paper can be tried

119
Luca Cambiaso (1527—1585)
Apollo and Daphne
Pen and bistre wash, 155 × 127 mm
Moravian Gallery, Brno

Esaias van de Velde (circa 1591—1630)
River Landscape with a Windmill
Pen and grey wash, 174 × 292 mm
Graphic Art Collection, National Gallery, Prague

out if you want to give your drawing an old-fashioned, antiquated character. These old papers will probably have yellowed with age and may even have rusty spots which show through in the work. However, if stored in the right conditions, high-quality artist's papers will store well and may even improve with age.

Brushes

Generally speaking, the best are those used for watercolour painting: sable, squirrel hair or ox-ear hair (or mixture of these) fixed on a wooden lacquered handle by a metal ferrule. The top quality brushes come from the Far East, where the tradition of exquisite, refined art of ink drawing originated.

Chinese brushes are set differently from European-made ones: the longest hairs are placed around the circumference on the tuft so that the tips close concentrically, which makes a better point than European brushes in which the longest hairs are located in the centre. Chinese brushes form a perfect point, take up a large load of liquid and make a very precise mark. These brushes have bamboo handles with a looped silk cord at the end so that the washed and cleaned brush can be suspended to dry with the tip pointing down. Brand new Chinese brushes are sold with the tip glued together with a weak glue, gum arabic or some other mild adhesive. The tip is rigid and the hairs cannot be parted. The glue is removed under running water and the excess water absorbed with a piece of rag. Shake the brush to form a point and start working.

All brushes must be thoroughly cleaned after use, especially if ink is used. The best way is to wash them in tepid water with soap. Build up a lather in the palm of one hand and rub the brush in it, then rinse the brush well under running water until it is perfectly clean and free of any soap residue. Stand brushes in a pot or jar, with the bristles uppermost.

121
Claude Lorrain (1600—1682)
Landscape with Three Trees
Brush and bistre wash, 139 × 250 mm
Musée Condé, Chantilly

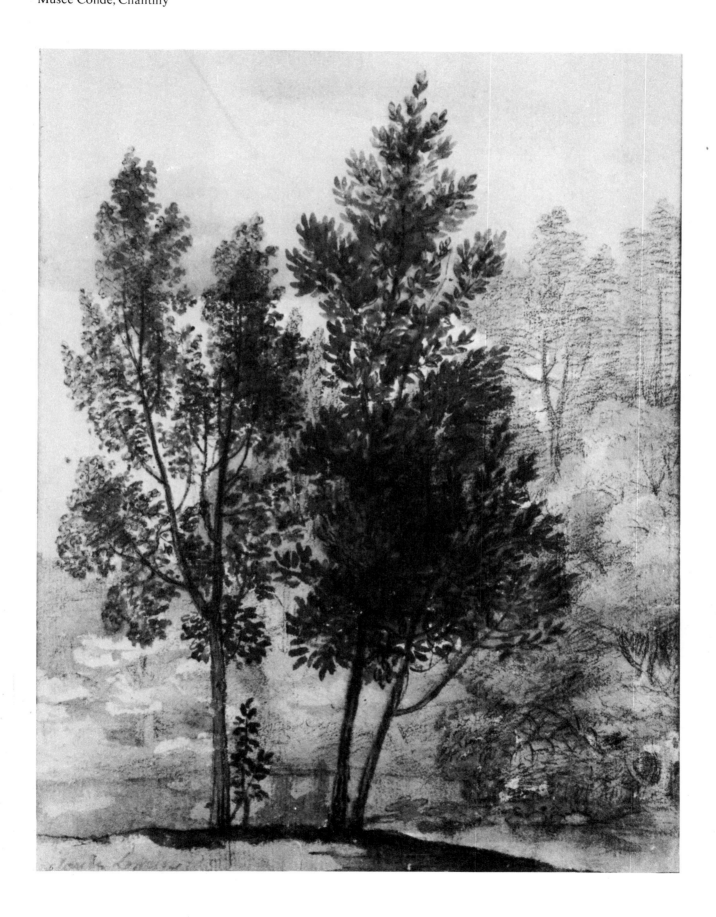

Brush
Drawings

Like other techniques, brush drawing has also undergone a development that has ultimately led to greater freedom and which uses all its specific qualities. The historical development progressed from austere, meticulous drawing with a semi-dry straight-edged brush to a more rapid, free expression employing a pointed brush fully saturated with ink. The development naturally reflected changes in the message of the drawing. The free character of brush drawing gradually spread from Italy northwards where it found much popularity. The evolution of brush drawing as a technique was closely associated with the development in painting, since of all drawing techniques brush drawing is closest to painting due to the fact that it uses the same tool and is based essentially on the rendering of the luminous and spatial properties of the subject.

Today, Chinese brushes can be used for brush drawing. It is always better to use a thicker brush because even a brush of a considerable thickness will form a good point producing sufficiently thin lines. A brush well-loaded with ink may be used for a linear style to produce soft, resilient outlines of uniform thickness. But it is also possible to use a semi-dry brush so that the ink or wash will adhere mostly to the minute ridges of rougher papers to give a mottled

122
Felice Gianni (circa 1760—1823)
St Theresa
Brush and bistre, with a preliminary pencil sketch, 238 × 201 mm
Graphic Art Collection, National Gallery, Prague

Rembrandt Harmensz van Rijn (1606—1669)
Saskia at her Toilet, circa 1632—34
Wash drawing in bistre with pen and brush,
238 × 184 mm
Graphische Sammlung Albertina, Vienna

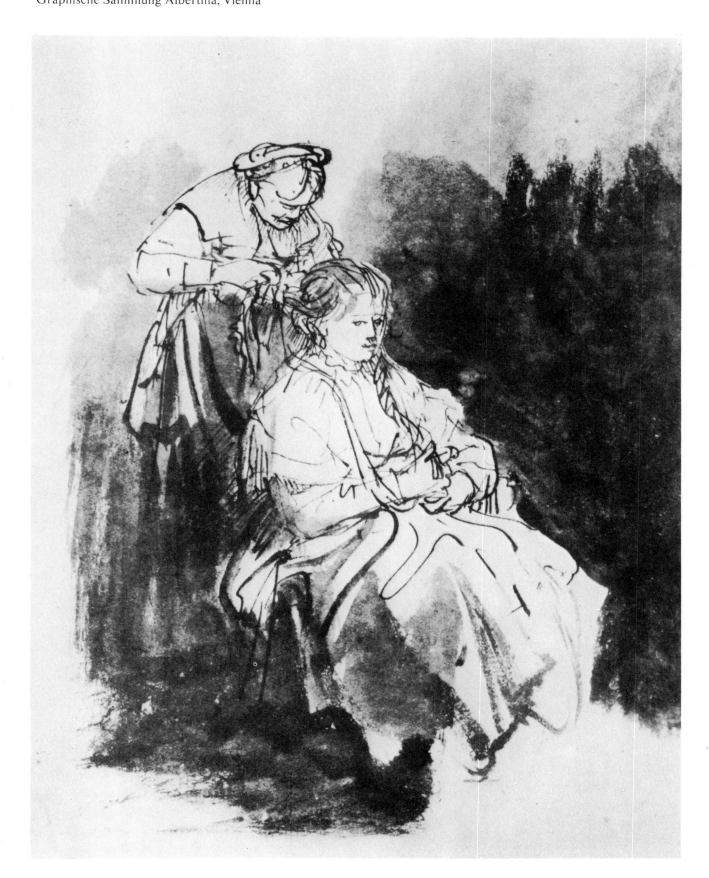

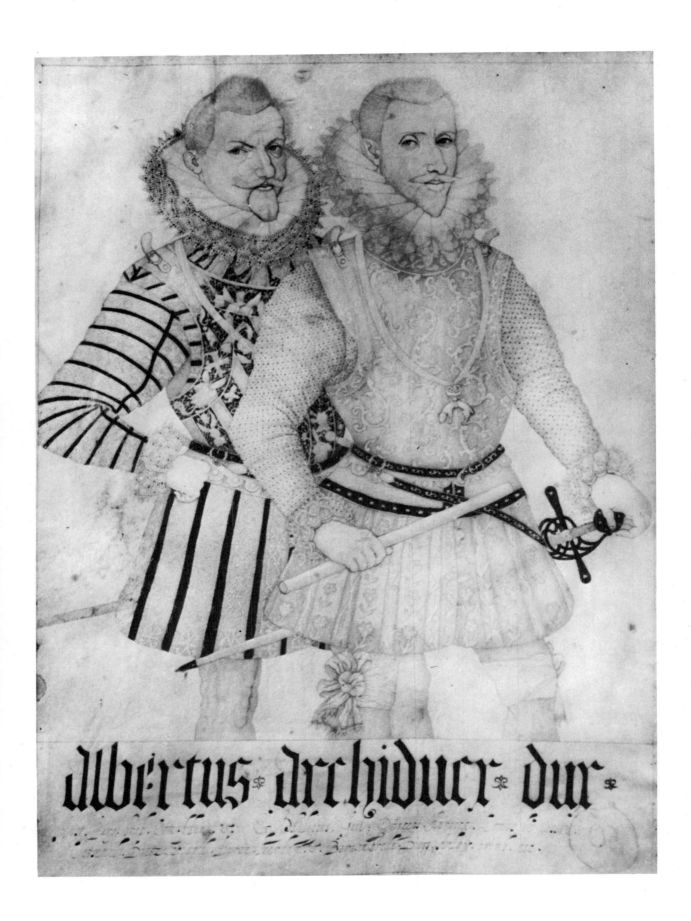

albertus archiduca dux

124 *(opposite)*
Frans Pourbus the Younger (1569—1622)
Male Double Portrait
Pen, brush, bistre and gold, 400 × 291 mm
Graphic Art Collection, National Gallery, Prague

125
Claude Lorrain (1600—1682)
Tiber Landscape with Rocks, 1710
Brush, pen, bistre wash and black chalk, 139 × 250 mm
Musée Condé, Chantilly

effect, known as dry-brush technique. Drawings by Tintoretto, which use this method, prove that it was known to the artists of the Italian Renaissance. Another approach is to fill in large areas with a well-saturated brush to depict the shadows while the light areas are left untouched and outlines are then drawn on top. However, this kind of drawing may tend to become too schematic.

As in all techniques, try to find the method that suits you best. A brush drawing should be concise in character and details should be subdued as much as possible. The form of the subject should be reduced to contours and shadows and the colour should be translated to a limited range of earth colours or greys and blacks. An example will serve to illustrate this point. When drawing a portrait the outline of the hair can be used to determine

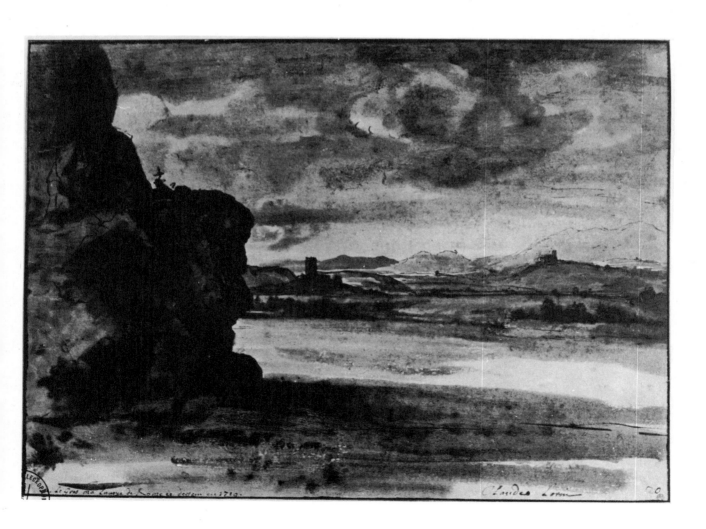

the undrawn contour of the face into which the eyes can be set. Other features can be added but the rest of the face is left as a white surface. The neck, or the profile of the chin is explained by the shape formed at the neck-line of the dress. Brush drawing gives you the power to suggest form through negative expression. On the other hand you may want to use it to explore modelling or to dwell on the ornamental character of objects, such as on the pattern of the dress fabric, or the decoration on the wall behind the model.

Brush drawing is a technique which requires speed. It requires a fresh, uninhibited and rhythmical approach. The viewer should understand what the artist has decided to leave out and what to translate, as well as the

127 *(opposite)*
Martin Schmidt (called Kremserschmidt; 1718—1801)
The Last Judgement
Pen and grey wash, tinted with watercolour,
296 × 188 mm
Graphic Art Collection, National Gallery, Prague

126
Rembrandt Harmensz van Rijn (1606—1669)
Sleeping Girl; The Hendrickje Studies, (circa 1655—56)
Brush and bistre, 245 × 203 mm
Reproduced by courtesy of the Trustees of the British Museum

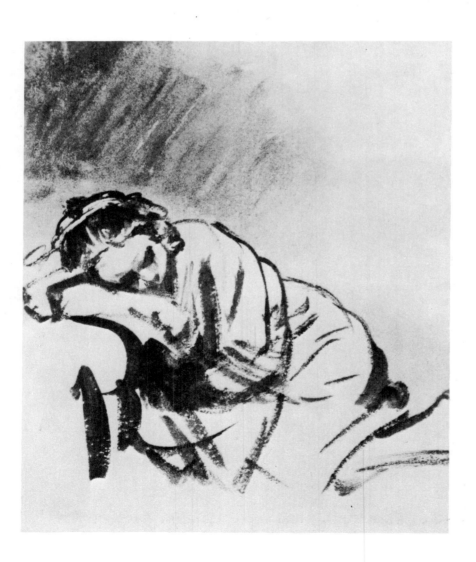

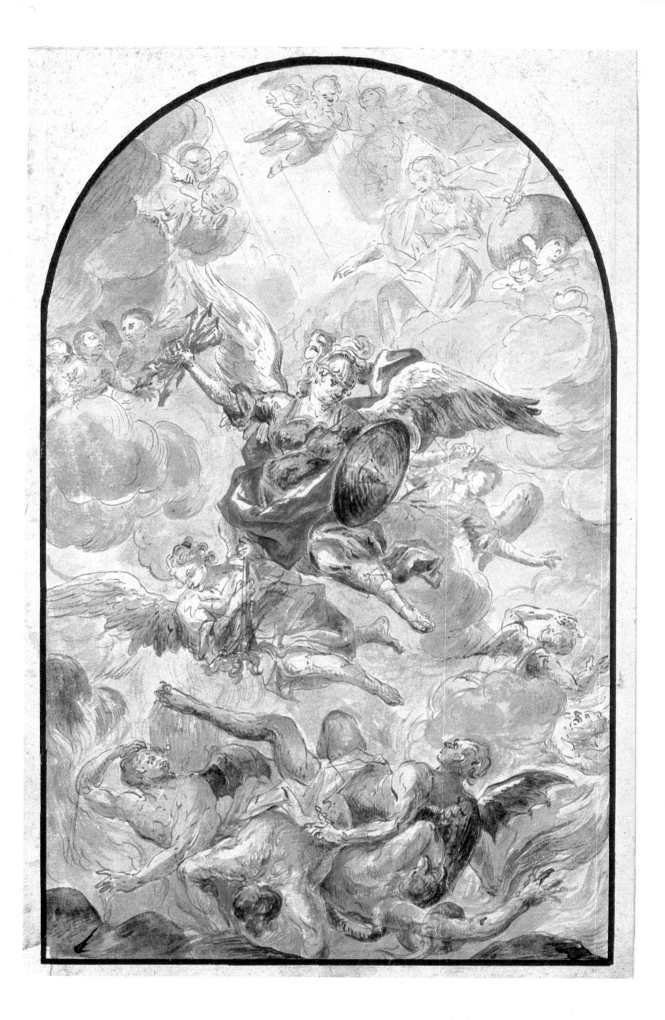

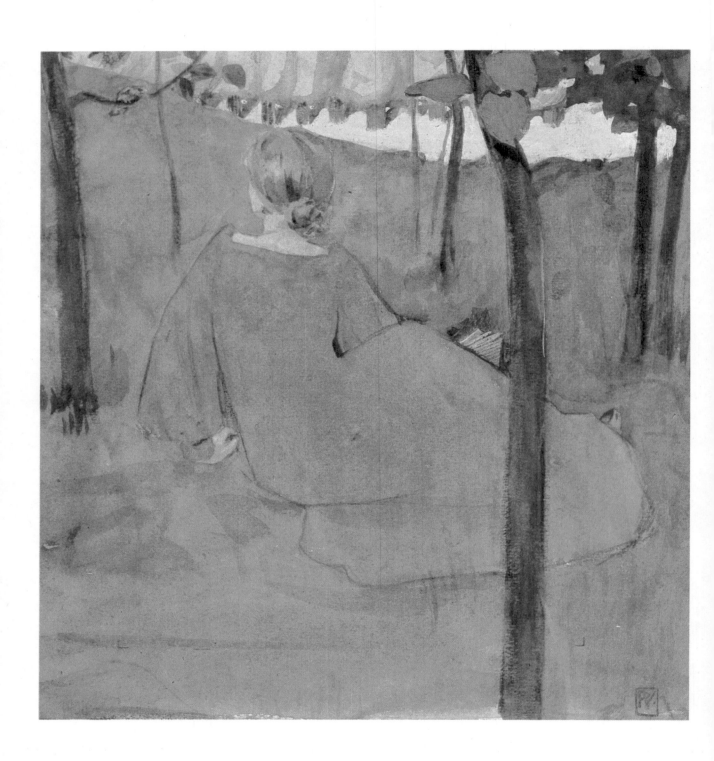

128
Vojtěch Preissig (1873—1944)
Bluebird, 1906
Watercolour, 469 × 294 mm
Graphic Art Collection, National Gallery, Prague

129 *(opposite)*
Luděk Marold (1865—1898)
Study of a Sitting Woman
Pencil, ink, watercolour and white paint, 220 × 130 mm
Graphic Art Collection, National Gallery, Prague

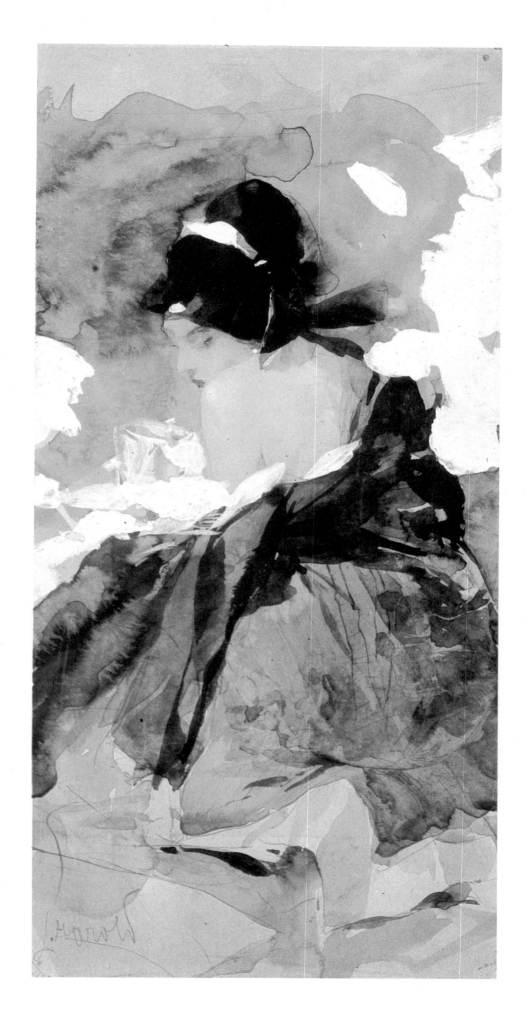

130
Jacopo Palma (called Palma il Giovane; 1544—1628)
The Entombment
Brush, watercolour and sepia, 245 × 185 mm
Graphische Sammlung Albertina, Vienna

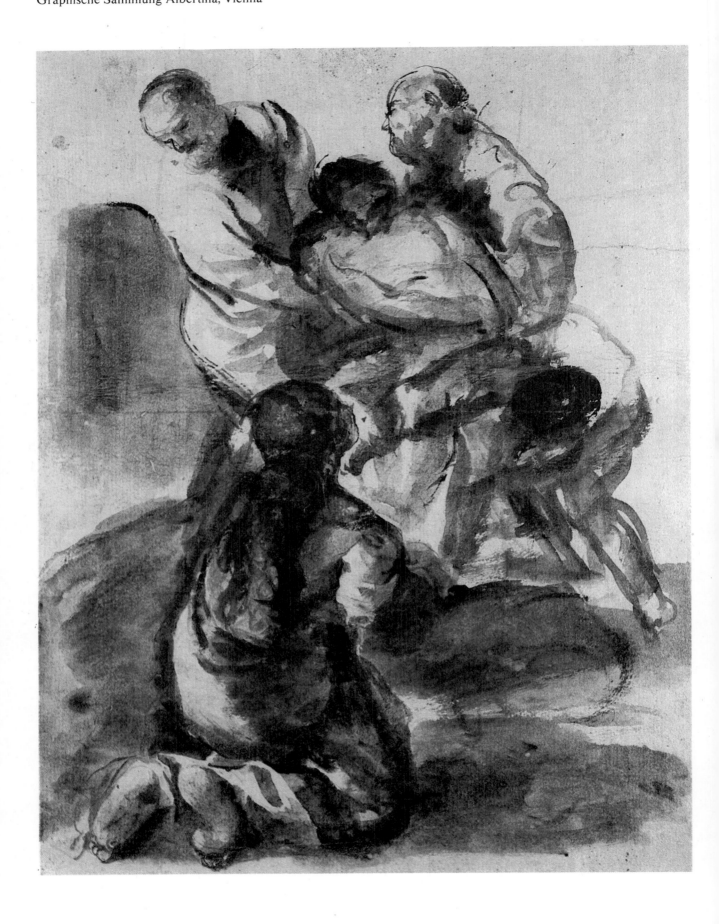

graphic intuition that governs the use of contrast. The pattern of this graphically effective alternation of black and white is the first thing that attracts the eye.

There is a useful way of checking the composition of the work as it progresses. Simply turn it upside-down. The work loses its narrative content and can be evaluated only on the merit of the purely decorative effect of its plan. This view will quickly reveal 'holes' in the composition as well as rhythmical lapses. Naturally, this method may be used for a preliminary evaluation of a work executed in any other medium or technique.

Brush drawings can serve many purposes: they are good for studies from live models, for sketches to catch an impression of a view, as well as for finished pictures. They can be also combined with pen-work or with watercolours. Brush drawings may be tinted with watercolours. Coloured inks and dyes can also be used, but their attractive transparent hues are not colourfast. Besides, unless used with care tinting may tend to undermine the graphic power of the drawing.

There are many ways of livening up a brush drawing in ink with interesting textural marks. Try dipping strips of surgical gauze, about 15 cm (6 in) long, in ink, wring them out lightly, stretch them and lay them on a piece of stiff paper. Tap the gauze strips lightly with your fingers to transfer the ink to the paper. If you have a clear idea of how these broad bands of texture can be used to supplement the brush drawing, the image can be very effective, producing a subtle interplay between the black and white textural areas and a more dramatic one between these areas and the white of the paper. This method naturally requires a positive approach, bold brushwork and a tendency towards exaggeration.

Practically any paper will do for a brush drawing: the selection is governed by the desired effect. Any surface can be used to some advantage. Rougher paper will produce a good effect since the texture reflects light well and thus lends force to a brush drawing, which has limited means of expressing a subject in terms of light and dark.

Any beginner in the field of graphic art will sooner or later feel an irresistible urge to try his hand at using colour, which can be more immediately exciting than working in monochrome and is another step forward in the art. Watercolour and gouache are closely related: both are bound by gum arabic, but gouache has an addition of white or light body colour that renders it opaque, while watercolour is transparent. They are discussed here because they are customarily classed among the drawing media while other pigment media are considered as vehicles for painting.

Henri Matisse (1869—1954)
Study of a Nude
Pen, quill and ink, 264 × 202 mm
Graphic Art Collection, National Gallery, Prague

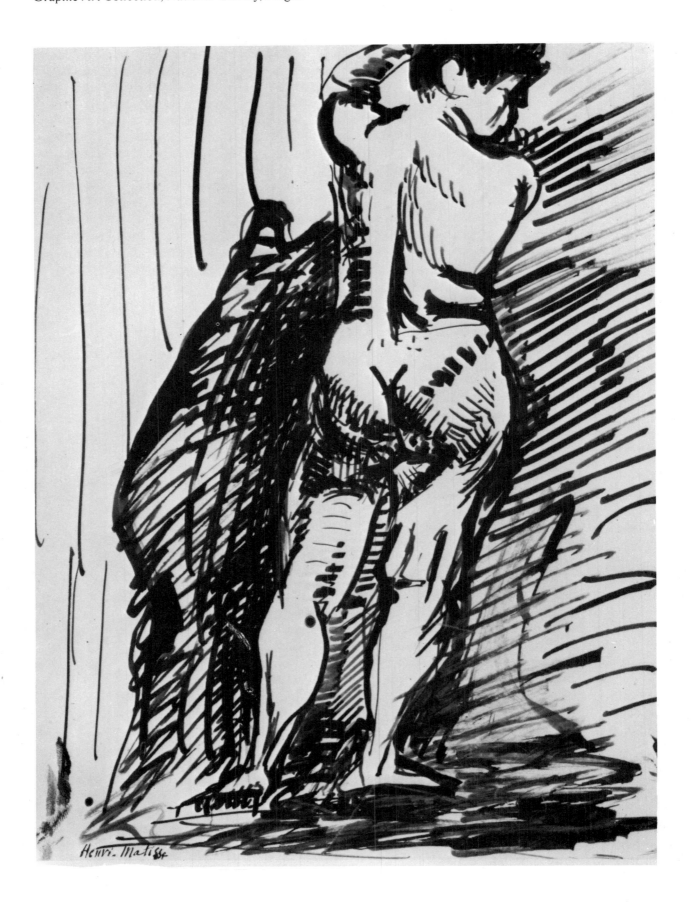

Watercolours are pigments bound in the water-soluble gum arabic. They are mixed with water and generally used on paper although in the past grounds such as parchment, ivory, plaster of Paris and silk were used.

Watercolour painting has its origin far in the past — it was known to the ancient Egyptians. But in spite of the fact that watercolours are still highly popular and technologically easy to use, watercolour painting ranks among the most difficult and challenging of painting techniques. It requires a positive, methodical approach and a thorough knowledge of the rich possibilities it offers. The tricky character of watercolour painting stems also from the fact that corrections are practically impossible.

The basic element of watercolour painting is a transparent area laid with a brush richly saturated with the pigment mixed in a certain amount of water. The proportion of pigment to water determines the darkness, or saturation, of the colour (its luminosity) from deep tones to very pale, airy washes of transparent tinted liquid on the paper. Paper plays an extremely important role and is one of the major factors that helps to determine the final effect of the work. Its capacity to take to colour, to reflect light, and the character of the grain, all affect the structure of painting.

Watercolour painting is based on a drawing filled with colour although it may take on a more 'painterly' effect. It is not far removed from the technique used for a wash drawing. However, the characteristic of watercolour painting is the liquidity and transparency of the medium that is stabilized and lightens as it dries.

It was the English artists who excelled in this technique. In the late 18th century a school of outstanding watercolourists appeared in England and watercolour painting actually became thought of as an English speciality. Its great popularity (and achievements of the artists) were, no doubt, associated with the proverbial English concern with the weather, and the interest in the atmosphere, its quality and transformations with which watercolour painting is perhaps best equipped to capture adequately. Amateurs and professionals alike zealously pursued the art and it was gradually liberated from the former dependence on supplementary drawing techniques to achieve a professional perfection. From England watercolour painting spread to the rest of Europe during the 19th century. The fact that artists who had been trained in highly diverse manners took to watercolour painting is proof of the great possibilities of expression of the technique: it can be used for decorative purposes, for illustration and to render any spiritual or natural atmosphere.

Pure and stylistically genuine watercolour painting consists of the subsequent laying of the thinnest possible layer of diluted pigment on a white ground. It is in this respect that it resembles the technique of wash drawing. Like the draughtsman, the watercolourist must also try to preserve the white, luminous tone of the paper as much as possible for only then will the painting breathe with that desired inner radiance and brilliance. Watercolour paintings must be open, airy, uncluttered and uncongested. Any addition of process white, gouache or even pastels to watercolours was traditionally regarded as a sign of stylistic impurity. Even a minor retouch with watercolour white (quite different from white gouache) was considered a stylistic *faux pas.* The strength of a good watercolourist has always been in the precise, masterful painting that is direct and fresh and requires no retouching. Whereas the opaque techniques such as tempera or oil painting permit the paints to be scraped off and repainted, the watercolourist must have from the start a very clear idea of what he wants to achieve by very simple, uncomplicated means.

As already mentioned, watercolour painting is generally considered one of the most difficult drawing (or painting) techniques. Many people will be superficially familiar with watercolour painting from school art classes when it may have been used to simply 'colour in' areas of a drawing. Nothing could be further from the way in which this medium can be used to its full advantage as a sophisticated technique.

The traditional method used a preliminary

painting in very weak sepia which outlined airily the contours and hinted at the modelling. This foundation layer was subsequently overlaid with more intensive, local colour (the actual colouring of objects) in such a way as to preserve the luminosity of the lights; some parts of the paper were even left untouched. It is very important to render the drawing precisely and thoughtfully, yet very simply. To be able to achieve this simplicity the artist must have a very clear, definite idea in his mind. It is also possible to delineate the basic drawing with a thin brush using a very weak watercolour paint of a neutral character, or of a colour that will be dominant in the picture. The preliminary sketch may be drawn in soft pencil or charcoal. However, these preliminary media must be stabilized by a fixative prior to the application of watercolour paints because they would otherwise smudge and contaminate the watercolour.

Before you try your hand at a large piece of work, do a smaller sketch or a study. You will soon find out that the spontaneous lightness achieved in minor sketches is quite difficult to recapture in a larger final version. It is therefore advisable to leave out some of the intended effects in the sketch and to save them for the final work. There is nothing as boring as a watercolour 'technical drawing', a smooth, slick and pedantically coloured piece that lacks the attractive appeal of this sparkling technique. Such drawings do not reveal anything about the subject or about the artist.

Today, the tendency is to use an *alla prima* approach to watercolour painting. This method tries to lay the right tone on the right spot with the very first layer, since each subsequent layer will reduce the original brilliance and luminosity to some extent.

How to start

A thick, good quality watercolour paper should be stretched on to a drawing board. The format should be chosen after careful deliberation since watercolour brushes will not cover large areas, so start by working on a fairly small scale. If you work on un-stretched paper or in your sketchbook, you must be prepared that the water will make the paper buckle.

Some papers will resist the colour even when stretched with water; such papers should be first washed with diluted ox gall, dried and then used for a preliminary light sketch in pencil or charcoal. Be careful not to touch the paper unnecessarily because it will get greasy quite easily, and do not damage the surface by erasure.

Watercolour may be applied both to dry and wet paper. Bear in mind that a wet-on-wet technique will soften the appearance of the work but is not too good for greater detail. It is also a technique that requires considerable experience and skill. Wet the paper with a sponge. The water will dry at a slower rate if a few drops of glycerine are added.

The brush is held lightly and gently and the hand should not rest on a support if possible. Only when you are doing fine, detailed work with a thin brush should you rest your hand on the paper (covered first with blotting paper). Skilled brushwork is as important for effective watercolour painting as your choice of paper and the quality of the luminous layers of paint. Study the masterful works of art produced by the Japanese and Chinese artists.

The brush should be fully loaded with the watercolour which must flow really abundantly to leave a rich, saturated and succulent mark. Do not worry if the brush mark spreads to give a fuzzy effect with tiny air bubbles. This is one of the chief attractions of the technique and proof of the spontaneity of the work.

A wide range of colours is available, which vary in degrees of permanency. However, certain rules should be observed when mixing paint. Combine only those that are chemical-

132
Auguste Rodin (1840—1917)
Two Nudes
Pencil and watercolour
Staatliche Kunstsammlungen, Weimar

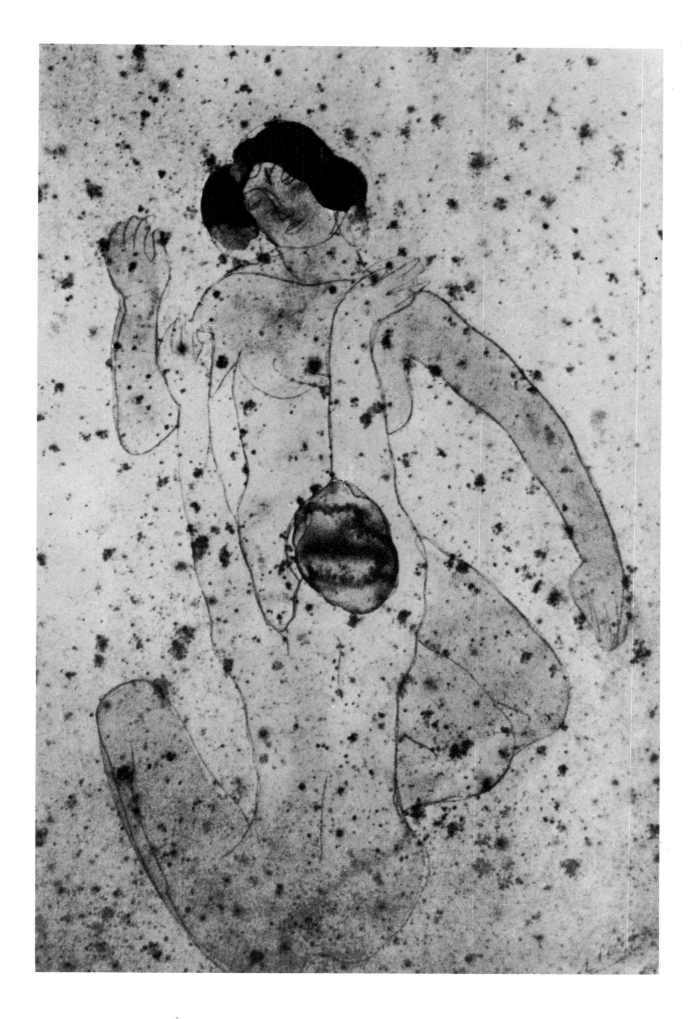

ly compatible and do not mix more than three together since the purity of the colour will be lost.

The quality of the watercolour tone differs with respect to whether it is laid direct (or *alla prima*), or whether it is obtained by successive transparent layers (glazing). Glazing is a rather lengthy method which is less suitable for working out-of-doors.

It is quite surprising how mixing and glazing a relatively limited range of primary colours like red, yellow and blue will produce very complex hues. However, to achieve an overwhelming variety of colours should not be the ultimate aim.

If you want to subdue a harsh colour, add a minute amount of a colour that is close to it in hue, either directly on the palette or by brushing on a thin layer over the dry colour on the paper.

When laying a large area, use a large, soft brush and start with the darkest or chromatically most saturated areas. Leave a drop of liquid at the bottom of the area when you stop to re-load your brush so that you can continue to work down smoothly. The board should be at a slight angle; if it is too steep the colour will run down the paper. If you intend to lay a very complex tone, prepare the tint in advance in a small bowl. You can also mix the colour directly on the wet brush from the pan and let colours fuse directly on the paper. It is useful to have several ready-mixed colours so that you keep your work within a certain colour and tonal range.

Light areas can be made by leaving the paper untouched (but work carefully since the edges of these areas tend to turn darker when dried), or they may be taken out of the wet surface with the brush squeezed almost dry. However, no matter how much you try to thin the tone in this way, you will be never able to restore the paper to its original whiteness. The appeal of an *alla prima* painting lies in the spontaneous contrast of colour and areas that are either dazzling white or laid with a thin, transparent tone. But even a staunch advocate of this technique will probably be tempted to try thinning areas since this permits a certain amount of modifi-

cation. Thinning will change, weaken or wash off parts of the painting and the possibilities of the technique can rid the artist of inhibition, hesitation and overscrupulous care. Besides, the painting will be enriched by the effects of this quality which is unique to watercolour painting.

Wet areas may be washed with a semi-dry brush and the pigment that is removed squeezed into a rag. To wash a surface that has dried the entire area must be first wetted with a large brush and once the water has partially dissolved the layer, the brush is used to wash out the area to the desired thinness. A bristle brush or a small piece of wet natural sponge can also be used. This washing or relieving technique is suitable for softening backgrounds, for highlights and transitions of tone, for the blurring of contours on dark backgrounds, for soft clouds, in fact, for the typical way of modelling with watercolour. It is a subtle way of giving cohesion to the picture.

A 'wet-on-wet' watercolour painting can be done on a surface that has been entirely washed with a sponge or under running water. This, however, will lead you on to tricky ground. A partially washed drawing may look quite interesting when still wet because it has a kind of 'underwater' gloss, but when it dries it often loses its appeal, becomes dull and some colours may be absorbed into the ground more than others so that the washing makes them rather conspicuous and the result is a confusing cloudy chaos. Nevertheless, if you feel that there is still a chance to revive the painting, you must start all over again, and try to find inspiration in all the blotches that have emerged from the washing. Sometimes they provide surprisingly fresh, new compositional and sensual impulses that the original painting logically could not have evoked. Often a few fresh strokes may be enough to save the picture.

If opaque white has to be used in a watercolour painting, it should be zinc white (Chinese white) which does not turn grey, is stable and unlike flake white (white lead) is chemically compatible with other colours. However, any addition of white must be done

very sparingly and must be justified by the subject. If white is mixed with any other colour (for correction or highlights) it will turn somewhat darker upon drying. The mixture may appear to be quite harmonious when wet but after drying it sometimes jumps out from the surface of the watercolour painting as an alien element. This is caused by the different rates of light refraction by the white paper and the white paint.

Watercolour paints may be also applied by spraying with a spray diffuser or an air brush or by flicking it from a brush through a wire mesh. However, all these technical procedures are more suitable for applied commercial graphics where the possibilities for their use are very extensive. Besides, these techniques are more compatible with coloured inks and transparent dyes. Watercolour paints based on earth colours are dull when sprayed.

If the colour wash is not too thin, the semi-wet surface may be used as a ground for drawing, or rather scratching, with the sharp end of a brush handle. This will produce an incised line which has an almost negative character that is not entirely white, but is tinted to a lighter tone of the adjacent colour. There is another similar and rather effective technique: engraving washed with watercolour. A bold drawing is made with a needle on the clean, white surface of a thick, good quality paper. It is virtually impossible to inspect the drawing as it progresses. When it is finished, take a large brush richly saturated with a tint and paint the whole surface (or parts of it) with the colour. Use a neutral colour such as indigo, sepia or a flesh-coloured tone. The wash will cover the whole surface and penetrate more deeply into the incised lines to give a darker tone that will be more fuzzy in some places, more delicate in others.

Watercolour paints are marketed as dry and viscous, in pans and tubes. They consist of the colourant (a pulverized pigment) and the binder, gum arabic. The pliability is achieved by the addition of glycerine, which retains the moisture content; ox gall improves the run-off quality and facilitates uniform spreading. Watercolour paints can be bought individually or in sets in enamelled metal boxes. The box lid is ribbed to form compartments which can be used as a palette for colour mixing.

As the name implies, watercolour paints require water as a solvent. The water should be either distilled or boiled. A drop of vinegar may be added to the water to give the colours a greater freshness. When you work you should have always two or three bowls of water to hand; the first bowl should contain absolutely clean water, the second is used for washing the brushes and the third supplies the water to be used with the paints. Palettes for watercolour painting are usually enamelled metal or porcelain; the best colour is naturally white which corresponds to the colour of the paper and enables one to judge how the mixed colours will look on the paper. This is extremely important for mixing transparent tones. Needless to say, the palette must be kept meticulously clean and wiped frequently with a rag. It is also advisable to keep a few pre-mixed (even dried) colours that are used frequently for drawing or as a neutral tone. When a large amount of a paint is required, the desired tone may be mixed separately in a small, preferably porcelain bowl. A piece of cardboard makes a useful palette for tube paints as it can be simply discarded after use. This is also advisable for gouache and tempera painting.

The selection of colours for your box or palette is a matter of personal preference although sooner or later every artist will limit his range to the smallest number possible. This list will help to guide you in selecting a basic range:

Yellows and oranges cadmium orange
 cadmium yellow
 (deep and pale)

Reds
Indian yellow
Naples yellow
yellow ochre
alizarin crimson
cadmium red
crimson lake
Venetian red

Blues
coeruleum
cobalt blue
French ultramarine
indigo
Prussian blue

Greens
terre verte
viridian

Browns
burnt sienna
burnt umber
raw umber
sepia

A strong case should be pleaded for black, which is useful in the palette although some people hold that black does not exist in nature and that it should be mixed. If used with care it is a very beautiful and useful colour.

Paint from the tube should be squeezed on to the palette in a specific pattern: the centre is reserved for white, the right-of-centre for yellow ochres, browns and black while reds, greens and blues are placed to the left of white. If using pans arrange them in a similar manner into three or two rows. However, be careful not to have yellows next to blues or reds: careless handling of the water will result in unpleasant mixtures of these colours.

Brushes are very important in watercolour painting, perhaps more vital than in any other technique. It does not pay to save on brushes because your brush is the most important tool that will enable you to lay the paints well. A good brush should be springy and should form a perfect tip which must not divide or fray when being used.

Buy the best hair brushes you can afford. Sables are best, but squirrel or ox-ear hair (or a mixture of these) have their uses, as do the Chinese brushes already mentioned. Start off by buying one small, pointed brush, a large one that comes to a fine point and a flat brush for painting broader areas.

No matter how large a brush may be, it still must be able to respond sensitively and precisely to the artist's will and produce a flowing, smooth and personal 'calligraphic' line. Small brushes should be used only for fine, detailed work although a larger brush can deal with quite intricate parts provided it has a fine tip.

Needless to say, brushes must be kept perfectly clean and the hair including the metal ferrule should be washed thoroughly in weak soap suds. The hair need not be dried after washing, just shake out the brush to expel excessive water.

Brushes can be stored in a vase or a jug, but remember that dust is the worst enemy of brushes. Keep them in dust-proof boxes if they are not in use. Chinese brushes can be suspended from their silk cord loops.

133
Giovanni da Udine (1487—1564)
Study of Hazelnuts
Watercolour and black chalk, 268 × 180 mm
Moravian Gallery, Brno

Paper is not the only ground that can be used for watercolour painting. The characteristics of other materials like silk, parchment or ivory were used often in the past to enhance the qualities of the watercolour technique.

If you want to use silk as a ground for your watercolours, you must prepare it in order that the paints do not blur. The stretched silk must be painted with pure egg white and allowed to dry thoroughly. The *alla prima* painting technique will give remarkable results on this ground.

Paper is most commonly used today. When selecting a paper the most important determining factor is its whiteness and colourfastness. Another property that a watercolour paper should have is good absorption capacity since it must be able to withstand repeated wetting and washing: it should be therefore well sized. Less well-sized papers must be prepared with a coat of a dissolved gelatine and stabilized with a coat of a 4 % formaldehyde solution.

Some reliable trade names can be recommended as producers of good-quality paper: English — Saunders, R.W.S., Bockingford; American — Strathmore; Italian — Fabriano; French — Canson and Aquarelle Arches. Watercolour paper is available in sheets, in sketchbooks or in blocks (a pad of stretched paper glued at the edges and backed by stiff card, ready for immediate use). Rough and 'not' surface papers are useful for most subjects, and a heavy, thick paper will give a more substantial ground.

The result of any watercolour painting is vitally dependent on the quality of the paper. Since some flaws are discovered only when the work is in progress or possibly a long time after it is finished, it may ruin the painting. You should know how to test a paper.

Colourfastness (its resistance to yellowing) is tested by exposing the paper to sunlight. Cover one half of a sheet of paper and leave it in sunlight for some time. If the uncovered part turns yellow, the paper is not suitable for watercolour painting.

The sizing rate is tested by several strokes with a pen dipped in ink. The character of the pen mark reveals the degree of sizing. Sharp lines indicate a well-sized paper. Less-sized papers produce blurred lines and are not suitable because they would be damaged and soiled by washes.

The most important characteristic of a paper from the watercolourist's point of view is the texture. Selection is largely a matter of personal preference, although a correlation does exist between the texture and the format of the painting which may be a determining factor. The larger the watercolour painting is in size, the rougher the texture can be.

Paper is a hygroscopic material that absorbs moisture from the atmosphere. It should be therefore stored in a dry, dust-free place at a cool room temperature, if possible, stacked flat. If it is kept in rolls, it makes stretching very difficult.

Stored watercolour paintings are very sensitive to moisture and light. It is best to frame them under glass, or to store them wrapped in high-quality acid-free tissue.

The surface may be stabilized and made waterproof with a protective coat of matt, spirit-based watercolour varnish that will not yellow.

A watercolour painting may be also protected with a spirit-based fixative. The surface will either be unaffected, or it may acquire a very slight, practically indiscernible 'fused' appearance. However, varnishing and fixing are not recommended.

Watercolour paints can be used as a tinting (or colouring) agent to complement a drawing although their use must be exercised with care or they will obscure the purity of the drawing.

From the 15th century watercolour paints were used to tint small drawings and cartoons (patterns for large-scale tapestries or mural paintings), like Mantegna's cartoons for

134
Luděk Marold (1865—1898)
Sitting Man
Pen, ink and white paint, 307 × 220 mm
Graphic Art Collection, National Gallery, Prague

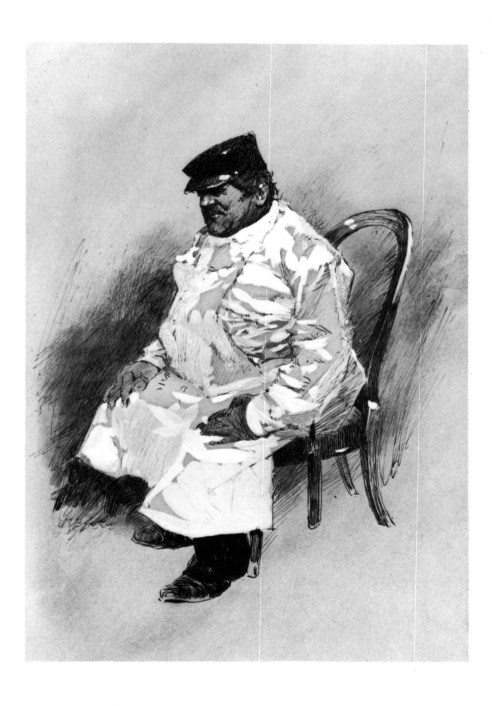

his *Triumphs of Caesar* (1486—94) or the tapestries by Raphael for the Sistine Chapel (1515—16). Charcoal, pen and, most commonly, pencil drawings were among those works which were tinted.

A drawing that is to be tinted should be relatively well-detailed or modelled in monochrome. The tinting should be very pale and light and restricted to selective areas and in a limited range of colour and tone. It is more difficult than it might seem to make a good tinted drawing. A precise, detailed black-and-white drawing has more power than colour which may lose its transparency and should not be used to cover up the shortcomings of a poor drawing. The tints must be subordinated to the monochrome line and tone; only in this way will they enhance the emotional effect of the drawing.

The boundary between gouache, watercolour painting using an addition of opaque (body) paints, and a light tempera is very difficult to define. Actually, gouache lies somewhere between watercolour and tempera painting, and it is often substituted with a thin tempera diluted with water. It is easier than watercolour painting because it is essentially an opaque technique.

Only a light gouache can be classed among the techniques of drawing because it still depends on the effect of the uncovered paper. One of the typical features of gouache painting is that the same hue can have two different qualities: if the paint is diluted with water it will become transparent and glassy while an admixture of white paint will turn it matt and opaque.

Gouache painting refers to the technique that uses either watercolour paints with a greater proportion of Chinese white added, tubes of gouache (also known as designers' colour) or jars and tubes of poster colour. All these media are more or less opaque and if laid in a translucent glaze they are much duller than genuine watercolours. The colour range is similar and the selection is governed by the same rules. A white plastic palette with shallow wells is useful. Brushes can be of both hair and bristle, either round or flat.

Since gouache is a partially opaque technique, it is possible to use coloured papers (preferably of neutral tones) to good advantage. The surface, however, should be somewhat finer than that used for watercolour. The best tones are grey, yellow, salmon-pink and blue but black can also be very attractive. Ingres is a particularly good paper to use for gouaches, which can also be used to complement a charcoal drawing on this kind of paper. With this combination allow the colour to dominate the drawing.

Old pieces of cardboard, possibly painted and then washed under running water, make excellent grounds for gouache painting. Although it may seem illogical, the dried colour stains may inspire a new painting.

A genuine gouache is essentially a wet-on-wet technique (the wet ground is repeatedly overlaid with thin layers of paint). If you

forget this main rule and do not keep the ground wet, the tones will not blend well and the result may be an unpleasant surprise because the difference between a wet and a dry painted tone can be very striking. This is perhaps the only snag of this otherwise very satisfactory and attractive technique. It requires skill and experience.

The quality of tube paints could lure the beginner to lay thick layers of paint, which will crack easily and peel off; the paint is very brittle. Besides, thicker layers do not use the specific character of gouache to advantage. Mix in the white with care: colour must always predominate and too much white will congest the painting and the surface will develop an unpleasant 'plastery' character. However, keep the tones relatively pale. Colours that are too dark, or black mixed with other colours will lack brilliance.

Keep the painting open from the start and let it breathe. The preliminary painting should grow over the entire surface. In this way you will ensure that the painting radiates freshness in all stages of its progress and will entice you to go on with your work.

Naturally, it is also possible to do an *alla prima* gouache. It has all necessary prerequisites of the method; the direct and powerful qualities of the paint are not suffocated by the addition of white. This technique requires a certain amount of courage.

Like watercolour paintings, gouaches can also be corrected, repainted or washed off. If the painting is too dull and lacks lustre, it may be refreshed with a light spray of pure water containing a drop of vinegar. As the work progresses it may be fixed with a pastel fixative which will form a very thin film, rendering the surface less washable and permitting the application of subsequent glazing layers. The finished painting should be framed under glass or preserved with watercolour varnish.

Gouache colours differ greatly in value according to the type of lighting they are seen in. It is quite interesting to note that a gouache done under daylight conditions will stand artificial illumination, but this does not work in reverse. Bear this in mind before you start painting.

Some painters prefer to work by artificial light, using fluorescent tubes, which least affect the character of the colours. Nevertheless, the best illumination for colour painting is daylight. The situation is quite different if the finished work is destined to be displayed in a room where the only source of illumination will be artificial light. In this case the artist will do best to simulate those conditions while working on the picture. The Czech artist Josef Šíma spent his last years working almost exclusively in his apartment rather than his studio, saying that his 'things' were intended for the same environment. At this level the question of illumination ceases to be a purely technical matter and becomes a reflection of the artist's personality and of his aesthetical judgement.

Frottage is based on the principle that children so often adopt to transfer the impression of a coin by rubbing through paper with a pencil. Max Ernst was the first to employ the technique as an art form and it was taken up by other members of the Surrealist movement, who used it to give them inspiration for imaginative compositions or as part of a collage.

This applied technique is based on chance findings. A piece of paper is laid over a surface with an interesting texture, such as wood grain or canvas, and a crayon or soft pencil is rubbed over the paper to reveal the impression below.

This technique can be used either as the starting point for a drawing, or as a supplementary method of achieving the required texture in a particular area of drawing.

Monotype is a fascinating technique that has become highly popular in this century. It is thought that Giovanni Benedetto Castigliano (circa 1610—1665) invented the technique; it was revived by William Blake and more notably by Edgar Degas, who produced some magnificent examples.

A thin zinc or aluminium plate should be cleaned and then coated with a thin film of dark oil paint or printing ink applied with a roller. The drawing is made on the inked surface using any kind of tool: a brush, a stick, a finger, or a needle.

Lay a sheet of thin, white, slightly damp paper over the plate to take a print. This can be done either in a printing press, or through an old-fashioned mangle. It can also be taken by hand by simply applying pressure with the palm of the hand or by rubbing the back of a spoon over the paper. If hand printing is done a sheet of glass can be used as a plate. Remove the printed sheet carefully by peeling it off from one corner.

The resulting image will be a negative impression on a coloured ground. It is difficult to control the results and much depends on the amount of ink used and the pressure applied during printing. As the word 'monotype'

135 *(opposite)*
Václav Tikal (1906—1965)
Spring, 1945
Frottage, 285 × 230 mm
Private Collection, Prague

136
Květa Válová (born 1922)
Oppression, 1973
Monotype and brush drawing in printing ink,
442 × 467 mm
Graphic Art Collection, National Gallery, Prague

implies, generally only one print is taken, although two or three could be made, but the image would change each time.

The image will have something of the quality of a lithographic print. It is not a pure drawing technique and it lacks its immediacy, but it is a spontaneous method of printing that is most closely related to drawing.

A prepared surface for a high-contrast 'engraved' drawing that works on the same principal as scraperboard (or scratchboard) is made by laying ink over a layer of nitrocellulose paint. This paint, or white primer, can be bought from any car-paint specialist (be sure that you are not sold acrylic cellulose, which is too absorbent for this purpose, nor a gloss or enamel, which would not hold the ink).

Use a wide, flat brush to apply a good coat of paint to a smooth piece of cardboard or mounting board. Lay the board flat and leave it for 24 hours or until thoroughly dry. Do not let the surface become greasy by touching it. Coat the dry, white paint with black ink, using a thick, soft hair brush. Be sure to spread the ink evenly so that it does not create pools or it will crack as it dries and ultimately peel off.

The ink will be dry in about two hours and you can then start working. Use engraving tools such as a burin, etching point, or lino-cutter to cut away the ink with a minute layer of the white paint. This will produce a sharp, dazzling, white image. If large areas of the black layer are removed to make the linear element stand out in black, leave certain irregular black marks to retain a special graphic appeal. It will have some of the appearance of a lino- or wood-cut.

A thin needle can be·used to produce a negative linear image on the black background. Corrections can be made by touching-up areas with ink but it is difficult to re-engrave in these areas.

Another method is to wash off the dried ink with a brush and water. This will produce a sort of wash drawing in reverse, but with a very distinct lithographic character. The wash drawing may be further combined with scratchwork or with a positive drawing in pen or brush and ink.

An 'engraving' of this kind tends to be

137
Alfred Tonner (1859—date unknown)
Woman with a Dove, circa 1850
Scratchwork on coated paper, 180 × 147 mm
Graphic Art Collection, National Gallery, Prague

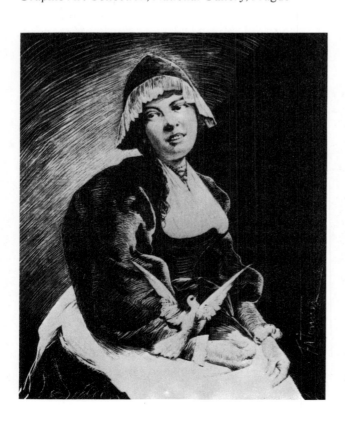

138 *(opposite)*
Josef Navrátil (1798—1865)
Man and Woman with a Sleigh
Gouache, 264 × 217 mm
Graphic Art Collection, National Gallery, Prague

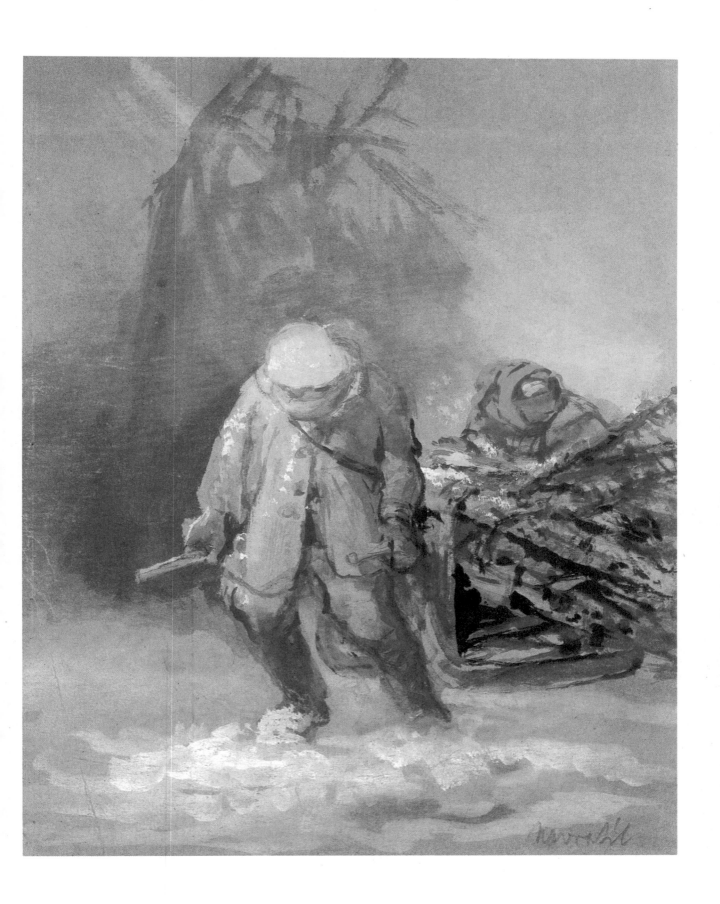

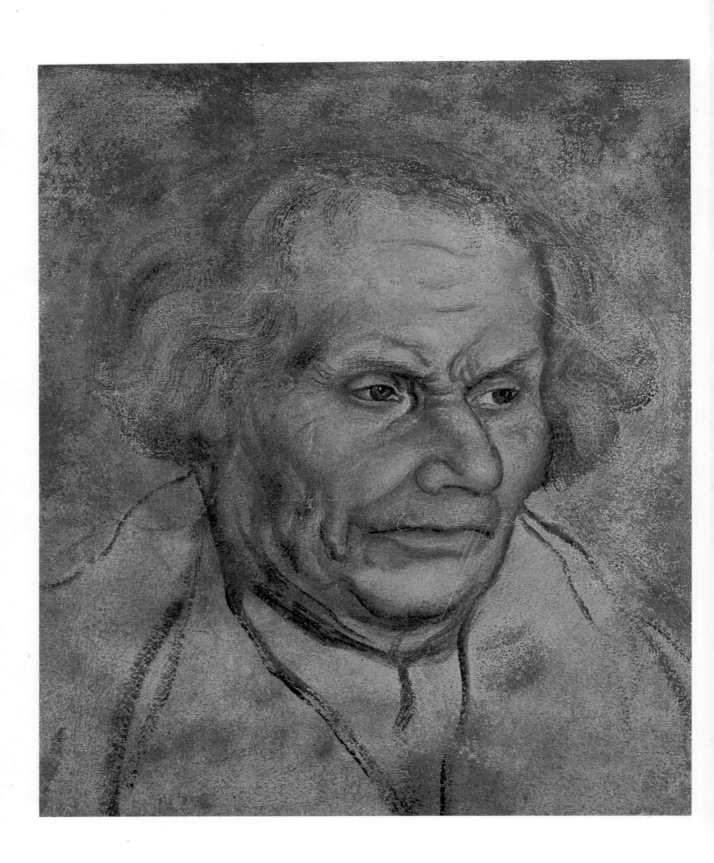

quite glossy. A thick layer of a shellac fixative will turn both the black and the white surfaces a beautiful matt.

The nitrocellulose paint-treated boards can be prepared well in advance and stored for future use. However, the ink must be applied only immediately prior to starting the work because otherwise the paint would absorb it too much, the ink would be difficult to scrape off and impossible to wash off.

A similar intaglio technique can be done on scraperboard (or scratchboard). These are paper boards coated with a layer of plaster mixed with degreased oil size. A white scraperboard can be used as a ground for a thick brush drawing in black ink. When the ink sets and dries, the drawing can be elaborated by scratchwork using needles or cutters of various sizes. Black scraperboard is perhaps better to use because the colour of the ground forces the artist to work in relief in a negative expression and therefore to think in more graphical terms. Limited corrections with ink are possible in this technique although the corrections will be visible because the spots retouched with ink are a different character from the untouched scraperboard.

Nitrocellulose paint gravure and scraperboard require a definite concept, a certain degree of stylization, and a graphic approach. First make a preparatory sketch in ink or soft pencil and use it as a basis for the layout of the final picture.

Scraperboard and nitrocellulose paint can also be tinted with dyes or coloured inks laid in a transparent glaze. However, the robust black-and-white drawing should remain predominant and the tinting must be used as a purely complementary technique subordinated to the drawing. Remember that these tints are not light fast.

A grey or neutral tint will look effective with the black drawing. Always wait patiently until a tinted area becomes thoroughly dry before applying the next in case they blur. The ground is totally unabsorbent and the drying takes a very long time. Sable or Chinese brushes are good for this type of work.

Watercolour paints are not recommended for this kind of tinting because they are not sufficiently transparent and produce a foggy film on the black ground, which will lose the drawing's crisp, graphic qualities.

139
Lucas Cranach (1472—1553)
Portrait of Hans Luther
Brush and body colour, 218 × 183 mm
Graphische Sammlung Albertina, Vienna

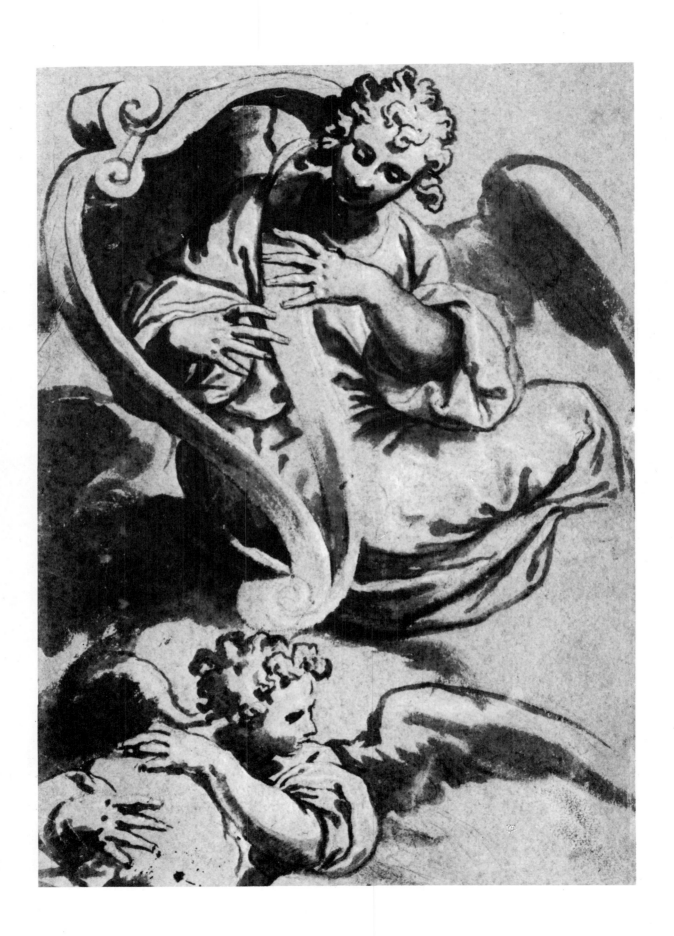

Washed Gum Arabic

Make a drawing on white card in pen or brush dipped in diluted gum arabic with a few drops of ink added to make the line visible. Allow the finished drawing to dry thoroughly. If it is made to dry quickly the gum arabic will develop fine crackles that will subsequently lend the drawing a quite unique character.

Coat the drawing with oil paint or oil-based printing ink thinned with white spirit, using a wad of cotton wool. The spirit will evaporate almost instantly. Wash off the dried gum arabic carefully under running water. The lines made by the gum will appear as a negative image on a transparent or fully coloured surface with a blurry, fuzzy character that resembles a printed impression. The negative drawing will also retain some of the paint.

Several layers of drawing can be built up on top of the various tones of a colour, or several different layers of transparent colours can be superimposed on each other over large areas covered by the gum.

This technique is highly effective for applied art and decorative purposes such as textile design and posters.

140
Paolo Farinato (1524—1606)
Study of Two Angels
Brush and bistre, 138 × 950 mm
Graphic Art Collection, National Gallery, Prague

THE FINISHING TOUCH

The Signature

You may want to sign a finished drawing with your name, initials or a symbol to be used as proof of authorship. It should occupy a logical position in the drawing that does not conflict with the composition. The placing of the signature, date and other data is largely intuitive.

There is undoubtedly a definite correlation between calligraphy and drawing. Note how these two disciplines supplement each other: pictographic symbols and Chinese calligraphic characters are, in fact, drawings while the bare essentials of some drawings have a script-like character.

The signature will be your final gesture in a drawing; incorporate it with sensitivity. The date is an important reference that allows you to record the development of your work. Note also that it is customary to sign watercolour and gouache paintings in pencil.

Storing Finished Drawings

The best way to keep your drawings is to store them in a plan chest so that they are protected from light and dust, and kept flat. A portfolio may be used, but it is better to use a large box. Watercolour paintings should be protected with glass and kept out of the light as much as possible.

Drawings should be mounted and stored in cardboard boxes with tightly fitting lids and interleaved with fine acid-free tissue paper. Label the contents of the box for future reference. Gouache paintings should be separated with sheets of transparent plastic rather than tissue as their surface is even more susceptible to wear and abrasion than watercolour paintings.

The drawings that you would like to have on view should be mounted, protected with glass and framed. However, they should not be exposed to light for too long; many papers, inks and watercolour paints are not lightproof and will deteriorate. This explains why drawings are not put on permanent exhibition in museums. Some galleries use cur-

tains to preserve the priceless classical drawings from the effect of light. Special glass has been developed recently which cuts down the penetration of the harmful ultra-violet rays but its efficiency has not been conclusively proved. It is best to hang drawings in rotation for short periods of time.

Window Mounts

Window mounts are most effective when most simple. They can be made by folding a sheet of paper in half and cutting out a window in one half that is slightly smaller than the format of the drawing to be mounted. Stiffer mounting boards are more suitable. Colour is important — white or pale colours are most attractive although brighter colours, dark grey or black can be used to good effect.

The window opening is made by first establishing the centre on the reverse side of the top mount. From this point mark the side borders of the opening. The lower border should be deeper than the top one or the picture will appear to sink. Make the bottom margin at least one fifth wider than the top one, although this will depend on individual preference.

Cut the card with a sharp mount-cutter's knife or craft knife using a steel straight-edge or a metal ruler. The ruler should be placed against the line from the outside to prevent the knife from cutting accidentally into the mounts.

It takes a lot of skill to cut rounded corners. First trace the curves lightly with a pencil. After the straight sections have been cut with the use of the ruler as far as the start of the corner the rest must be done freehand.

Drawings can be also sandwiched between two glass plates and fastened with clips. These drawings are not window mounted and if there are any irregular edges, especially if the paper is handmade, they should be left as they are a proof of the unique character of the paper.

Frames

The choice of a frame will depend primarily on the character of the drawing, but also on the type of interior for which the piece is intended. One thing should be stressed here perhaps: richly ornamented, deeply profiled frames are not generally suitable for drawings. The best frames for drawings are those made from narrow mouldings. A wide variety is available: natural wood, black and gold composition mouldings, and also the very simple aluminium strips.

Although fashions may change it is always important to observe that the frame does not steal from the effect of the drawing. Many artists have been known to include the design of the frame in the overall concept of their work. It is known that some artists have been inspired to create a work that is designed to match an existing frame, but this would apply more to paintings than drawings. The appeal of drawing lies in its personal, intimate character and internal freedom — be sure to choose a frame that does not limit this sense of freedom.

In contradiction to the general advice of choosing a simple frame and a simple mount, a surprisingly successful combination can be achieved by framing a small, delicate drawing in a heavy and richly ornamented frame.

141
Raphael (Raffaello Sanzio; 1483—1530)
Kneeling Woman
Chalk, 332 × 215 mm
Ashmolean Museum, Oxford

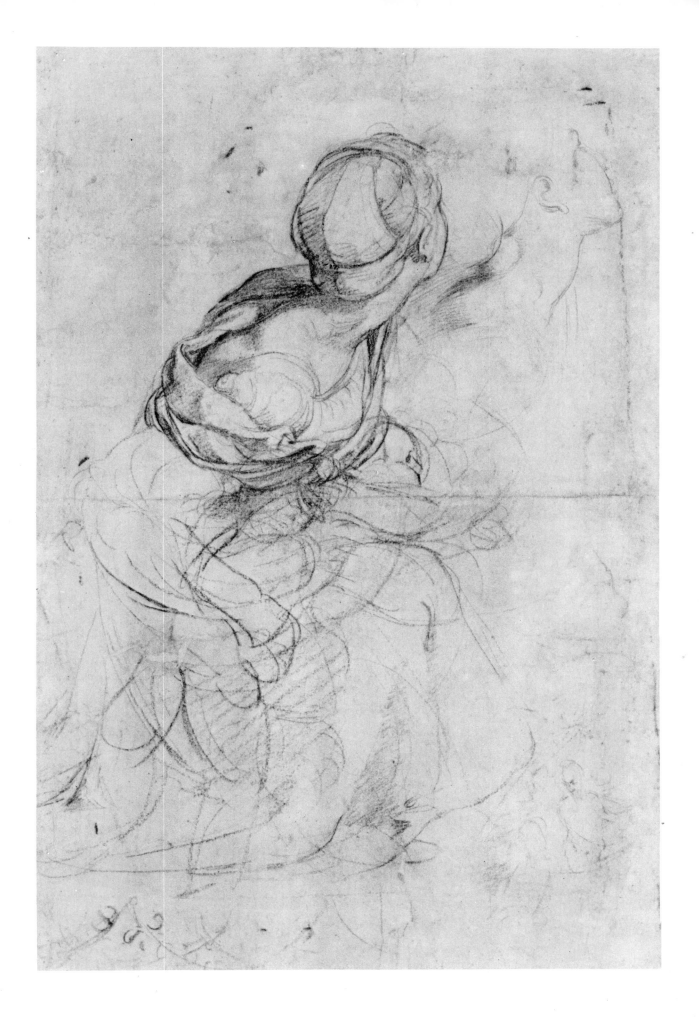

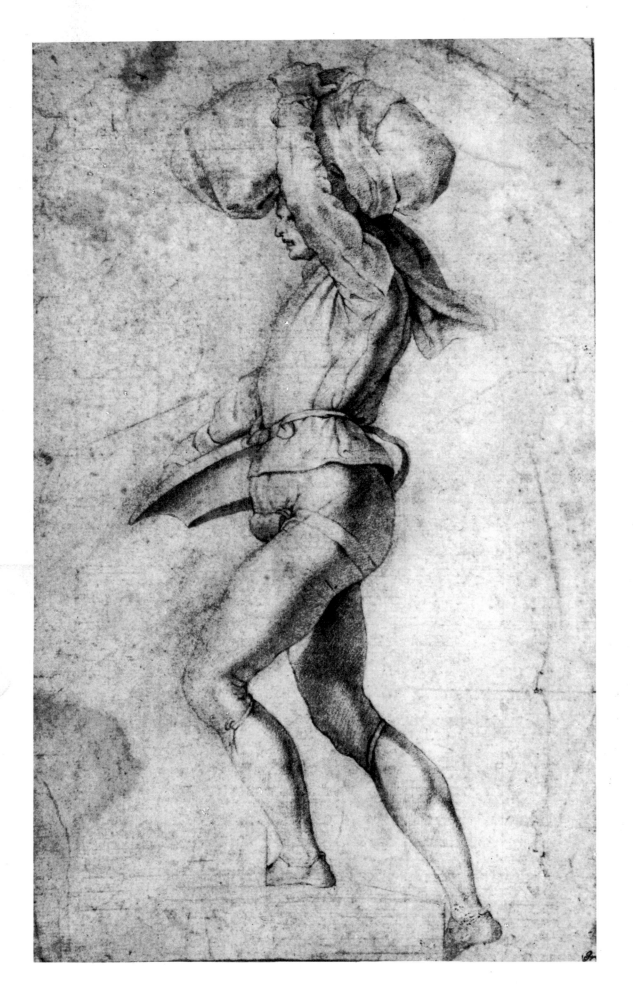

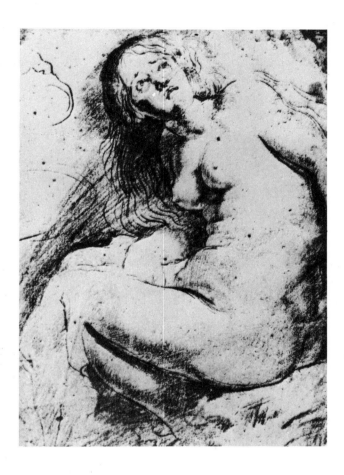

143
After Sir Peter Paul Rubens (1577 — 1640)
Susannah at the Bath
Chalk and sanguine, 263 × 181 mm
Staatliche Graphische Sammlung, Munich

142 *(opposite)*
Andrea del Sarto (1486 — 1530)
Porter
Pencil, 376 × 217 mm
Moravian Gallery, Brno

It was chance that first caused me to start working with drawings. But in no time at all drawings became my primary professional interest, my love and my passion. Drawings enable me to peer over the shoulder of long-'dead artists and give me a chance to learn what these people were like. I can see Pietro da Cortona sketching rapidly with sanguine and witness a composition emerge from a seemingly abysmal confusion of lines at the very moment that one thinks the result could be nothing but utter chaos. I can see the precise hand of Dürer proceeding unhesitatingly from one particular detail to another, always guided by a profound concept of the whole. I can observe how Rembrandt makes do with a few sketchy observations that suddenly reveal a part of that great mystery of life. And nobody has Rubens' humble, yet passionate ability to capture the ephemeral beauty of a human being; no one has yet surpassed Raphael in the fusion of a personal ideal with the ideal of a period.

I can see how an artist asserts various aspects of his personality in different periods of his career through different techniques. The more I look at these drawings, the more I can read from them about the artist, the period and the capacity of art to unveil the mysteries of the human soul. And the more one knows, the deeper is the experience.

It is the desire to understand better and to know more that leads you to learn more about the techniques and methods of drawing and through your own work to penetrate the inner world of the art. You must realize that a handbook alone cannot make an artist of anyone. However skilled you may ultimately become, without exceptional talent you will remain a mere 'dilettante'. But this is no reason for despair. Retain a passion for this noble hobby and above all always be critical of your own work. Do not be sentimental; be ruthless about parting with a bad drawing, no matter how much painstaking work it may have taken. For no effort is made in vain. Every drawing will stimulate your explorations of the world at large and of your inner being, it will enrich you, help you to understand the art of drawing more intimately and

generally sharpen your artistic sensibility. And there is always the hope that one day you will finally step over that threshold beyond which lies the realm of genuine art.

Drawing involves not only the mastering of the rules, it is not a mere training of skill, but also a mental and spiritual education, a journey into the depth of one's soul. From there the road is open to the souls of others, into their spiritual worlds and into the nature in which we live. It is to teach a way of discovering you all this that has been the ultimate goal of this book.

AUSTRIA
Vienna — Akademie der Bildenden Künste (Kupferstichkabinett)
Graphische Sammlung Albertina

BELGIUM
Brussels — Musée des Beaux-Arts d'Ixelles

CZECHOSLOVAKIA
Prague — Graphic Art Collection, National Gallery

FRANCE
Albi — Musée Toulouse-Lautrec
Bayonne — Musée Bonnat
Chantilly — Musée Condé
Lille — Musée des Beaux-Arts
Montauban — Musée Ingres
Paris — Musée du Louvre (Cabinet des Dessins)
Musée Rodin
Musée Picasso

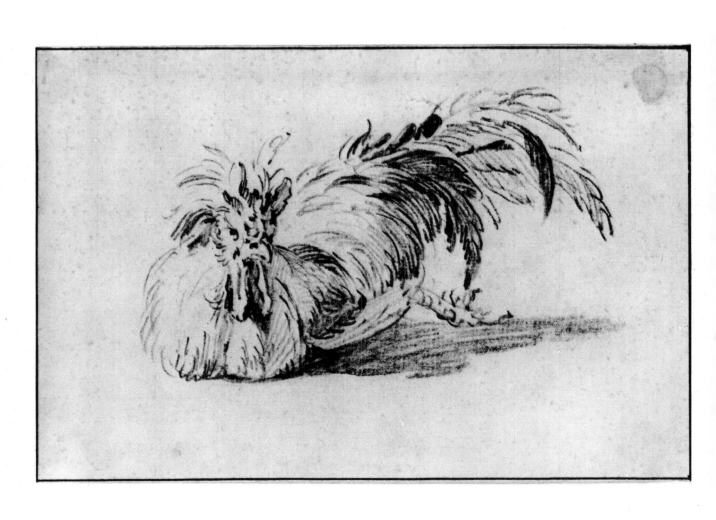

GDR	
Dresden	Sächsische Landesbibliothek
Weimar	Schlossmuseum
GFR	
Berlin	Staatliche Museum Preussischer Kulturbesitz (Kupferstichkabinett)
Frankfurt	Städelsches Kunstinstitut
Hamburg	Kunsthalle
Munich	Staatliche Graphische Sammlung
HUNGARY	
Budapest	Szépmüvészeti Museum
ITALY	
Florence	Museo della Casa Buonarroti
	Galleria degli Uffizi (Gabinetto delle Stampe)
Milan	Pinacoteca Ambrosiana
Rome	Gabinetto Nazionale delle Stampe
NETHERLANDS	
Amsterdam	Rembrandt's House
	Rijksmuseum Vincent van Gogh
	Stedelijk Museum
Haarlem	Teylers Museum
Rotterdam	Boymans-van-Beuningen Museum
NORWAY	
Oslo	Munch-Museet
POLAND	
Warsaw	Muzeum Narodowe
SPAIN	
Madrid	Academia de Bellas Artes

SWEDEN	
Stockholm	Nationalmuseum
SWITZERLAND	
Basel	Öffentliche Kunstsammlung (Kupferstichkabinett)
Berne	Kunstmuseum
Castagnola	Thyssen-Bornemisza Collection, Villa Favorita
Zurich	Kunsthaus
UNITED KINGDOM	
Birmingham	Birmingham City Art Gallery
Cambridge	Fitzwilliam Museum
Dundee	Dundee City Art Gallery
Edinburgh	National Gallery of Scotland
Leeds	Leeds City Art Gallery
Liverpool	Walker Art Gallery
London	British Museum
	Courtauld Institute Galleries
	Tate Gallery
	Victoria and Albert Museum
Manchester	Whitworth Art Gallery
Oxford	Ashmolean Museum
	Christ Church Picture Gallery
Plymouth	Plymouth Museum and Art Gallery
Port Sunlight	Lady Lever Art Gallery
Windsor	Windsor Castle (Royal Library)
USSR	
Leningrad	State Hermitage Museum
UNITED STATES OF AMERICA	
Baltimore, Md	Baltimore Museum of Art
Boston, Mass	Museum of Fine Arts
Buffalo, NY	Albright-Knox Art Gallery
Chicago, Ill	The Art Institute of Chicago
Cincinnati, Ohio	Cincinnati Art Museum
Cleveland, Ohio	The Cleveland Museum of Art
Los Angeles, Cal	Los Angeles County Museum
Minneapolis, Minn	The Minneapolis Society of Fine Arts
	Walker Art Center
New Orleans, La	New Orleans Museum of Art
New York, NY	Frick Collection
	Metropolitan Museum
	Museum of Modern Art
	Pierpoint-Morgan Library
	Solomon R. Guggenheim Museum
Pasadena, Cal	Norton-Simon Museum
Philadelphia, Penn	Pennsylvania Academy of the Fine Arts
San Francisco, Cal	California Palace of the Legion of Honor
San Marino, Cal	Huntingdon Library and Art Gallery
Washington, DC	National Collection of Fine Arts
	National Gallery of Art

144
Gysbert Hondecoeter (1604—1653)
Rooster
Pencil, 123 × 184 mm
Graphic Art Collection, National Gallery, Prague

LIST
OF DRAWINGS
REPRODUCED

Brush and ink
100 Hieronymus Bosch: Man-Tree
Pen and bistre
101 Martin Schongauer: Martyrdom of St Ursula and
her Companions
Pen and bistre, in places finished by another hand
with black wash
102 Willem Pietersz Buytewech: Street Vendor with
a Dog
Pen and black wash
103 Urs Graf: Scaffold
Pen and black ink
104 Hieronymus Bosch: Sheet with Various Studies
Pen and bistre
105 Pieter Bruegel the Elder: Summer
Pen and bistre
106 Bartolomeo Passarotti: Devil
Pen and bistre
107 Max Švabinský: Large Family Portrait
Pen, ink and watercolour
108 Josef Navrátil: Shepherd Girl with a Goat
Pencil, pen, sepia and watercolour
109 Mikoláš Aleš: St George
Pen, ink and pencil with wash
110 František Kupka: Zusza and Villete
Watercolour
111 Adam Elsheimer: Tobias Accompanied by an
Angel
Quill and bistre wash
112 Guercino (Giovanni Francesco Barbieri): Dragon
Observed by Spectators Behind a Wall
Pen and brown ink
113 Eugène Delacroix: St Sebastian Nursed by Pious
Women
Pen and bistre
114 Felice Gianni: Study of Two Dogs
Bistre wash
115 Josef Redelmayer: Two Dragons
Pen and bistre wash
116 Jacopo Palma (called Palma il Giovane):
Christ
Pen and bistre wash
117 Tadeo Zuccaro: Illustration from Aesop's Fables
Pen and bistre wash
118 Giorgio Vasari: Hera
Pen and bistre wash
119 Luca Cambiaso: Apollo and Daphne
Pen and bistre wash
120 Esaias van de Velde: River Landscape with
a Windmill
Pencil and grey wash
121 Claude Lorrain: Landscape with Three Trees
Brush and bistre wash
122 Felice Gianni: St Theresa
Brush and bistre, with a preliminary pencil sketch
123 Rembrandt Harmensz van Rijn: Saskia at her
Toilet
Wash drawing in bistre with pen and brush
124 Frans Pourbus the Younger: Male Double Portrait
Pen, brush, bistre and gold

125 Claude Lorrain: Tiber Landscape with Rocks
Brush, pen, bistre wash and black chalk
126 Rembrandt Harmensz van Rijn: Sleeping Girl;
The Hendrickje Studies
Brush and bistre
127 Martin Schmidt (called Kremserschmidt): The Last
Judgement
Pen and grey wash, tinted with watercolour
128 Vojtěch Preissig: Bluebird
Watercolour
129 Luděk Marold: Study of a Sitting Woman
Pencil, ink, watercolour and white paint
130 Jacopo Palma (called Palma il Giovane): The
Entombment
Brush, watercolour and sepia
131 Henri Matisse: Study of a Nude
Pen, quill and ink
132 Auguste Rodin: Two Nudes
Pencil and watercolour
133 Giovanni da Udine: Study of Hazelnuts
Watercolour and black chalk
134 Luděk Marold: Sitting Man
Pen, ink and white paint
135 Václav Tikal: Spring
Frottage
136 Květa Válová: Oppression
Monotype and brush drawing in printing ink
137 Alfred Tonner: Woman with a Dove
Scratchwork on coated paper
138 Josef Navrátil: Man and Woman with a Sleigh
Gouache
139 Lucas Cranach: Portrait of Hans Luther
Brush and body colour
140 Paolo Farinato: Study of Two Angels
Brush and bistre
141 Raphael (Raffaello Sanzio): Kneeling Woman
Chalk
142 Andrea del Sarto: Porter
Pencil
143 After Sir Peter Paul Rubens: Susannah at the Bath
Chalk and sanguine
144 Gysbert Hondecoeter: Rooster
Pencil
145 Rembrandt Harmensz van Rijn: Resting Lion
Pen and bistre wash

145
Rembrandt Harmensz van Rijn (1606—1669)
Resting Lion, circa 1651—52
Pen and bistre wash, 138 × 107 mm
Cabinet des Dessins, Louvre, Paris

Acknowledgements
for Reprint
Permission

Note: numbers in bold refer to colour reproductions

Ashmolean Museum, Oxford: 49, 141
British Museum, London: 126
Cabinet des Dessins, Louvre, Paris: 7, 20, 32, 33, 34, 35, 36, 47, 54, **60**, 71, 89, 104, 145
Graphic Art Collection, National Gallery, Prague: 4, 10, **11**, 13, 19, **22, 23, 24, 25**, 26, **39, 40, 41, 42**, 50, 52, 53, **57, 58, 59**, 62, 63, 65, 69, **73, 74**, 79, 82, 84, 88, 90, **91, 92, 93, 94**, 95, 96, 99, 102, **107, 108, 109, 110**, 113, 114, 115, 117, 120, 122, 123, 124, **125, 126, 127, 128, 129**, 131, 134, 136, 137, **138**, 140, 144
Graphische Sammlung Albertina, Vienna: 3, 5, 6, 8, 15, 17, 27, 28, 38, 46, 48, 51, 54, 55, 64, 70, **72**, 77, 80, 81, 83, 98, 100, 101, 103, 122, **130, 139**
Kunsthalle, Hamburg: 105
Moravian Gallery, Brno: 2, 68, 71, **75**, 78, 106, 116, 118, 119, 133, 142
Musée Condé, Chantilly: 9, 45, 61, 86, 121, 125
National Gallery of Scotland, Edinburgh: 66, 112
Private Collections, Prague: 37, 97, 135
Regional Gallery, Ostrava: 31
Royal Library, Windsor Castle: **12**, 21
Schlossmuseum, Weimar: 87
Staatliche Graphische Sammlung, Munich: 18, 143

Staatliche Kunstsammlungen Albertinum, Kupferstichkabinett, Dresden: 16
Staatliche Kunstsammlungen Albertinum, Sächsische Landesbibliothek, Dresden: 1
Staatliche Kunstsammlungen, Weimar: 44, 132
Städelsches Kunstinstitut und Städtische Galerie, Frankfurt am Main: 111
Stedelijk Museum, Amsterdam: 67
Szépmüvészeti Museum, Budapest: 14, 29, 30, 43, 85, 113
West Bohemian Gallery, Pilsen: **76**

Photographs of drawings from the property of the National Gallery in Prague and from private collections in Czechoslovakia:

Soňa Divišová 2, 4, **10, 12**, 13, 19, **22—25**, 26, 37, 38, **39—41**, 50, 52, 53, 55, 56, **57**, 62—66, 68—70, **73—76**, 78, 79, 82, 83, 87, 90, **91—94**, 95, 96, 99, 102, 106, **107—110**, 114, 115—120, 123, 124, 125, 126, **127, 129**, 133—136, **137, 139**, 141, 144, 146; **Jiří Hampl** 135; **Majka Pavlíková** 31

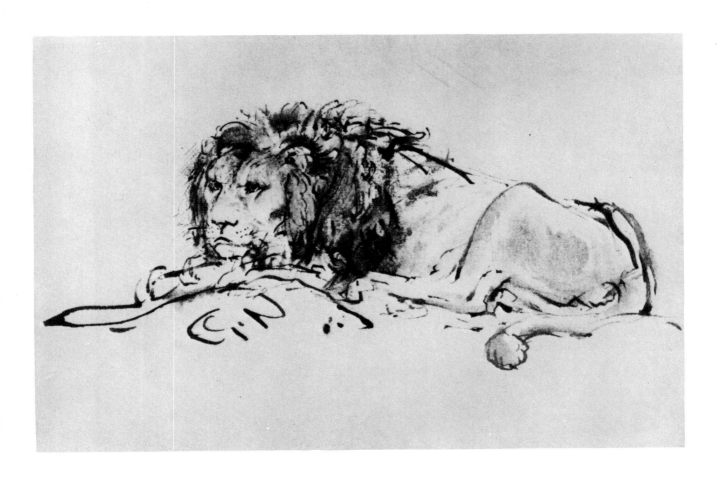

INDEX
OF NAMES

(Numbers in italics indicate text pages; other numbers refer to illustrations, those in bold — to colour plates.)

INDEX
OF OBJECTS

Measurements

Measurements of the drawings reproduced in this book are given in millimetres with the height preceding the width. The following table gives an approximate conversion to imperial measurements.

100 mm	4 in	400 mm	$15\frac{3}{4}$ in
200 mm	$7\frac{7}{8}$ in	500 mm	$19\frac{11}{16}$ in
300 mm	$11\frac{7}{8}$ in	600 mm	$23\frac{5}{8}$ in

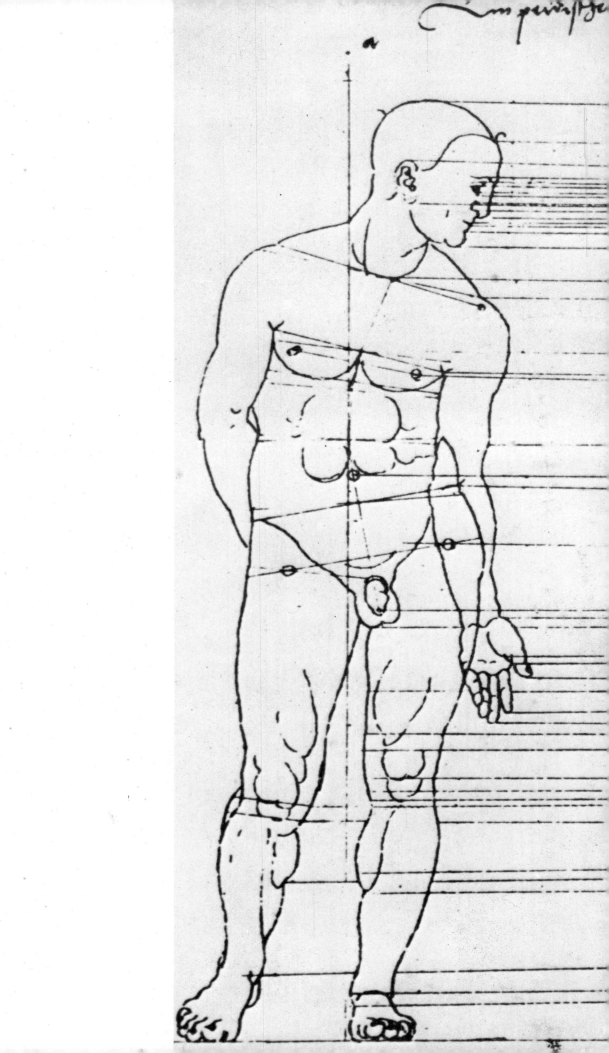